...y and Soul

Body and Soul presents a unique and emotionally intelligent approach to building a sustainable boudoir photography business. The higher-level strategies within these pages will enable photographers to move beyond the task of simply making pretty pictures to greater goals, such as understanding the emotional journey of the boudoir process, building meaningful, long-term relationships with clients, and creating a referral engine to sustain the business. Susan Eckert combines her professional experience as an internationally published photographer with her advanced degree in Psychology to deconstruct the boudoir experience. Each chapter is complemented by interviews with her clients, and illustrates how photographers can partner with their clients throughout the boudoir process in the development of meaningful work.

Susan Eckert is an internationally published photographer, a career-long member of PPA, and a member of WPPI and AIBP. Prior to becoming a boudoir photographer, Susan earned a master's degree in Psychology from Columbia University.

"This book is an absolute must-read not only for anyone shooting boudoir, but anyone who photographs women in any capacity. Susan has proven through her years of experience that she has mastered not only the technical aspects of boudoir photography but, more importantly, the emotional skills. This is a book that has a special place in my library."
Jennifer Rozenbaum, Boudoir Photographer, Educator, and Author of *The Boudoir Photography Cookbook*

"Susan Eckert's Body and Soul is truly a work of art, in and of itself. Immediately hooking the reader with her clear mission of a deeper calling to boudoir photography, Eckert's background in psychology and creative talent radiate through the pages. Body and Soul is not just a how-to on boudoir photography; rather, it is a serendipitous layout of a deeper connection to one's work and to their clients. Fulfilling the creative's vision of purpose and experiencing financial success is shown to be possible in this thorough and sincere masterpiece."
Erin Zahradka, Founder, Association of International Boudoir Photography

"Susan's work transcends the usual genre types one may too quickly apply to her sensual and sublime imagery. Her reverence for the subject, the setting, and the photographic art makes her work enchanting, elegant, and provocative. For a photographer wanting to enter the boudoir marketplace, this book will become your business bible. You will be applying the knowledge and ideas contained here every single day. My suggestion . . . buy two copies!"
Don Giannatti, Photographer and Author

"Of all the photography genres, I think boudoir may have the loosest interpretation as to what defines it. Susan has done an amazing job of giving shooters of all levels a guide that will take them to a place where they will be able to define the genre of boudoir for themselves as artists."
Craig La Mere, Moz Studios

"Perfectly unveiling the emotional world of boudoir, Susan has crafted a book that is as intimate as it is inspirational! This is the perfect resource for photographers who want to explore women's photography from the inside out. Susan generously shares her soulful approach to creating portrait transformations that are nothing short of life changing."
Megan DiPiero, Beauty Portrait Photographer

"As a psychologist who works with patients of all ages and body types, I would say this book is a must-read for all boudoir photographers! Working with women while they are at their most vulnerable requires a special kind of sensitivity to issues surrounding body image, weight, or age. Susan Eckert has done an amazing job of describing these issues."
Dr. Laura Ellick, Clinical Psychologist, Speaker, and Author of *Total Wellness for Mommies*

"With a razor-sharp mind and an artist's heart, Susan provides us with a clinical understanding of the female psyche and its translation to visual imagery. Susan's work, backed by over 10 years as an Ivy-league Organizational Psychologist, teaches us that impact is not something that can be bought or injected into one's images, but rather uncovered . . . In sharing this consideration, she enables us to uncover the hidden emotional impact in the work we do, through empathy and self-realization."
Cate Scaglione, International Award-Winning Boudoir Photographer, Brand Consultant, and Educator

Body and Soul

Lucrative and Life-Changing Boudoir Photography

SUSAN ECKERT

First published 2016
by Focal Press
711 Third Avenue, New York, NY 10017

and by Focal Press
2 Park Square, Milton Park, Abingdon, Oxon OX14 4RN

Focal Press is an imprint of the Taylor & Francis Group, an informa business

© 2016 Taylor & Francis

Library of Congress Cataloging in Publication Data
Eckert, Susan, author.
 Body and soul: the pathway to lucrative and life-changing boudoir photography/
 Susan Eckert.
 pages cm
 1. Glamour photography–Vocational guidance. 2. Glamour photography–
 Psychological aspects. I. Title.
 TR678.E34 2016
 778.9'974692–dc23 2015024551

ISBN: 9781138856998 (pbk)
ISBN: 9781315718989 (ebk)

Typeset in Stone Serif
by Keystroke, Station Road, Codsall, Wolverhampton

Printed and bound in India by Replika Press Pvt. Ltd.

Contents

Introduction

Like a butterfly stuck in a chrysalis, waiting for the perfect moment, I was waiting for the day I could burst forth and fly away and find my home.

Emme Rollins, *Dear Rockstar*

My Transformation

I've always loved art. As a teen, I'd spend hours sketching models' faces. And while I'd marvel at the "perfect" symmetry of faces like Cindy Crawford's, I was even more captivated by the beauty of "imperfection" and asymmetry—for example faces like Christy Turlington's, where one side was notably different from the other and yet the result was hauntingly beautiful and, to my eye, perfect.

As my skills improved, I'd draw whole figures—paying close attention to the lines of the female body—all its curves and angles. But the outcome of my work was often more figurative than realistic. I realized I was drawn to the abstract, to capturing the *idea* of things, rather than to a literal or precise replication. Capturing the idea of things meant I had to look at people and things in a different way. I had to see them in a more meaningful way. It helped that I was fascinated by people in general—not just how they looked, but also what made them tick, what made them feel, interact with, and experience the world as they did.

As a student, Psychology became my passion. I earned a master's degree from Columbia University in the field of Organizational Psychology and, upon graduation, began working for Fortune 500 companies. Corporate America is a very interesting place, psychologically speaking, and the lens I'd developed as a result of my advanced studies gave me an interesting perspective on its culture. I was most struck by the ways in which power structures and hierarchies affected women; how much the corporate world was and still is very much a man's world.

While I did encounter organizations making great efforts to equalize the playing field, many women were struggling to find their space in the workplace. I watched women battle to forge work identities distinct from and at times at odds with who they are in their personal lives. I observed the guilt, anxiety, and strain of conforming to a workforce culture very much shaped by men. And while my role often involved developing programs and initiatives that would support the inclusion, engagement, retention, and morale of women in the workplace, I still found myself growing restless.

I did not want to help women mold themselves to fit an environment that wasn't built to enable them to work from their strengths in the first place. I did not want to perpetuate the status quo by teaching women to cope with unfair power and hierarchical structures. I wanted to support women through the process of self-discovery, in their journey toward greater appreciation for who they are—their strengths and challenges.

I wanted to help women see how their feminine qualities and strengths were a source of beauty, not weakness. But it wasn't until I myself experienced tension between the competing roles of motherhood and corporate life that I ultimately reevaluated what I was doing workwise.

I felt a strong pull to return to my art, but I wasn't sure how I would express what I'd experienced, what I felt . . . until one Christmas when my husband bought me a Nikon DSLR. (I can hear the collective *Ahas!* of photographers everywhere.) I'd always loved taking pictures, but photography was never something I'd considered as a tool for my artistic expression. This particular Christmas, though, something literally and figuratively clicked. I decided I would make photographs as a means of getting back to my art. I should note here that I wasn't thinking along the lines of becoming a photographer . . . not just yet.

I set a date with a dear friend and former ballet dancer to capture some art nudes. I thought I would use the photographs as inspiration, or studies, in a renewed attempt at painting the figurative nude. I knew nothing at the time about photography other than you point, shoot, and then check the screen to be sure you got your image. I'm sure my camera was set to auto throughout the shoot and I'm sure I was using whatever kit lens came with the camera body. But knowing we'd be shooting in her basement, I had planned ahead and purchased a strobe from eBay. It cost me a whopping $29 and even came with a 12" softbox. Mind you, I had no means of triggering the strobe— I wasn't even aware that I needed to trigger it! So, I went forward with the shoot, relying instead on the strobe's weak modeling lamp for light.

Our shoot was a fun exploration of poses, angles, and desperate attempts to make a measly 12" square softbox spread light across my friend's long, lean, elegant figure. It was a learning experience on so many levels: I learned a lot about the importance of working *with* your model; about providing guidance and instruction so that you can achieve your vision; but most importantly I learned just how critical it is to *have* a vision in the first place.

I am not exaggerating when I say that looking through the resulting images from our play session changed my life. Despite the lack of light and occasional awkward attempt at a creative angle, I was forever changed: I immediately fell in love with the act of creating imagery. There, among the grainy images, was a story about timeless beauty, grace, and elegance. Seeing firsthand how even a crappy strobe had such potential to sculpt, frame, and highlight, I also fell in love with light and its ability to tell a woman's story. There in the determined poses, shadows, and light, I also found a compelling story about strength, tenacity, and fortitude.

I would spend the next seven years building my knowledge and skill in photography, and establishing the leading female-owned boudoir photography studio in a region where you throw a pebble in any direction and inevitably hit 10 to 20 photographers before it drops to the ground. My approach to learning followed two paths:

1) Believing education provides a solid foundation no matter what you intend to pursue, I enrolled in a distance-learning program offered through the New York Institute of Photography. Their format worked well with my general do-it-yourself, self-paced approach to learning.

2) So that I might translate education into experience, I also sought out mentors and assisted photographers in other niches (e.g. wedding, fashion).

Little by little, I began to put myself out there—to market my services via a website I'd built myself using *HTML for Dummies* as a guide. To be honest, I don't even think I used the term boudoir. Boudoir was better established on the west coast than it was on the east coast at the time. I just knew my intention was to create a powerful experience for women, to enable them to look and feel like artist muses, to enable them to express themselves, their beauty, strength, and personality—and have all their amazing qualities forever recorded in beautiful imagery. This was the gift I wanted to give. This was my vision.

I started with a studio in my living room. I now operate out of a 2,000 sq ft commercial space I've worked hard to transform into a cozy, feminine, women's hideaway. It's been an amazing journey, but it hasn't been easy.

When I first set out in boudoir photography, I was told I'd never make it work—that it wasn't the kind of niche you could specialize in alone because it wasn't like child or family portraiture where clients came back again and again. Boudoir, I was told, was a once in a lifetime thing. Women might do it once but then never again. I was also told that the market was too small as boudoir was only suitable for women in their twenties through mid-thirties at best (gosh that was so wrong)! I was further warned that out of this already small population probably only half would even venture to do a boudoir shoot in the first place because, after all, why would a woman need pictures of herself in her underwear? In short, I was encouraged by the pros to stick to safer bets like wedding photography, children's portraiture, or even better yet, given the already oversaturated photographer market in my area, to try something different . . . like pet photography.

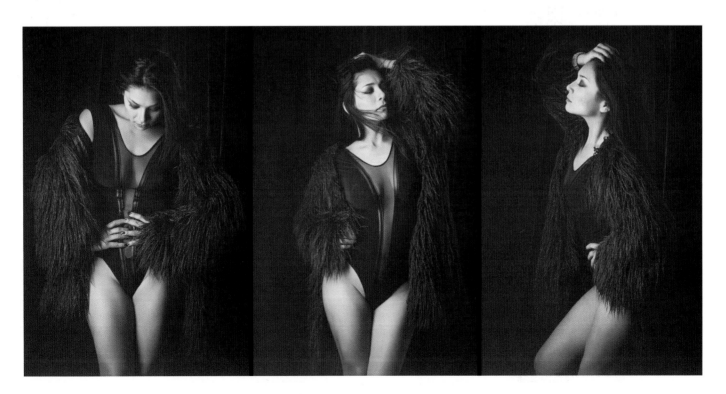

There has always been, and still remains, a lot of misinformation about boudoir photography—what it is, why clients pursue it, and how it should all work. Long story short, I'm glad I ignored the bad advice, all the misinformation, and instead followed my heart. I have proven each of those initial reasons for not pursuing boudoir wrong. And despite the fact that many women on the east coast *still* have never heard of boudoir photography, I have a thriving business and am busy year round. And because I make the experience first and foremost about my client and her goals, I have:

- clients who return like clockwork once a year as a gift to themselves;
- clients who return more than once in a single year to explore and express different aspects of their multifaceted natures;
- clients who are single and are simply doing this as an act of self-love or self-acceptance;
- a very healthy referral machine in place, which steadily introduces new relationships into the system while providing opportunities to reinforce long-standing relationships with clients I have come to think of as old friends.

It turns out the market for boudoir is really much larger than we think, provided we educate our prospects about what this thing called boudoir photography can actually be. In contrast to the limits some photographers arbitrarily set for themselves, I've shot women aged 20 through 82. My clients reflect women from just about every walk of life: college students; brides-to-be; fitness queens; soccer moms; divorcees; grandmothers; plus size beauties; etc. etc. But what I love so very much about this work is this: many of these women never, ever imagined they would pursue a boudoir shoot!

When you consider that every living, breathing woman wants to feel beautiful and own the right to express her sensuality, the market is unlimited!

So what's required to tap into this potential? Just as it was with my first-ever shoot:

- a clear and compelling vision;
- a sense of purpose so strong it drives you—and, in doing so, inspires others to overcome their fears and submit to the experience;
- an approach in which every aspect of what you do and how you do it is in alignment with your compelling vision and driving sense of purpose.

A Different Approach to the Boudoir Client

Let's pretend you meet a woman in a nonthreatening environment such as a farmer's market. You get into a discussion over the beauty of the tomatoes—how ripe, fresh, plump, and colorful they are. As you chat, you think to yourself: **This woman has no idea how beautiful she is**. She seems to shine from the inside. So you tell her: **I'm a photographer and it would be a great honor to capture your beauty**.

What do you shoot? she asks.

Boudoir, you reply.

What's boudoir?

Now pause.

What do you say? How do you describe boudoir?

This woman has never heard of boudoir photography before. How do you describe what you do so she will feel honored, flattered, but also intrigued and eager to try it for herself?

Let's imagine two scenarios.

In the first, you respond with: *Boudoir is about taking pretty pictures of you in your lingerie.*

Now step into her shoes for a moment. A stranger has approached you and just asked to take pictures of you in your underwear! Now while a direct approach is fine for children's portraiture or family portraiture, how effective do you think a direct response like this might be when it comes to boudoir? I'm guessing, not very!

So let's look at a second scenario. Here you respond by saying: *Boudoir is a means of exploring the power and beauty of our feminine qualities; a tool that enables us to explore and communicate the essence of who we are and how multifaceted we as women can be.*

Ahhh! Now we're getting somewhere. I'm sure you can imagine you'd get quite a different reaction to this second scenario. It speaks to a deeper purpose and will most probably entice your prospect into exploring it further.

The best answer when presenting what you do to any prospect is, of course, to describe your vision and inspire others with your purpose. Unlike with child, family, pet, or wedding photography, the approach to the boudoir client is a bit more delicate in that it addresses a generally private part of a person's life and character—stuff that's hard to discuss with a stranger. But when you know what you're doing and why, it's easier to communicate the value you offer to your prospective clients.

Having come out of organizational psychology work where visioning and value-propositioning were par for the course, this concept was immediately obvious to me as I entered into my boudoir photography life. I spent as much time building my photography skills as I did examining the value proposition for my boudoir work. In this book, I encourage and guide you in doing the same.

What This Book Is and Isn't

This book will guide you in clarifying your vision. I firmly believe that having a strong, clear vision and purpose for your work is a critical foundation for establishing a successful niche business such as boudoir photography. Without it, you will likely struggle—floating like a leaf in the wind, ever subject to its changing direction. Without a clear purpose you will waste lots of energy and time on things that will ultimately fail to bring you closer to your goals, vision, and purpose. And without a driving motivation you will find it difficult to set yourself apart from the ever-growing photographer market, particularly in an environment where many only know to compete on the basis of pricing alone (a losing strategy for sure).

This book will guide you in exploring what *you* uniquely bring to the table, so that you can distinguish what you offer in today's super-saturated photographer market, and attract the right clients for your business. Boudoir photography is highly personal and, unlike other niches in photography, who *you* are has everything to do with your client's ability to trust, feel safe, engage, and reveal herself throughout your process so that you can ultimately create the most powerful and meaningful images you can.

This book will walk you through the critical steps you must take throughout your time with your client and beyond. Creating an experience clients will never forget requires attention throughout your client engagement—from first contact going forward. Leveraging that experience for your business so that you can enjoy high client retention, increased word-of-mouth referrals, higher sales and satisfaction requires that you take very important steps throughout your time with your client, and even after you've delivered the goods to her.

I will show you that the relationship should have no end, and how each woman who steps through your door is the start of a lifelong relationship—one worthy of investing in for the foreseeable future. Many photographers feel their relationship with the client ends once they've delivered her book, album, or other art materials, or that it ends once they've collected feedback on the goods and experience. It shouldn't!

This is not the first book on boudoir photography. As such, I do not aim to skim the surface in an attempt to cover the basics of everything but the kitchen sink. There are books providing general information on making pretty boudoir photographs. There are books on lighting for boudoir, and books on posing boudoir clients. My goal is to move past the basics of lighting, posing, and process how-tos in order to present an alternative higher-level strategy for working with the boudoir client. It is a strategy based on:

- the principles of psychology;
- an inside-out approach: it starts with self-assessment and design of a business in which *your essence* is woven into the fabric of your business and brand;
- a purposeful and client-centered approach to your work;
- techniques that enable you to paint more meaningful portraits of your boudoir client;
- the direct connection between emotions and a sustainable business;
- in short, the concept of emotional intelligence.

In presenting this approach, the book presumes that the reader has some experience shooting portraiture and is not looking for an overview of the basics of photography. In short, this book moves beyond the task of how to make pretty pictures and focuses on next-level goals such as:

- creating transformative, life-changing experiences for your client;
- rethinking standard approaches to boudoir photography;
- building client relationships that will ultimately establish a business-sustaining referral engine for the photographer.

Why Not Just Make Pretty Pictures?

Photographers are taught to focus on lighting formulas, technical know-how, proven poses, camera settings, and lens choices. We're also taught to create a consistent look and brand for our work so our work will be recognizable regardless of the subject. Mastering these things may very well result in pretty (perhaps pretty **and** technically perfect) pictures. And these pictures may certainly win you awards and attention from your photography peers. But what's so often missing from these images is essential to meaningful, life-changing boudoir photography:

- heart;
- emotion;
- our client's soul—who she is at her core, as *she* sees herself.

Boudoir is not only about a woman's relationship with her body. It's all about intimacy, emotion, self-exploration, and revelation. It's about digging deep and expressing parts of ourselves we may seldom get to express.

Or at least it could be.

In the right hands, and with the right approach, more often than not boudoir photography becomes all these powerful things and more.

Which scenario do you think would be most compelling to a prospective client?

A. The cookie cutter photographer who learned the same series of poses as all her colleagues and whose images, in the interest of establishing her brand, reflect a narrow approach to lighting (whether only natural light or only studio light). Images in which you could swap out one face for another and not much else would be different.

Or, B. The client-centered photographer who shoots each client as *she* wants to be captured in order to tell the story of who the client is right now, today; whose wide range of lighting styles enables her to use lighting as an important tool that conveys the exact mood her client wants to communicate; who guides her client in understanding how the camera sees so that together they might explore movement and positions that will express what the client wants to say . . . so that when she sees her images, she is overwhelmed by emotion because she sees herself in a powerful way . . . in perhaps a way she's never seen herself before?

Based on my experience I would argue that, for prospective clients ready and willing to invest in a higher-end experience, the second scenario, B, is a clear winner.

Please understand that when your primary goal is to make images that speak to your own style as a photographer, to reflect your own view of women—the poses they should do, the clothing they should wear—you miss out on the opportunity to use the boudoir experience as a transformative tool, as a means of self-expression for your client.

I argue that relinquishing a bit of our control as photographers and setting our sights higher—moving beyond making pretty pictures and aiming to make images that matter, that will transform our clients' lives—is not only more fulfilling to the client, who has played a greater role in shaping the look and feel of the images, but also serves the photographer better as well. Following is a list of some of the advantages of shifting our focus to providing our clients with a transformative, life-changing experience:

- greater likelihood the experience will be more meaningful and therefore unforgettable;
- higher level of engagement and revelation on the part of the client;
- deeper level of trust and connection;
- greater degree of buy-in from the client at all stages of the process (eliminating the surprise of a dissatisfied client upon image review);
- greater perceived value—because her images are unique to her, and not a dime a dozen, she will invest more for this personalized experience;
- expansion of sales—because the experience itself is so highly valued, add-ons like proof boxes, slideshows, etc. sell themselves; and because she feels proud of her role in creating these works of art, she is more likely to choose higher end albums and products;
- greater possibility of repeat business from a single client—she can continue to come up with new ways to express herself, new stories to tell;
- higher rate of referrals because the glow from the experience can last several years.

Quite often prospective clients will call me after having reviewed several boudoir photography sites and portfolios, and they will say, "Yours just felt so different that I had to pick up the phone and call."

What they are reacting to is the emotion and energy of the images in my portfolio, and the wide range of images from one client to another. "It's obvious you didn't just stick each woman in some random pose," they will tell me. And they are right. While I do often begin each session with standard poses as a means of building the client's confidence and ease, the ultimate goal is always to get each client to follow her instincts and to use movement as a means of telling her own story.

My primary goal with this book is to help you formulate and build a business that is meaningful to you, and whose services are so meaningful to your clients that they enable you to sustain it. I want to take you ten steps further than most photographers will aim in running their business.

It is one thing to make pretty pictures that reflect your style and brand as a photographer. It is quite another to partner with your client in the co-creation of images that bring happy tears because they transform a person's view of themselves, conquer long-held fears or insecurities, and/or validate a woman's self-worth.

It is such a beautiful thing to commit your life's work to making images that truly matter.

A Word about Dudoir

Given the growing popularity of boudoir photography for women, it's no surprise that "dudoir"—as some have coined the term to refer to men's intimate portraiture—is also growing in popularity. I get more and more inquiries every year for this special niche, and while I do shoot couple's boudoir, I have not yet chosen to shoot dudoir.

The reason for this is simple. As an art student, I studied lines and figures, more often than not focused on female dimensions. Men are completely different when it comes to aesthetics and their emotional needs. I once watched a male photographer edit a shirtless male model. As I watched him make small adjustments to the model's proportions, I thought to myself, *I would never have thought to make the particular edits he did.* Men want to appear larger, women smaller. Men want to appear rough and tough, women soft. In order to shoot dudoir, I'd have to prepare by first taking a few art courses in figurative drawing of the male form. Otherwise I would not feel confident in my ability to capture men in their most flattering light.

For this reason, and because I chose to write in depth about women's psychological and emotional needs, I felt a discussion of dudoir was outside the scope of this book.

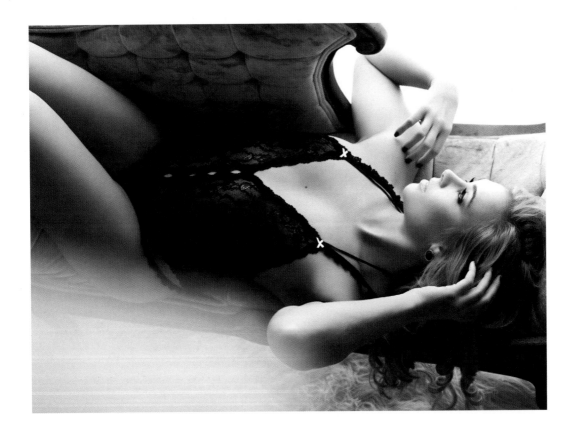

How I Organized This Book

The book takes what is known as an inside-out approach to building a sustainable boudoir photography business and to partnering with your client to create a transformative and life-changing experience.

Accordingly, Part 1 starts with a focus on *you*. You might feel tempted to skim over this part and move on to the how-to, boudoir process information, but please don't. Remember I shared that I spent as much time developing my client's value proposition as I did building my photography skills? It's critical for your business that you do so too. Think about it: how else will you make decisions going forward regarding marketing, defining your target market, developing service and product offerings, pricing, or structuring your client experience? In the absence of this introspection you will likely be taking shots in the dark. And I assure you, when you flip the light switch on, you may very well find you've not only missed your intended target, but you've been aiming at the wrong wall altogether.

Part 1 will help you:

- define your motivations, purpose, and goals;
- clarify what you offer your boudoir client, and who your ideal boudoir client might be;
- determine your boudoir photography business parameters and brand;
- get equipped with the tools to handle challenges and avoid detrimental pitfalls throughout the boudoir photography process;
- determine the market you are working in and how to position yourself for success (as you define it).

Once you have a compelling vision, an understanding of who you want to be in the boudoir market, and how you will address a given need, Part 2 goes on to discuss how to engage your client throughout the boudoir photography process from moment one.

Part 2 addresses:

- understanding who your client is—an important goal throughout your engagement;
- becoming familiar with a woman's psychological development as it relates to body image, self-worth, and her emotional needs; and
- translating your client's goals into reality using a photographer's greatest tools.

Many photographers only concern themselves with their client's experience up to the end of Part 2, with the launch of an impersonal online gallery where clients may sort through images on their own and submit file numbers for the images they want. In handling their business this way, they've missed a tremendous opportunity.

Part 3 presents an alternative approach and introduces the concept of creating an ongoing experience for your client even after the shoot. In Part 3 we discuss:

- prepping for the in-person review and selection process;
- managing emotions during image reviews;
- communicating with your client and managing expectations post-shoot;
- managing the relationship on an ongoing basis.

In each chapter there are select interviews with clients I've had the pleasure to partner with. Their stories illuminate the importance of personalization and support points made throughout the book.

Concluding the book is:

- an interview with a therapist on body image, women's emotional needs, and the potential power of boudoir photography;
- an additional series of client interviews.

Last but not least, the book's extras include:

- a self-assessment: is boudoir right for me?
- a sample client intake questionnaire;
- a sample follow-up questionnaire;
- a resource list for boudoir photographers.

So, are you ready for an enlightening journey—one that can open up new and rewarding business opportunities for you? Let's begin!

Join the Body and Soul community on Facebook: Facebook.com/BodyandSoulBoudoir.

PART 1

WORKING FROM THE INSIDE OUT

Your Transformation into a Professional Boudoir Photographer

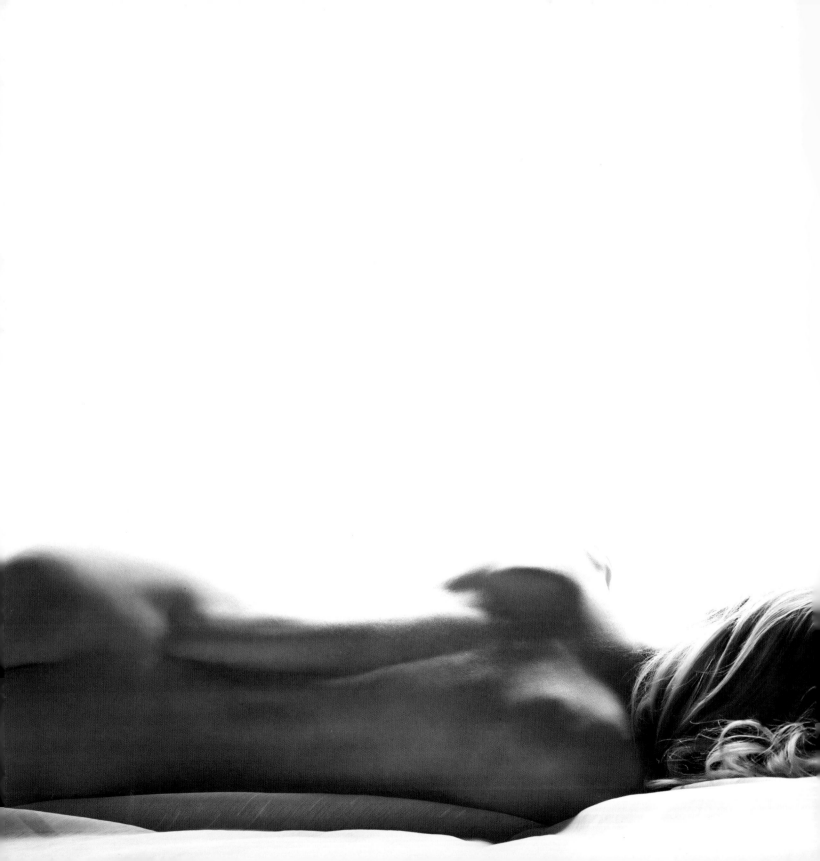

1

Looking Within
The Importance of Self-Assessment

A strong relationship is a two-way street; to engage with others meaningfully you must first be sure of what you offer, what you bring to the table . . . and then, communicate that loud and strong . . . to just the right person who's been waiting to hear it.

What's Your Motivation?

I will share a secret with you. I've never confessed this to anyone . . . and yet here I go writing it in a book! Ah well, here goes. When I look in the mirror, I'm surprised by the reflection. The person I feel I am on the inside doesn't match up with the person staring back at me. I've taken issue all my life with that reflection. The hair is too curly. The skin too brown. The lips too full. The eyes too big. The body the wrong shape. The legs too strong. It goes on and on . . . but the end result is the same: I avoid mirrors much like other people avoid needles or unpleasant coworkers; it's just too uncomfortable.

Instead, I focus on helping other women so they will *not* feel the way I feel. I want to be my client's cheerleader, confidence-builder, an uplifting friend who gives her something valuable: maybe it's the gift of seeing herself in a way she's never seen herself before; a renewed sense of confidence; or ammo she can use in the fight against her own negative internal script.

Whatever I can provide her so that she can begin to see herself as others likely see her—her strength, the beauty of her femininity, her fierceness—is what I want to give.

Because I tend to be successful in achieving this, I draw many women to my business who never imagined they'd ever pursue a boudoir photography shoot. Word-of-mouth reaches the quiet ones, the introspective types, and the damaged souls who hear about the experience other women have had at my studio; they decide they want the same for themselves. They want to feel powerful, beautiful, transformed. And the grapevine has informed them I'm the one who can help.

Illuminating the Power of the Feminine™

That is my tagline, my mission, and I am driven by it. It shapes every single thing I do:

- from the very first moment a prospect reaches out to me and I excitedly share the potential and power of boudoir photography;
- to every encouraging word I say to calm her nerves during the shoot;
- to sharing a laugh or a happy tear with her as I reveal her beauty—raw and perfect;
- to the care I take in packaging and handwriting a meaningful personal note;

- to the warm hug as I send her back out into the world—armed with her book filled with proof that she is a beautiful, sensual, strong individual, and that she is, quintessentially, a woman.

I am so deeply motivated by my work—my vision, my purpose—that I can't imagine doing any other kind of "work" for the rest of my life.

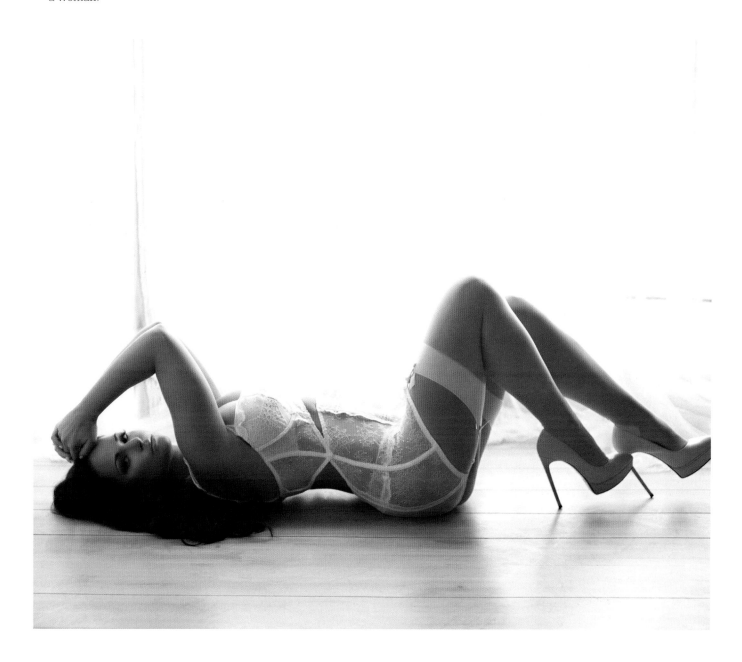

An Interview with Dayna

Dayna is a model I had the great pleasure to meet and shoot at a workshop I attended in the fall of 2014; while I was initially unaware that her bald head indicated an ongoing struggle with cancer—she was simply so vibrant and strong I figured it might have been a personal choice or alopecia—I asked her to work with me on this book project because I was so inspired by her. Her responses to my interview questions showed me just how strong and inspiring this young woman truly is!

What motivates you to pursue a boudoir shoot right now?

I want to be able to help people like myself. I was diagnosed with Hodgkin's Lymphoma in 2013 when I was 22 and have been at battle with the disease ever since. It wasn't until my second chemotherapy that I had chunks of hair missing and I decided to take control and shave it all off . . . shaving my head was one of the toughest things I've had to do as a woman . . . Without hair there is nothing to shield you from everyone's stares, you're out in the open like a target . . . I would get panic attacks regularly from having groups of people stare at me, their eyes piercing through me like lasers . . . What made me stronger was each and every woman that would come up to me with a bandana or a hat on that would stop me and thank me for having the courage to go out without anything on my head . . . I do photo shoots now for those women out there

who are going through experiences like mine and need a reminder that having no hair is nothing to be ashamed of and that you can look just as sexy as women with hair . . .

Heading into a boudoir shoot, what concerns you most?

Being in lingerie can be intimidating enough as it is, never mind being portrayed in a way I don't want to be. With boudoir there is definitely a fine line between artistic and sleazy.

What are you most excited about?

I'm mostly excited to work with Susan again. Her energy and enthusiasm on sets makes me excited about the outcome . . . I'm also excited to see the finished photos after the shoot, that's always the best part.

What three words would you select to describe the look/feel of the images you hope to create?

Strong. Classy. Cool.

What, if anything, would make you feel more comfortable and confident heading into your shoot?

I understand [Susan's] style of shooting and am confident that she wouldn't put me in poses that I didn't feel were right.

What specifically might the photographer do to help you feel more comfortable and confident heading into your shoot?

It always makes me feel better when I've connected with the photographer before I take all my clothes off in front of them.

Please share any other insights or information about your thought process, fears, hopes, etc.

I'm excited to show others that you don't necessarily need long hair in order to show your sexuality. That you can be strong in many different ways and showing that in a picture can sometimes help others without you even realizing it.

Some clients describe the boudoir experience as a roller coaster of emotions. Was it so for you?

What helped me feel more comfortable is when Susan expressed her excitement with the few shots that she did take and showed them to me, making me feel more confident that I could move around more. By the end of the shoot . . . I was reaching outside of my comfort zone in poses with ease.

What did the photographer do specifically that helped ease any anxiety or fears?

I love that Susan shows me the photos that she's taking of me while we're working. It gives me a great touch point of where I'm at.

Once you saw the images from your shoot, what was your reaction? Did they capture the three words you identified?

They were amazing! They all represented a little bit of me . . . The words I used in the pre-shoot were strong, classy, and cool which I feel came across in each one of my shots.

Aside from beautiful images, are there any other positive outcomes from your boudoir experience?

Doing this boudoir shoot and seeing the results made me feel more sexy than I had before. While struggling with this disease for the past two years, I've lost more than just my hair. With the intense chemotherapies and stem cell transplants I've had, I actually went through an early menopause which can be common for many female cancer patients. With an early menopause you can lose your sex drive which can interfere with your feelings of being sexy to others. These photos were a reminder of how I can truly look and made me realize that I'm just as sexy if not more sexy than I was before because of my confidence and strength.

On a scale of 1 to 10 (10 being most confident) how would you rate how you feel about your body post-shoot?

After seeing the shots and what an amazing job Susan did, I could say that I would have a 10 for confidence. My scars are just another part of my story and there's nothing wrong with that. Every body is different and beautiful in its own way. *(Pre-shoot she'd indicated an 8.)*

Anything else you wish to share . . .

I hope to help others in gaining confidence in being who they are, cancer patient or not. A lot of women these days are so focused on their bodies and what may be wrong with them instead of embracing who they are and their differences from everyone else. Women are beautiful no matter what size, shape, or color they are as long as they have confidence within themselves and truly love who they are and what they have to offer. I loved working with everyone on this shoot and would love to continue working together to create a positive and creative image for people to be inspired by.

Before we proceed, here's a suggestion: you might want to dedicate a composition notebook or pretty journal book (if you, like me, are inspired by pretty leather-bound notebooks and journals) to recording your thoughts as you progress through Part 1 of this book—the self-assessment work. This book will also serve you well as you make your way through the stages of client engagement as presented in Parts II and III. By checking back across your notes and ensuring consistency, you may just find you've crafted a plan for your own boudoir photography business . . . should you choose to establish one. While I present how I have designed *my* process as a result of my overall vision, purpose, and brand, you may wish to note how yours might differ and align better with your particular mission and brand. Also note, for your convenience, that the self-assessment questions at the end of chapters 1 to 5 sum up the key ideas to be considered in each chapter.

So, what is your motivation? Why are you interested in pursuing boudoir as a niche at this time?

Don't misunderstand my intention in asking this question: there is no right or wrong answer here. Some photographers might be interested in exploring boudoir photography because it's trendy, up and coming, hot right now, or because they've heard it's a lucrative niche. Whatever your reason, the point is to be clear about your motivation. This clarity will help you shape a business that's direct in its purpose. And by being direct in your purpose, you can be clear in your communications regarding the services you offer. And by being clear in your communications, you will attract the right clients for your business.

A Word of Encouragement to Male Boudoir Photographers

Let's be honest. Men and women tend to see differently. I've reviewed images with a woman where hubby was present and it never fails to happen—she will point to one image and he will point to another. Depending on her goals of course, most women prefer a quiet sensuality, a subtle sexuality, whereas men, accustomed to the more graphic depictions in media, will go for the bolder expressions of sexuality.

Now, I say all of this knowing that for every generalization there are examples to the contrary. Of course, I have shot women who wanted to achieve in-your-face sexy images, and met husbands who preferred the quiet, intimate beauty revealed in an image of their wife. Still, aesthetics do tend to fall along gender lines. If that were not so, we would not have so many cultural jokes referring to the predictable differences between men and women.

So where does that leave the male boudoir photographer? I've heard from some of my male colleagues that it's tough to market to women for boudoir. I understand that challenge as a woman. There are concerns about discomfort, feeling embarrassed, revealing too much, maybe wanting to please, or getting the wrong kind of images with a male photographer.

And yet, I know other male photographers who do just fine attracting women as boudoir clients. So what's the difference? Often when I take a look at the portfolios of the men who state they are having difficulty, I see men's pinup magazine type images—overly sexualized, impersonal renditions of women. In short, their images reflect how men want to see women, not how women see themselves. By contrast, the male photographers who aren't struggling have a wider range of styles—sexy in-your-face images, sure, but also soft, beautiful images that speak to the photographer's respect for women, his appreciation for the female form, and his ability to hear and translate her vision.

See, all of this goes back to vision. Is your purpose to make pretty pictures that primarily please you, and that first and foremost communicate your aesthetic as an artist? Or is it to serve as a vehicle for your client's self-exploration and self-expression? The latter can result in a much more powerful experience for your client.

Truth be told, the question of a male or female boudoir photographer is a double-sided coin for most women:

Male: pro—it might be easier for a woman to feel sexy in front of a man; con—it might feel more uncomfortable being scantily clad in front of a male you barely know.

Female: pro—it might feel more comfortable being in underwear around a woman—after all we do it all the time in locker rooms; con—it may be more difficult to bring out your sexy side in front of another woman.

For sure, not every client is a fit for every photographer. I've had women say, "I thought it would feel awkward trying to be sexy in front of a woman photographer."

If we, as photographers, put our client's aesthetic, goals, and needs first, we might find that our gender becomes less relevant a factor in her decision to hire us or not.

So, to the male photographer, I say don't be discouraged, read on, and see how you might shift your prospective client's focus from your gender to the more important stuff—your ability to empathize with him/her and provide a life-changing experience that will result in images that build their self-esteem and self-worth.

What Do You Bring to the Table? (Hint: Life Experiences Count)

A great exercise when considering a new job, role, or any switch really is an assessment of the fit between you and the new role you're thinking about taking on. Once you clarify your motivation, the next step is to identify everything you bring to the table in a boudoir photographer–client relationship. This chapter, along with the remaining chapters in Part 1, will guide you in taking a full inventory.

What do you think of when you consider what you bring to the table?

Most photographers may be automatically inclined to list all the concrete stuff like degrees, certifications, awards, number of years spent doing X, Y, Z, and, sure, that's all helpful and important. But when it comes to a niche as personal and as intimate as boudoir photography, the personal, life-experience stuff—weight struggles as a kid; that awkward phase you experienced in your teens; your own battle with cancer—becomes just as important and just as valuable.

As I mentioned in the opening to this chapter, my own struggle with my body and identity fuels my passion for helping others avoid similar challenges. It's what enables me to empathize with the women with whom I feel so honored to work; to feel their pain; and to do my very best to alleviate their sadness. Because I can relate firsthand with the emotional toll such discomfort brings, I am willing to listen, and I am determined in my efforts to help. But even outside of this, there are lots of other things I bring to the table as a boudoir photographer.

As a mother of three, two of whom are twins, I can empathize with women:

- who are also moms;
- who've experienced multiple pregnancies and the body-changing effects they have;
- who've had challenging pregnancies;
- who lament having taken their beautiful, fit young bodies for granted;
- who struggle with making time for themselves because they've been taught to put spouse and children first;
- who feel guilty about doing something for themselves; and perhaps
- women who feel unappreciated for all they do and sacrifice as moms.

As a former athlete and dancer, I can relate to women:

- who are themselves athletes and dancers, and are proud of the effects their training and fitness have on their bodies;
- who fight as they get older to retain fitness levels that once came so naturally and so easily;
- with a passion for dance;
- with a passion for fitness;
- who've achieved levels of fitness they'd never imagined because they've committed to their goals and worked toward them in a determined and focused way;
- with muscular legs;
- with muscular arms;
- who value their strength.

As a mixed-race female of Puerto-Rican, Irish, Afro-Caribbean and Native American ancestry, I understand:

- the challenges that result when popular beauty ideals lie in stark contrast with my client's body shape, hair type, or skin color;
- the many challenges of curly hair;
- the frustration of "nude" stockings and lingerie that clearly don't match brown skin tones, or porcelain ones for that matter;
- the gender-based power differentials so firmly established in many cultures;
- the joys of having been exposed to a warm, vibrant culture;
- the feisty nature of women from certain cultures.

And it goes on and on . . .

Personal connection requires that you start with a connection to yourself, without which you cannot have a connection with someone else. To be connected to yourself means to be able to identify and accept your feelings without self-judgment . . . and to have clarity around what you are willing to accept and tolerate in your relationships.

Paul Weinberg, coauthor of *The I-Factor*

Once you begin to identify labels under which you could neatly place yourself—mother, dancer, athlete, Latina—you can then start to see all the opportunities for establishing common ground with your clients.

So, what do you bring to the table? What labels might you identify with—providing opportunities for common ground?

What's Your Attitude?

If we expect our clients to be courageous in facing their insecurities, fears, and worries—no matter how big or small—we ourselves must be courageous and willing to do the same. I know I mentioned I still battle with my own issues; it's okay to be a work-in-progress but if you want to be in sync with the women you'll be expecting to dig deep, to find strength and courage to destroy their negative body image, and to once and for all silence their negative internal script, it will be most helpful if you yourself:

- have engaged in self-assessment and introspection so that you can provide a frame of reference and relatable scenarios;

- are equipped with tools and strategies for overcoming the kinds of challenges they will also inevitably face;
- can empathize with what they're going through.

If you've never experienced self-doubt, a negative body image, or insecurity, what's your attitude toward those who do? Some have a "Get over it!" attitude that's not especially helpful to those who suffer from these issues. That kind of attitude will only shut your client down and prevent any possibility for her to open up, reveal her authentic self to you, and experience transformation.

Even if you have experienced self-doubt and other debilitating feelings and thoughts, your preference may be to simply

not deal with your client's. You may prefer she keep all that baggage hidden; that she deal with it on her own. Accordingly, you may be inclined to ignore her body language even when it screams, "I'm uncomfortable!" If that's your attitude, you should examine your goals.

Some boudoir photographers seek to experience boudoir for themselves specifically for the purpose of building a relatable point of reference. If you as the photographer can tell your client, "I know, I've been through a boudoir shoot; I was a nervous wreck until I settled in and started to have fun!" it just might provide that extra bit of credibility and trust with your client. It might also allow you to better empathize with her discomfort and insecurities throughout the process.

Bottom line: do you want to facilitate a transformative experience for your client, or are you simply interested in creating pretty, albeit superficial, images for your client? Your answers to these questions will shape every facet of your business: from your mission, to your brand, to the manner in which you interact with your clients, to the way you conduct your shoots, all the way down to the details including lighting, shooting, styling, reviewing, and retouching. However, you should know that this book involves discussion on building an experience for your client that, because it is transformative, can help you achieve a viable business that benefits from repeat business and a healthy referral engine.

Self-Assessment Questions for Chapter 1

1. What is your motivation to pursue boudoir at this time?
2. How might you translate that motivation into a mission?
3. What might a tagline for your business, given your mission, be?
4. What do you bring to the table?
 Make a list of labels that might apply to you: how might these labels create opportunities for finding common ground with your clients?
5. What's your feeling about women who face internal challenges such as deep insecurities, a negative body image, and self-doubt?
6. What's your overall goal when working with your clients?
7. What is your vision for your business in terms of its goals and purpose and how might that shape the way you go about conducting your business?
8. Who might your target market be?
9. Are there any clients, based on your experience or concerns, you feel you would prefer *not* to work with?
10. Describe your ideal client.

2

Values, Ideas, Morals

When people make judgments they close all the possibility around them.

Jeff Koons

One day a photographer who was still pretty new to the field invited me to lunch. Although she was quite busy through word of mouth, she was eager to have someone to bounce ideas off. She wanted to chat with someone who'd been at it a bit longer than she had. I was reluctant to be seen as one who had all the right answers about the world of photography, but I did agree to meet with her and offer whatever advice or guidance I could.

She had been shooting children and families and a review of her portfolio revealed she had quite a knack for getting little ones to reveal their rambunctious sides, their innocent beauty, and their wide-eyed enthusiasm for the world around them. But she was curious about other niches of photography, she said, and asked about my experience shooting boudoir.

I gave her an overview, sharing stories that helped her see that boudoir could be so much more powerful for clients than just a pretty-image-making experience. I shared inspiring stories about women going through and overcoming cancer; women getting reacquainted with themselves after significant weight loss; women recovering from abusive relationships and rediscovering their worth; women battling body dysmorphia and other mental distortions that made them feel inadequate and/or unattractive; and stories about everyday women who wanted to express their individual beauty regardless of age or color.

As I shared my stories, her eyes grew wider and wider. She'd never realized there could be so much emotion and meaning behind the sexy pictures she'd seen in my portfolio. Inspired, she thought she might entertain the thought of trying boudoir photography. I encouraged her to think about it carefully, and then shared other realities pertaining to boudoir: the need to separate boudoir work from marketing efforts to families and children; the importance of sensitively handling nervous requests for nudes; the ability to comfortably engage in open discussions with clients who might want to push the envelope a bit in an exploration of their sensual identities; entertaining clients who'd read *Fifty Shades of Grey* and thought it might be fun to explore some of the edgy concepts presented in that book in their own shoot . . .

As I continued, her expression began to reflect concern. When she opened her mouth to speak, the words were: "I don't think I could shoot nudes, or that other stuff, for that matter." I wasn't surprised. Her facial expressions and body language already told me what her words had not yet expressed.

We laughed and I told her: "Well, like I said, think about it carefully. The last thing you want to do is inadvertently offend your client or make her feel you're judging her in any way. And if you have reservations about any of it, it's probably best to steer clear and avoid stress for yourself and your client!"

She nodded in understanding, thanked me for the enlightening discussion, and with that our lunch came to an end.

This story highlights an important aspect regarding what we as photographers bring to the table. Whether we're consciously aware of it or not, our values, morals, and ideas about what's

right and wrong lie just beneath the surface in everything we say and do, and how we respond to those around us.

And yet, most of us spend very little time actually looking into and thinking about our values, morals and ideas about the world.

Values are fascinating. They are handed down to us from one generation to the next. Many remain intact and unchallenged, while others are slowly molded over time—shaped by broader cultural shifts which are reflected in movies, music, and other media. Values may also change over time as a result of new life experiences. In any case, we human beings have a tendency to expect that others share our values, and when we find they don't, we can react negatively and be quick to judge.

Judgment is detrimental in the context of a client relationship.

How can we understand our clients' needs if we are busy judging them? How can we effectively listen for their emotional needs, when who they are and what they are trying to say is colored by our bias and judgment? How can we remain focused on providing the experience they seek when we (specifically, our judging thoughts) get in the way?

Imagine this scenario: a client shows up for her shoot. She's a bundle of nervous energy. She confesses that she took the day off from work in order to be able to fly under the radar and not have to account for her whereabouts. This happens often enough that you don't bat an eyelash. You go about prepping her for the shoot, making her laugh, and helping her channel all that nervous energy into excitement for her shoot. Ultimately, you succeed. The shoot, which had started off a bit slowly at first, is now on fire—every shot seems to be a keeper. And then she blurts out why she was so nervous: the boudoir album she plans to have you make is not for her husband, but for someone else. She looks relieved to have released the burden of this huge secret, but she is also anxiously looking at you to gauge your response.

How you feel about what she said has everything to do with your value system, your morals, and your thoughts about infidelity. But your ability to maintain the bond with your client depends on your ability to keep all of that from getting in the way.

In moments such as these—whether it's an issue about infidelity, someone who's escaped an abusive relationship, a client with debilitating body image issues, or someone who lives a different lifestyle from yours (e.g., a member of the LGBT community)—it is important to realize that you don't have to agree or disagree with your client's life decision or situation. You don't even have to understand it. You do, however, have to refrain from judging it, and you do have to stay tuned in to her emotional needs. *That* is your job as the boudoir photographer.

By remaining focused on the task at hand, you are in no way sanctioning her circumstances. You have no way of knowing what this client's life is truly like and, in the end, that unfaithful client may very well choose to give the album to her husband as a means of bridging a long-existing gulf between them, in which case your work will serve as an olive branch and a beautiful start to their healing. Just maybe. Long story short, you have no way of knowing what the future holds for your client. Your sole focus is guiding her through an amazing experience in the here and now—one she will never forget.

Values Can Be a Source for Common Ground

Rest assured, values aren't always a source of tension. In fact, they can often be a powerful source of bonding between photographer and client. Take the following scenario:

A 40+ year old mother of four decides to gift herself a boudoir shoot. She says: "I've spent so many years putting everyone else first that I wanted to do something just for me. I don't spend a lot of money on clothing or shoes, like a lot of women do, so I'm justifying this expense because this is really important to me. I need to feel feminine and pretty. It's been so long since I've felt that way."

As a female photographer and mother of three, there's so much in this woman's story I personally can relate to, so I would feel motivated to make this the best experience she can remember. In this case, part of what I bring to the table is my life experience as a mother, wife, and 40+ woman. But I also know, as an experienced photographer, that her happiness can have a long-lasting ripple effect—not just in her life, but also in her family's life, and in my own as well. How do I know this? Because: 1) I've heard beautiful stories from lots of husbands over the years, many who've taken the time to

write and thank me for "whatever magic" took place at my studio; and 2) I continue to hear about glowing referrals from new prospects whose friends and family I shot six or more years ago!

The greatest value in this scenario with the 40+ year old mother of four who shares how she feels is this: because she feels comfortable enough sharing her thoughts, you—the photographer—are then able to directly address them and allow her to rest easy knowing that she is understood; that she doesn't need to feel she is doing a selfish thing; that other women feel this way too; and yes, this is a gift worth giving herself.

Part of the process, and benefits, of examining one's values involves figuring out where you draw the line in your work. Clients may approach you:

- misunderstanding what boudoir photography is all about, perhaps equating it with soft porn;
- requesting a certain theme or types of images you would prefer not to shoot;
- asking if you would shoot a woman based on the fantasies and ideas her husband or significant other has.

Boudoir Shock Treatment—Are You Ready for and Open to New Ideas?

I still remember early in my boudoir photography career when a client showed up and surprised me by bringing a get-up I'd never seen before. To be honest, I never even knew such a thing existed. It was a collar from which long

chains dangled and attached to wristlets. She asked for help getting into it but at first I hadn't a clue what I was even looking at! Once I realized what it was, I felt a bit unsure . . . I didn't really know what I felt about shooting

her in this thing, but I did it anyway. Although she'd caught me off guard—and that was my fault because I hadn't done a great job with helping her plan for her shoot—I was careful to keep the focus on her and what she wanted out of the shoot. She never knew I'd had my own little boudoir shock treatment moment. So she never felt judged.

Soon after this experience, I realized the importance of working more closely with my clients on concept-building. Not only is planning ahead a value-added service to my clients, but it also prevents surprises. Planning ahead allows you, the photographer, the opportunity to check in with your values, and refocus your thoughts and ideas back onto your purpose for your work.

Now, years later, having defined my vision, purpose, and motivations for shooting boudoir, I tend to draw clients whose goals sync up with my own. However, on those occasions when I receive inquiries from prospective clients whose goals do not, I may choose to refer them to other photographers. Having clarity about my values and comfort levels enables me to differentiate between the two.

An Interview with Barbara

Barbara is a sixty-something year old client I had the pleasure to shoot. Although she initially wanted to keep her images private, she felt strongly enough about this book project that she decided to participate in it.

What motivates you to pursue a boudoir shoot right now?

I was having my milestone 60th birthday. I wanted to do something special. Creating a photographic memory of how I felt as a sensuous 60 year old woman became my plan. I was happy to be one and wanted to be able to capture that feeling in print.

Heading into a boudoir shoot, what concerns you most?

As I had not done this before . . . I was trusting my own instinct to select a photographer I believed could accomplish this mission with me successfully.

Aside from beautiful photographs, what else do you hope to get out of this experience?

I hope to build on my self-esteem by creating a sustainable feeling in print that I could see of my own sensuality and enjoy it forever.

What three words would you select to describe the look/feel of the images you hope to create?

Sensuous. Playful. Sexy.

What, if anything, would make you feel more comfortable and confident heading into your shoot?

From the moment I met you I felt the connection I needed to carry me through this new adventure/journey.

What specifically might the photographer do to help you feel more comfortable and confident heading into your shoot?

1. Meet with me and connect with me.
2. Ask me what I was hoping to accomplish.
3. Show me samples of her boudoir work.
4. Explain how the process would unfold . . . beginning to end.
5. Reassure me that all would be both okay and wonderful.

Some clients describe the boudoir experience as a roller coaster of emotions. Was it so for you?

At the beginning of the shoot I was a ball of energy. Each step relaxed me . . . the makeup application, the photographer's experience showing through, and the professional boudoir sets. As we began . . . I seemed to emerge as the 60 year old sensual woman I had been feeling I was and in partnership with my photographer we were creating my photographs . . . I was both exhilarated and exhausted at the end of the shoot. It was rewarding work . . . Perhaps I will do it again.

What did the photographer do specifically that helped ease any anxiety or fears?

My photographer reassured me of the confidence she had in me and my ability to bring to the shoot everything I was hoping to create because she saw in me . . . the me I wanted to capture. She got it.

Aside from beautiful images, are there any other positive outcomes from your boudoir experience?

This was a truly sensual awakening for me of sorts. I felt I had it in me but the photographs reassured me of my sensuality. It was a self-esteem and confidence booster to look at the photos and feel both beautiful and sexy at the same time.

Even if you started this journey as a gift to someone else, do you feel this experience was a gift to yourself in some way?

I started this project as a 60th birthday present to myself. I consider it one of the greatest gifts I have ever given myself. It captured the "me" I was feeling inside in such a beautiful way. I cherish the photos and the "me" that was captured.

Anything else you wish to share . . .

You can feel sensuous at any age. I believe I will always feel sensuous as long as I am alive. It is a state of mind. It doesn't come out at every moment obviously but it is always in you for the taking. It is a beautiful part of a woman to be shared . . . Finding a photographer to capture that feeling in photos to save and/or share was a dream come true.

Morals and Boundaries—Where Do You Draw the Line?

As a photographer of boudoir, you will have to figure out where you draw the line in your work, and where you will feel more comfortable referring a prospect. Couples boudoir, for example, is one such niche photographers may or may not feel comfortable shooting. I will gladly shoot a couple so long as we've had extensive discussions regarding the vision or concept for the shoot. I am always quite straightforward about the types of images I am willing to shoot versus those I am unwilling to shoot. The key is to communicate expectations and limits without judgment and to use visuals (sample concept images) in order to establish a shared language so there is no confusion and all parties remain on the same page.

If the purpose is to highlight the positive aspects of a powerful relationship, and I perceive that she has an equal say in what will be shot and how, then I will shoot a couple. In my experience, it can be a beautiful experience! One couple I shot had so much chemistry. He could hardly take his eyes off her. I assumed they were like this every day until she said, "I am so happy we did this! He hasn't looked at me that way in years!" Wow. So take all those good vibes and feelings the women I shoot in solo sessions experience and multiply that by two. Not bad for a day's work!

The Insurmountable Obstacle That Is Judgment

I cannot overemphasize how there is no place for judgment in boudoir photography. Clients will sense the moment you are being judgmental—whether it's body language, the words you use, or your facial expressions. The minute we become judgmental, we shut down any possibility that the client is going to have an all-around positive experience, that she is going to feel proud of her images, and that she will leave with a raised self-esteem.

By being judgmental we limit the extent to which the boudoir experience can be transformative, because we risk losing our client's trust and partnership.

Be ever mindful of the emotional needs of the person before your lens. Boudoir clients often feel vulnerable and exposed. It's our job to ensure our clients feel safe even as they tangle with their feelings of vulnerability.

Self-Assessment Questions for Chapter 2

1. Make a list of values you were taught as a child (e.g., be honest; aim high; work hard, etc.)

2. Make a list of values you hold which may differ from those with which you were raised.

3. How do you react when you encounter someone whose values may differ from your own?
 Be sure to label the emotions as well as identify the actions you might be inclined to take.

4. Think of a time when someone reacted in a judgmental way to something you said or did . . . how did you feel? What was the outcome of your exchange? How might a business relationship change if you felt judged by the other person?

5. How might you have felt with the client who confessed she was doing the boudoir shoot for someone other than her husband? How might those feelings have affected your expression, language, or willingness to work with them?

6. Where might you draw the line in your work?

3

Taking Inventory

Anyone can plot a course with a map or compass; but without a sense of who you are, you'll never know if you're already home.

Shannon L. Alder

Top 10 Characteristics of a Successful Boudoir Photographer

In thinking about what makes for a successful boudoir photographer, I reflected on my experience building a leading boudoir photography business in my area over the past seven years. But then I decided to make things really interesting! I reached out to several other boudoir photographers—at various stages in their careers—all of whom I admire, and asked what they thought.

Following is a list, in no particular order, representing the common themes across the responses as well as some interesting observations I made.

The successful boudoir photographer:

1. is **self-aware**: in touch with self and their own sensuality;

2. has a **great personality and people skills** and is able to **generate 100 percent trust** from the client: some of the descriptors were bubbly, fun, easy-going, general likeability, relaxed, funny, relatable, encouraging, has integrity, patience, kindness, brave, and honest;

3. is **compassionate and empathetic**: a good listener; able to create a therapeutic experience; understands women's body issues/a woman's psyche; able to make women feel comfortable at their most vulnerable; has a genuine desire to make an impact on someone's life;

4. shows **vision, creativity and flexibility**: a true artist; is always exploring, growing, and pursuing education; is innovative yet consistent; has good fashion sense and styling skills; finds inspiration in unlikely places and can make magic happen anywhere; is able to work on the fly, and able to see potential in all clients;

5. is **nonjudgmental and unbiased** regarding beauty standards: one photographer, echoing what we covered in Chapter 2, said, "Sensuality is very personal and photographers cannot impose their values;" also expressed was the ability to *see* beauty in all shapes and sizes;

6. is a **good director**; able to elicit emotions and expressions;

7. **understands posing**, particularly as it pertains to different body types; understands c and s curves;

8. **loves women**; knows how to make a woman feel sexy, but is honest in telling her what can/cannot be achieved;

9. has **great technical skills**: able to see light; understands light patterns and proactively employs lighting that flatters different face and body types; offers better than average retouching and editing skills; has intimate knowledge of camera settings, lens choices; depth of field (DOF); understands tones vs. colors; owns/has access to appropriate equipment;

10. **balances being an artist with being an equally great business person**: able to incorporate logic in an

emotionally driven business; learns from mistakes; effective at marketing and branding; understands that word of mouth is worth more than any ads you can afford; is up on government regulations; armed with legal contracts; well-organized; outsources areas they cannot handle (such as bookkeeping and accounting); and always delivers on promises to clients;

10.5 is a **respectable community member**: is respectful of other photographers; doesn't stress about or focus on competition.

Although only two photographers mentioned this last point, I thought it was worth including. Although the photography industry can be somewhat cutthroat at times, one of the most wonderful things about it is the willingness of many photographers to share their knowledge and inspire others.

Rising tides lift all boats.

As I reviewed the responses from the other boudoir photographers, it was interesting to note:

- While each tended to emphasize one characteristic over the others, overall it was super easy to group everyone's responses into a clear top 10 list.
- The males were more inclined to incorporate more points regarding technical skill, while the women were more likely to emphasize the more psychologically based skillsets (take note guys—if you want to be an emotionally intelligent boudoir photographer you just might have to build your skills in this area).
- There were few differences between the newer vs. more seasoned boudoir photographers in terms of their input, the main exception understandably being that the more seasoned photographers were more likely to mention the business-related success factors.

An Interview with Linda

Linda is a client who'd overcome cancer and someone I look forward to shooting again in the near future.

Heading into a boudoir shoot, how would you describe how you feel?

When I was on my way to Susan for my consultation, I was cautiously optimistic and a little scared to do a boudoir shoot as it was all new to me. Additionally, my body is not what it used to be! But after speaking to Susan, I was sooooooo excited and ran out to go shopping for lingerie for the shoot.

What concerns you most?

Having certain parts of my body, which I think are flawed, being shown in a picture. And I am definitely shy in front of a camera. Age makes everything a little flabby and droopy!!!!! Even your knees droop!!!!!

Aside from beautiful photographs, what else do you hope to get out of this experience?

Well, I did not know this but, after seeing the beautiful photographs, it gave me a sense of confidence and surprise that I can really look that good! It definitely boosts your self-esteem. There are many women, including my 24 year old daughter, who have body issues and eating disorders. I think if they can see themselves through Susan's lens, they would definitely feel differently. If Susan could associate with an eating disorder clinic, she would be able to help so many women.

What three words would you select to describe the look/feel of the images you hope to create?

Beautiful. Sexy. Classy.

What, if anything, would make you feel more comfortable and confident heading into your shoot?

Just talking to Susan and listening to her advice and directions made me feel so comfortable. She has a wonderful personality with the calmness and patience to bring out the best in you.

What specifically might the photographer do to help you feel more comfortable and confident heading into your shoot?

I felt very awkward because I never take good pictures . . . During the shoot, once Susan showed me some shots she liked in her camera, I was shocked at how good I looked! That gave me some confidence—therefore, by the end of the shoot, I felt comfortable and happy to be doing it!

Post-shoot: What did the photographer do specifically that helped ease any anxiety or fears?

Susan is a very special person! She has a calming personality and an ease about her that makes you feel comfortable. Not only is she a professional and an artist, but she has a talent of making you feel comfortable and confident.

On a scale of 1–10 (10 being most confident) how would you rate how you feel about your body post-shoot?
9. *(She indicated a 5 pre-shoot.)*

Anything else you wish to share . . .
Every woman should do this, especially if you feel like you hate your body!

Assessing Your Strengths (Technical *and* Interpersonal)

Note the Top 10 list—technical skill is only one out of ten success characteristics mentioned across the boudoir photographers I interviewed.

S hocking, right?

Well, not really. Boudoir is such an intimate niche that the interpersonal, soft stuff weighs in just as strong. But let's go ahead and talk about technical skill for a moment in the context of enabling your client to have a transformative experience with you, because, let's face it, the technical stuff is what most photographers think of first, and technical skill is very important if you're going to be capable of creating flattering images of your clients!

Ability to see light: Light quality is key in setting the mood for the images you create with your client. If she wants soft, romantic images, you might choose to use natural light. But if she wants an edgy Old Hollywood feel, you'll be better off using strobe or constant lights to create that beautiful glowing look she probably has in mind. Having a broader lighting skillset will provide you with far greater opportunities to deliver on your client's vision and bring her ideas to life than merely specializing in either natural light or strobe light.

Understanding of light patterns and face/body types: Sculpting a body with light so that she appears thinner; sculpting long ballerina legs; rimming a perfectly toned backside with glowing light; lining a beautiful profile with light—all of these things will encourage your prospects to pick up the phone and call you, and all of these things are possible only when you can see light and are familiar with light patterns and how best to use different lighting approaches for different body types and face structures.

Photoshop and great retouching and editing skills: Depending on your philosophy regarding retouching, your client's requests may present challenges and require advanced Photoshop skills. Removing an ex-husband's name or birthday tattooed on a wrist, stretch marks from multiple pregnancies, scars from a battle with cancer, stress-related breakouts—all can convincingly be made history and boost your client's self-confidence . . . but only if your skills are up to snuff (we discuss retouching further in chapters 15 and 16). While outsourcing is an option, know that some clients may not feel comfortable having

their images forwarded to another business for editing of their "flaws" and "trouble spots." These are intimate images and she may have really stretched her comfort levels to even come to you! Editing images to enhance or downplay colors or create soft tones in an image also depends on your ability to utilize software to enhance the mood of the images your client is hoping to receive.

Camera settings, lens choices, DOF: Purposefully over-exposing or underexposing shots for a magazine look; delivering creamy, dreamy images with a shallow depth of field; highlighting the muscles and definition of a fitness buff; maintaining proportions without distortion—all of these require that you have excellent command of your camera settings, and know when to use one particular lens over another, and that you know how to employ depth of field to add to the story of your client's images.

Equipment: Speak to ten photographers and each will produce a list of equipment different from the rest. That said, the ability to create flattering images depends on the ability to use light to tell the story you want to tell, and to highlight your client's best features in a flattering way. Whether you use low-tech tools like white foam board or expensive reflectors to manipulate light makes no difference. Whether you own three lenses or ten doesn't matter either. The point is to know how to use the tools at your disposal to create images that will show her in her best light, boost her self-confidence, and challenge her anxieties and self-doubt.

Note: In Chapter 14, Marrying the Emotional with the Technical, I break down 20 images, addressing the technical aspects that went into creating the images that directly delivered on the client's vision for her shoot.

The Emotionally Intelligent Photographer

Emotional intelligence refers to the ability to identify, understand, manage, and interpret emotions . . . and then take appropriate action in response to those emotions. Some scientists believe emotional intelligence (EQ) is more important than IQ and, in fact, some studies have shown that people with average EQs will more often than not outperform those with high IQs.

So what does this mean for the boudoir photographer? Well, if we consider that most photographers generally rate their excellence in terms of technical criteria—the technical excellence of their images, the number of times they've been published, the number of awards and merits they've received,

their ability to master lighting and photography tools—then the concept of the emotionally intelligent photographer opens up an entirely new way of being and evaluating one's effectiveness. And what better context in which to adopt this approach than boudoir photography?

So what does the emotionally intelligent boudoir photographer look like?

• He can *accurately* identify the *specific* emotions he himself and his client may be experiencing. Sound easy? Think twice. A *Time* magazine article entitled "18 Behaviors of Emotionally Intelligent People" by Travis Bradberry mentioned

a study which showed that only 36 percent of people were able to do this, which the author said "is problematic because unlabeled emotions often go misunderstood, which leads to irrational choices and counterproductive actions."

- She is able to help her client identify the emotions she may be feeling and/or struggling with and isn't shy about calling out the emotions she may be witnessing as a means of empowering her client.
- He is curious about his clients, genuinely cares about them, and is therefore empathetic and willing to "walk in her shoes."
- She can read between the lines of what her client is saying, what her client wants her to hear, versus what may be going unsaid.
- He is self-aware: knows his strengths as well as his limitations, and can use his strengths to overcome his weaknesses.

- She is passionate about her purpose.
- He is able to express his thoughts, feelings, and beliefs in a way that the client can hear and feel empowered by.
- She is self-motivated and keeps working toward the goals at hand, despite challenges.
- He is a good listener and an effective communicator—100 percent present when communicating with his client; always listening to what others are trying to say and never speaking over them or imposing his perspectives.
- She puts the needs, interests, and goals of her client first, rather than her own (e.g., her brand, her requirement that they meet in person to plan the shoot, her style, her lighting preferences, her shooting style, her aesthetic, her favorite poses, her retouching preferences, etc.).

Quotes from clients on the important qualities of the photographer:

- I love that Susan **shows me the photos** that she's taking of me while we're working. It gives me a great touch point of where I'm at.
- My photographer **reassured me of the confidence she had in me** and my ability to bring to the shoot everything I was hoping to create because **she saw in me . . . the me I wanted to capture. She got it.**
- This woman has such an **amazing energy and presence that you can't feel anything but comfortable**. I will work with [Susan] till the day I die; I love working with her! She's so **bubbly and happy** that she makes all those

around her feel the same way; it's so difficult to be upset around her because her **energy is so magnetic**.
- Throughout the shoot, Susan was so **calm and patient** with me as I fought to connect with my inner sex kitten. Seeing her **genuinely excited reactions** and hearing her **constant encouragement** throughout the shoot also helped calm my spirit and press on.
- I love your **energy and spirit**, and I love how **encouraging and nurturing** you are . . . **I feel safe and valued with you.**
- I would like to aim to be seen by any photographer I **work with as not just a face or body, but a real person with real sentiments, a distinct perspective, and a story to tell.**

- You were very gracious about advising me about posing and proper transitioning between poses. You were also very helpful if my hair was out of place or my outfits needed adjusting. Without this crucial support, I would be fraught with anxiety about the quality of the final product . . . you were **open to listening to my ideas as well as to giving excellent suggestions of your own.**

- Every person you come across has a particular story or is on a specific journey in their own way. It's commendable that you **genuinely care about every individual story and journey,** which you masterfully incorporate into stunning photos and works of art.

- She was **sincere and made it fun.** She **made me feel like a rock star.** She would **let me peek at some photos on her camera and that reassured me and it also gave me confidence** that I looked beautiful.

- Oh Susan, you did it all. You were **encouraging and supportive and fun. Showing me the beauty of the first few shots fed my confidence and helped me to relax** into the process.

- After seeing myself in the pictures that Susan just did, I realized that Susan didn't change who I was. She captured the person I am, and **helped me see through someone else's eyes just how beautiful I truly am.**

- The photographer is the one to **help you feel comfortable and confident. Susan's easy way and confidence that she instills in you makes you relax and smile. Nothing can put someone more at ease in front of the camera like a confident and fun person behind it.**

- I love Susan!! Very **professional and very talented** artist!

Assessing Areas for Growth

When taking inventory of our strengths, it's important to remember that we must address the technical as well as the interpersonal. Excellent interpersonal skills can transform an average photographer into a huge success (see the box on pp. 77–8, Chapter 6). On the other hand, an amazing technical photographer with horrendous people skills will be hard-pressed to survive in a competitive market.

Likeability, trustworthiness, compassion, and honesty were repeatedly mentioned by the boudoir photographers who shared their thoughts on the Top 10 Characteristics of a Successful Boudoir Photographer. Lacking any one of these traits will severely inhibit your ability to be effective in your role as a boudoir photographer.

Take inventory: Review the Top 10 list and the description of an emotionally intelligent photographer and generate a list of

your own strengths—both the technical and the interpersonal. Then consider your areas for growth—we all have them.

If you're technically minded, maybe your growth areas fall more along the interpersonal, psychologically based requirements mentioned among the success characteristics. For example, if the ability "to create a therapeutic experience" sounds foreign and unfamiliar to you, perhaps sitting with an experienced boudoir photographer to hear their clients' stories of healing and transformation or a specialist on body image (see the interview with a psychologist in Chapter 20) might provide you with an idea of how you could go about developing those particular skillsets.

If you get the interpersonal stuff, but "sculpting bodies with light" sounds like a ninja trick, perhaps signing up for a lighting workshop or two will provide you with knowhow you can then incorporate in a test shoot with a friend.

Being honest about where we are strong and where we can grow is not easy, but in the delicate field of boudoir photography—where everything is riding on a woman's ability to feel beautiful and confident—we must make every effort to be the best we can. Our client's self-esteem and body image depend on it.

Self-Assessment Questions for Chapter 3

1. How would you rate yourself on a scale of 1–10 (10 being the best) for each of the Top 10 Characteristics of a Successful Boudoir Photographer?

 Self-Awareness: _____

 Personality and People Skills: _____

 Compassion and Empathy: _____

 Vision/Creativity/Flexibility: _____

 Nonjudgmental and Unbiased: _____

 Good Director: _____

 Posing: _____

 Interactions with Women: _____

 Technical Skills: _____

 Business Acumen: _____

 Respectable Community Member: _____

2. What would you say are your top three strengths? How might you use those in establishing a strong boudoir photography business?

3. What would you say are your top three areas for growth? How might you take action to develop those three areas within the next six months?

4. If you are stronger in technical areas, how might you balance that out by strengthening the interpersonal, softer skillsets?

5. If you are stronger in the interpersonal, softer skillsets, how might you balance that by strengthening your technical skills?

A quick note of thanks to the photographers who pitched in during the compilation of the Top 10 Characteristics list:

Agnes Fohn of Yellowbrickcollective.com

Beth Claire of Losthighwayimaging.com

Cate Scaglione of Lifeasfineart.com

Craig Lamere of CraigLamere.com

Erin Zahradka—founder of the Association of International Boudoir Photographers and owner of z-pics.com

Fred Langstaff of FredLangstaff.com

Judy Cormier of Elementzoffoto.com

Marley Botta of Daringdamesphotography.com

4

Looking Outward

When you're doing what you love to do, you become resilient. You create a habit of taking chances on yourself.

Dick Costolo

As I mentioned in the introduction to this book, the market for prospective clients is larger than we might initially think. Every time I hear a photographer say boudoir is for women in their twenties through thirties, I get so annoyed. That's just a load of bull. I'm convinced 50 is the new 30, and that women in their sixties and even seventies know what it means to be sexy in a way that 40 year olds are only just beginning to figure out! And I'm not alone in feeling this way.

I regularly have 40+ year old clients tell me they're only now feeling settled in their bodies, which enables them to feel sexier than they ever have before. So, my fellow photographers, take note! I've come across many boudoir photographers who prefer to shoot the twenty-somethings, thinking less retouching, more natural beauty, or fewer issues. In the twenty-something population I tend to find something different: I find less body awareness, less loyalty, and less respect/value for the artistry that is boudoir photography, and therefore less revenue.

The Market: Exploring Five Client Types

In thinking about the clients I've served and the categories they might fall into, I've identified five client types you may or may not choose to target in the context of your unique vision and client value proposition. But again, who your ideal client is will of course depend on the vision and mission for your business.

One: The Bride-to-Be

Boudoir has become a popular gift for the bride to give her fiancé on their wedding day. Many brides-to-be work hard to look great on their wedding day, adopting strict dietary and fitness regimens months before the wedding, which, they

admittedly confess, they might never follow so strictly again. It makes total sense. They figure: *why not document all this hard work so he has a permanent record of how great I looked when he married me?*

The bride-to-be may be any age—I've shot twenty-something brides and fifty-something brides. But a common theme tends to be this: these women aren't primarily doing boudoir for themselves—they're doing it, first and foremost, for their significant others. As a result, these women tend not to pour as much heart and soul into having a transformative experience because they are consumed by wedding planning. Instead they are largely focused on the end product.

And while some brides are long-term planners—coordinating their boudoir shoots a year or more in advance—many more are last-minute seekers of boudoir photography because they haven't been able to identify a more compelling gift for their fiancés, or, being new to the whole wedding thing, they've only just learned that boudoir is a hot gift these days. This latter group is perhaps the most challenging to work with because: they are usually in a state of high stress; coming down to the wire as far as their wedding dates; preoccupied with last-minute wedding details; and often unable to commit the time and energy necessary to create meaningful images for their grooms-to-be.

Every wedding season I receive numerous calls from brides seeking boudoir as the perfect wedding day gift. On occasion, however, I have to inspire her to consider that the first wedding anniversary theme is paper and that therefore photographic prints make an excellent first anniversary gift—all because a bride has not allowed sufficient time to shoot, edit, and develop her boudoir gift in time for her big day.

Despite the challenges, there are many perks involved in working with brides-to-be:

- Many are proud of having reached their fitness/dietary goals and of their resulting svelte physiques, so they may feel more confident in front of the camera.
- As this is a milestone event in a woman's life, your contribution to it will forever be a part of this memorable occasion.
- Many brides will choose to present their grooms with the boudoir albums immediately prior to the wedding ceremony and as part of the big day's events, so wedding photographers will often capture the groom's response to the gift

(I may ask the client if she is willing to share those images as they make for invaluable testimonials).

- Brides tend to know other brides, who they will of course refer to you, assuming they feel inspired to rave about you and your work.

Two: The Married Mom's Anniversary or Birthday Gift to Hubby

This group is, for me, one of the most rewarding groups to work with. Although these women initially inquire about boudoir as a gift for their hunnies, they quickly come to understand the relevance and importance of the boudoir experience in the context of their own self-esteem, body image awareness, and sense of self-worth. Accordingly, they will pour all of their energy, time, and effort into making the most of the experience and creating meaningful images they will themselves cherish, and which they can share with their significant others.

Generally in their thirties and forties, these women may have had one or more children. As a result, they may be insecure about their bodies, fearful that the camera might emphasize the markers of childbirth, and less comfortable revealing too much skin in front of a total stranger.

But do a fabulous job showing this woman how beautiful she is—playing up her strengths and emphasizing her best assets—and you've got a cheerleader for your business, a long-term referral source, and a relationship with an appreciative woman for life.

The key with this client is to move slowly, invite her into the process, check in regularly, observe her changing emotional states throughout the process, and address them accordingly.

Three: The Married Woman Doing This as a Gift to Herself

You might wonder why I chose to separate this client type from the prior one, but the motivations, challenges, perks, and overall experience with the married woman who chooses to pursue boudoir as a gift to herself are quite different—both for the client and for the photographer.

In her thirties, forties, or fifties, this client has reflected on her life—all she gives to and sacrifices for others. And whether as a result of a milestone event or birthday (her own), she has decided to give herself this meaningful gift because, unlike other prospective clients, she already gets it. She is already sold on the power of the boudoir experience and wants to celebrate something about her life, the challenges she's overcome, the sacrifices she's made, or simply the woman she is today. She wants to partner with a professional who can help her communicate her value, her worth, and capture the essence of who she is—in a timeless way.

For this client, the experience alone is as valuable as the end result.

I've had clients joke time and time again post-shoot that they didn't even need the images any longer because the experience alone had done so much for their esteem and morale. I love to hear this!

The beautiful images we've created in the process of boosting her self-image then become icing on the cake—a future prompt and permanent reminder of the good feelings elicited by the shoot experience.

More so than any other client, this woman is also likely to become a repeat client because she:

- is more likely to have the funds;
- views the experience as a self-help exercise (not unlike spa visits, yoga, or therapy sessions);
- recognizes that she is multifaceted and may choose to play out her many facets over the course of several sessions.

On the flip side, a key challenge involved in working with this client may be the emotional roller coaster ride she introduces. Because she is so invested in the process as a form of self-expression and validation of her identity, she will likely go deeper in facing fears and insecurities, and in challenging negative internal messages. Evidence of the resulting emotional roller coaster ride may show up in the planning stages with overthinking of details, or changing her mind repeatedly about outfit choices. It may also show up in last-minute pre-shoot jitters—panicked calls about what else she might be forgetting. But the emotional ride will always inevitably make itself apparent during the shoot itself, when the worst thing a photographer can do is advise her to "get over it" or, as I've seen so many photographers do, ignore her tension and just keep shooting through it without addressing the emotional needs of the client. (This will be discussed in further detail in Part 2.)

An additional challenge with this client may be requests for levels of retouching that do not align with the photographer's

philosophy or practice. Everyone has seen the YouTube videos showing exaggerated distortions and edits—those viral videos advertising how we photographers now have the ability to make necks and legs super long; turn a size 12 into a size 2; and perform outrageous breast enhancements with a well-placed bloat tool.

Problem is, our clients have seen these too. As a result they may demand that you perform some of these miracles for them. In determining your vision, purpose, and motivations, you will also have to figure out what your approach to retouching will be, and be able to hold your ground when necessary.

Four: The Single Woman's Gift to Herself

Whether she is in her twenties, thirties, or forties, this client is giving herself a gift of self-love, and validating her belief that she is a worthy partner and a great catch. She may choose to share the images with a love interest if she deems him worthy enough, but may also choose to keep them private, for herself, or at the ready for a time when she feels she has met a potential life partner.

Because she does not have a life partner to give her ongoing feedback about her beauty and her power as a woman, these images may serve as a mirror—providing a reflection of her at her best.

The single woman tends to be easy to work with, appreciative of the experience and the resulting imagery—particularly when she has played a role in establishing the concepts for her shoot. She is also the second most likely client type to return for additional shoots—availability of funds being an important factor in whether or not/how often she can return.

Five: The Mature Woman

This woman may be in her upper fifties, sixties, or beyond. If she has children, they are grown and most likely independent. She may even be a grandmother. However, because of generational differences and the relative newness of boudoir as an everyday woman's venture, she may inquire long before she ultimately decides to set up the shoot.

It may also be a big secret in her life. Or worse, she may tell her friends she's planning on doing this, only to get a negative reaction from them and, sadly, inadvertently subject herself to questions like "*Why* would you do something like *that*?" or comments like "You're too old to do something like that!" These responses could ultimately discourage her from pursuing it in the end.

The boudoir photographer must be mindful that support for this client's exploration may be minimal in her world, so developing a strong relationship is essential if she is to trust you and ultimately allow herself to fully engage in the process. If she does, the resulting images are sure to build her esteem and prove what she sought to communicate in the first place: 1) that beauty has no age limits, and 2) that she's still got it!

Shooting the mature woman requires special considerations; most importantly, gentle guidance, constant validation, and remaining attuned to the client's emotional journey can all ensure your client's experience is unforgettable—that she is armed with compelling "I told you so" proof when she gets back to her circle of naysayers. Naysayers who, I might add, may very well end up scheduling a visit with you in the near future as well!

The five client types I've presented here are by no means an exhaustive list of all the possibilities, but they do, in my experience, represent broad categories of clients you will encounter unless you choose to specialize in a particular population or niche. Other client groups might include LGBTs, couples, or aspiring models, to name a few.

It is also worth mentioning that across all of the five client groups mentioned above will be either those who come hoping to celebrate something like weight loss, a new relationship, an upcoming wedding, anniversary, or birthday, or those who are looking to heal from an unfortunate life circumstance, whether it's a pending separation, divorce, an abusive relationship, an eating disorder, or a recent battle with a life-threatening illness.

Whoever stands before you, your job as their photographer is to design a process that will enable you to see them as they see themselves, and then utilize their inspiration as a backdrop as you capture the essence of their beauty through your vision and talent as a photographer.

This book will guide you through my process for accomplishing this.

An Interview with Dani

Dani is a young model and an aspiring lingerie model. I'd shot her before for a beauty project, but when an agency told her she could not be a lingerie model with short hair, she came to me for help in proving them wrong.

What motivates you to pursue a boudoir shoot right now?

I'm an aspiring lingerie model and boudoir has always fascinated me in how elegant and confident women can be in their own lingerie. For the first time I'm not just putting on someone else's lingerie to model, I'm getting to express my own fantasies with my personal collection.

Heading into a boudoir shoot, how would you describe how you feel?

I won't lie, I'm very nervous. I just ate a cheeseburger last night so of course I'm worried about how I will look on camera but, other than that, I'm SO EXCITED first off working with Susan is a breeze!!! This woman is AMAAAAAZING, she makes you feel comfortable and confident even when you don't necessarily feel it yourself! Somehow this woman just says the right thing at the right time and pow you're like YEAH I GOT THIS! Haha.

On a scale of 1–10 (10 being most confident) how would you rate how you feel about your body?

5.

If you responded 5 or less, please elaborate.

I wouldn't say I'm hating on my body but I wouldn't say I'm 100 percent confident in my body either . . . most people tell me I'm crazy but it can be nerve-racking getting in front of a camera in your bra and underwear, you can feel powerless if you don't like how part of your body looks. *(Post-shoot she indicated an 8, saying "I love my body, but it's not perfect.)*

What three words would you select to describe the look/feel of the images you hope to create?

Beauty, elegance, and confidence.

What specifically might the photographer do to help you feel more comfortable and confident heading into your shoot?

Just knowing [Susan's] there makes me feel comfortable! But while shooting she knows just what to say that boosts your ego or makes you laugh so hard you can't feel anything but comfort.

Some clients describe the boudoir experience as a roller coaster of emotions. Was it so for you?

. . . my brother had just left for a year long trip to Thailand so I was truly feeling empty and I guess nervous I wasn't gunna look good or do good for this shoot because I couldn't connect with any emotions . . . I felt like a zombie . . . working with Susan may be the best experience I've ever

had as a model. She makes you feel so comfortable in your own skin and you open up in so many ways by the end of the shoot I was on my GAME, I was having a blast . . .

What did the photographer do specifically that helped ease any anxiety or fears?

This woman has such an amazing energy and presence that you can't feel anything but comfortable . . . she's so bubbly and happy that she makes all those around her feel the same way . . .

What was most challenging for you during the shoot?

As a model you can be poked at and told you aren't good enough at points and it can really mess with your head. I've had some troubles with my weight and this was my first shoot back so I was nervous I wouldn't look good and also that my emotions wouldn't be there because I didn't even think I had any . . .

The Market: Other Players

Aside from exploring the potential client market in your area, you must also examine the existing boudoir photography market when positioning your business. Who are the players? What's their vision? And who are they targeting?

This information may not be easily accessible. For starters, many photographers don't know that they *should* define a vision and a target market, so they may operate as everything-but-the-kitchen-sink shooters. Most of us have been there. However, gleaning as much information as you can from those performing this service in your area will enable you to establish a strong position in the market by introducing a unique service that is clearly defined and articulated, and ultimately targeted at your ideal client.

When examining the market of boudoir photographers, here are a few helpful steps to consider:

- Perform a local search on boudoir photography—start close and expand your search as you go (e.g., town, city, county, state, east coast).

- As you explore these websites, read the About pages to identify vision and target clients; often photographers will articulate their vision, purpose, and motivations in this section.

- Review pricing/investment pages, if available, to assess the type of client experience and end result this photographer provides—Are there short or full sessions? What are the pricing levels? Do they offer images on a disc or high-end products?

- Examine the images. What is the overall style and quality of the photography? Where are the shoots taking place—does this photographer have a studio or are they renting hotel rooms and other spaces?

- For each website you visit, note who their ideal client might be.
- Find the gap: How might your business vision, purpose, motivation, or target client be different?

When you muster up the courage, contact a few of the photographers you feel are most effective in communicating their value proposition to a specific market or around a targeted purpose. They will likely be more inclined to be helpful if you choose ones not in your immediate area. Develop a short, targeted list of questions you might want to ask rather than appearing aimless in your focus, as many successful photographers have hectic schedules and will be more likely to take time out of their busy schedules to help if they are clear about your goals and intentions. Whatever you do, don't be shady or try to mislead the photographer by pretending to be a prospective client. We can sniff posers out from a mile away!

Identifying Your Place: Where Do You Fit In?

Note: there is always a gap! Finding your place in the market comes down to doing your research, and clarifying your own vision. Once you are clear about your unique client value proposition, and have researched how other photographers are/are not meeting your target clients' needs, you can then craft an effective, targeted marketing strategy to communicate your unique message and fill the market need.

Self-Assessment Questions for Chapter 4

1. In defining your target market, and your ideal clientele, what age ranges would you prefer to target?
2. Of the five client types presented in this chapter, which appeal to you most, given your vision for your boudoir photography business, and why?
3. List any other client types you might be interested in pursuing? Ensure they align with your business mission.
4. Research and identify the top three boudoir photographers in your market.
 How might your mission differ?
 How might your target market be different?
 How might your services differ?
 How might your style be different from theirs?
 Identify any other ways you might distinguish your business.
5. Identify three to five photographers you might want to contact. What specific questions might you want to ask?
6. Based on your research and any discussions you might have had with other photographers, where is the gap? Clarify an opportunity in the market you might fill with your boudoir photography business.

5

Putting It All Together

We all make choices, but in the end our choices make us.

Ken Levine

Define Your Vision: Who Will You Be in the Market?

Up to this point, we've explored:

- your key motivation(s) for establishing a boudoir photography business and how they might align with your interests;
- the strengths, valuable life experiences, and skillsets—both technical and interpersonal—you bring to the table and that can help you establish rapport and effective working relationships with your clients;
- your values and boundaries—clarifying limits to the services you will provide and the clientele you will serve;
- an assessment of your skills and personal traits as compared to the Top 10 Characteristics of a Successful Boudoir Photographer and a description of the emotionally intelligent photographer;
- identification of areas for additional development and growth so that you can optimize your success in your boudoir photography venture;
- five common client types and the advantages and disadvantages of working with each;
- the boudoir photography landscape in your area to identify ways to distinguish your services and fill a need/gap in the market.

It's probably helpful at this point to pause for a minute and consider everything you've worked through at this point.

Maybe, like the child photographer I sat with and who ultimately decided perhaps boudoir wasn't for her, you're beginning to question whether or not you feel it's a fit for you.

It's a fair question to ask. Shooting boudoir is not going to feel right for everyone. Your motivations have to be clear. Critical skillsets must be in place—i.e., your ability to ease women into a scenario where nine out of ten women will struggle to feel confident and comfortable; your comfort level with the emotional aspects of the boudoir photography journey; not to mention your ability to make the right choices behind the camera that will result in flattering and esteem-boosting images for your client every time, no matter what shape, color, or size she might be.

But if you have decided you are interested in moving forward in establishing a boudoir photography business, the important question then becomes:

Who will you be in your market?

Perhaps through your research you've identified a gap in the market and have decided your business will be the high-volume, low-priced, boudoir photography studio that uniquely specializes in retro style pinups, targeting twenty-somethings and aspiring models, and offering location-only shoots.

Or, perhaps your research has identified a different gap, and you've decided your business will be the go-to low-volume,

high-end fine art portrait studio offering in-studio shoots as well as shoots in luxury locations for women in their forties and fifties from nearby affluent neighborhoods.

As you can see from these two examples—quite different in style, direction, and focus—your interests, mission, business vision, and market opportunities can ultimately provide an opportunity to create a business that is unique and different in your area, no matter how many boudoir photographers there may already be! The important thing is to do the work, dig deep, and explore yourself, as well as the market in which you live, and then to identify opportunities to bring something new and exciting to precisely the women who would be best served by your offering.

Identify Your Ideal Client

Having achieved clarity about gaps in the market and possible business models that might present something unique and different in your area, you can then begin to think about who your ideal client might be. In the examples above, I presented a low-cost pinup business targeting twenty-somethings, and a high-end fine art business targeting wealthy forty and fifty-somethings. I'd like to point out here that, of course, there are always exceptions to the rule. While it goes without saying that twenty-somethings might be so moved by the fine art work of the high-end studio that they'll save up and pursue it anyway (and vice versa), the idea is to visualize who your client is **most likely** to be. Does she work? Is she a mother? What kind of house does she live in? What role will boudoir photography play in her life? And how can you meet a need she might not even know she has?

Great sales people talk about the importance of developing a pitch that emphasizes the value your services and products provide. If you're a vacuum salesperson, for example, you might not say you "sell vacuums" in response to a question about what you do for a living. Instead, you might believe your mission is to "give people the gift of health and cleanliness by providing them with advanced tools they can bring into their homes." Sounds a lot more inspiring than just selling a vacuum, doesn't it? The point is this . . .

If you know who your client is and what she might need (e.g. peace, self-esteem, confidence) to get her sexy back, then you can design your marketing efforts to address those needs rather than offering exactly what everyone else does—boudoir photos.

My tagline says a lot about my mission and about the women I intend to serve: **Illuminating the Power of the Feminine**™ speaks to my goals of lifting women up, empowering them, helping them see themselves in a way that is powerful and confidence-building. And the women who are drawn to me are the women who want to feel powerful and empowered, while at the same time celebrate their femininity.

What might your tagline be and who might it draw to you?

Reach Your Target Market

Over the years, the reputation I've established because of the experience I give my clients means referrals keep me busy. But it takes a few years to get the referral engine churning. (I address building your referral engine more in Chapter 18.) In the beginning, I'd give visitors to my website a sense of who I am via a very personal About Me page on my website. I communicated my mission, my vision, and my passion for delivering a certain kind of experience. I spoke about who could benefit from working with me and why. I spoke directly to my target client. And I posted inspiring messages on my site and on social media—messages that would appeal to the women who were interested in personal growth in general.

Little by little, the message got out there. Women began to see that through boudoir photography they could experience something deep and meaningful. And the right prospects began to come my way. With a clear idea of who your target client is, you can shift your emphasis to figuring out how to reach her and how to craft messages that will appeal to her.

When the fit between your mission and your client's need is right, it's pure magic, AND that magic is the best fuel for the referral engine you're slowly building!

Understanding YOU Are Your Brand

Unless your goal is to establish a large-scale studio, where other shooters will work for you and represent your studio, YOU are most likely going to serve as the face and feel of your brand. Prospects may choose to work with your studio simply because they like you, or feel they can relate to you. And they will expect their experience to be consistent—start to finish—with the personality and approach they associate with you.

For this reason, and we'll talk about this more in Chapter 9, your staff and any freelancers associated with your business—makeup artists, hair stylists, office managers, etc.—must all personify your mission and the mood you wish for your clients to experience. Be sure to communicate your mission to those you employ, along with your expectations for how they engage with and respond to your clients. Everything must work in unison to create the perfect safety net for the client's self-exploration, revelation, and ultimate transformation.

An Interview with Michelle H.

I met Michelle when a client brought her own licensed makeup artist. Michelle does beautiful makeup, but also expressed one day wanting to do a shoot. That day finally came when several years later she signed up for one of my mini-shoot days.

What motivates you to pursue a boudoir shoot right now?

Several months ago, as I spent time learning who I am, I ended a long and unhealthy relationship with my body. While I always exuded confidence, I was also ashamed of my body. I was living alone for a bit, having separated from my husband temporarily to figure out whether or not I wanted to remain in the marriage. During this time apart, I took advantage of all the quiet time to figure out what was making me unhappy with myself—physically, emotionally, intellectually, and so on. Following my transformative experience, I ended the self-hatred and stopped depriving myself. As a result, I realized that I was ready to be a wife again, and a boudoir shoot seemed like the perfect opportunity to test my new self-perception, and give my husband a fun, sexy Valentine's day gift as a gesture of my renewed devotion to our relationship.

Heading into a boudoir shoot, how would you describe how you feel?

The day of the shoot I was full of nerves. I felt out of my element, arrived late, and was terrified . . . but the makeup artist, Kelly, and Susan were so welcoming I couldn't help but be a wee bit excited. As I was unpacking my bag, I continued in this mental tug of war—going from excited to petrified all at once . . . Susan was so encouraging . . . Throughout the shoot, Susan knew what to say and when to reassure me and calm my nerves.

On a scale of 1–10 (10 being most confident) how would you rate how you feel about your body?

Depending on the day, I could feel as confident to say I'm a 10 or as low as a 3.

If you responded 5 or less, please elaborate.

Usually hormones play a big part in this low rating . . . Or if I have just watched the latest Victoria's Secret runway show . . .

What three words would you select to describe the look/feel of the images you hope to create?

Artistic. Captivating. Inspired.

Post-shoot: Some clients describe the boudoir experience as a roller coaster of emotions. Was it so for you?

At the beginning and almost the entire time, I kept thinking to myself, "Oh my god, am I really doing this?" I was so anxious and nervous and I couldn't stop shaking on the inside! Once Susan started directing me to pose and move legs/head/arms, I felt a little less nervous. Then when she showed me a shot from the back of the camera,

I was shocked! I looked FABULOUS! After that, I stopped worrying so much if my thighs looked big or if my gut hung too low and just went along for the ride . . . feeling every bit as camera worthy as any gorgeous other sex kitten in front of that lens.

What was most challenging for you during the shoot?
Bottom line: I find it very, very hard to look at photos of myself. Photos usually make me cringe because I'm scared of what I'll see. Doing this shoot helped me face my fears, in a sense, and heal the not-so-great relationship I have with my body.

Aside from beautiful images, are there any other positive outcomes from your boudoir experience?
Knowing that Rome wasn't built in a day, I have to say that this experience helped with improving my self-image. And a picture is much more than what you see.

Plot Your Path to Success

When you start any new business—and this applies even if you're an experienced photographer who's simply looking to break into a new niche—you must begin with the end in mind. You don't want to jump into the pool only to find yourself quickly exhausted because all the while you've been pouring tons of effort into freestyling it, you suddenly realize you've only been treading water—not making any progress, and not making any money. Think through all the important steps involved in establishing a boudoir photography business and get help when necessary:

- What steps do you need to take to establish a legal business?
- What will your product offerings be and what are the costs associated with those?
- Will you work out of a studio or be location based?
- What will your overall expenses be?
- How much time do you anticipate putting into each client engagement?
- Who will you use for makeup and hair services and what are the expenses associated with their services?
- Will you be low or high volume and how many boudoir clients do you hope to take on per month?
- How will you charge for your services—will you be low cost or high end and where does this place you in your market?
- How will you market your services or, if you already provide other photography services, how will marketing this new niche be approached differently?
- What policy and contract terms will you need to clarify on your business documents?
- Who will handle your bookkeeping and accounting?
- How will you build a portfolio that markets your services and style?

- What equipment do you need to acquire in order to deliver a professional service?
- What insurance do you need to protect your business?

Building a business is like running a full marathon. You have to learn all that's required and then prepare well before you even attempt it if you're going to have a chance to make it to the end. Meet with small business consultants—most towns offer support at little to no cost. Consult with accountants and legal experts to be sure you're covered and protected (particularly important with boudoir is language regarding usage of your clients' images). And secure liability and equipment insurance to protect your investments. I'm seven years in and in some ways I still feel like I'm building my business! Remember the story about the turtle and the hare? Sometimes taking it slow is the way to make it in the end.

Prime Your Referral Engine from the Beginning

Although I hadn't set out to build a business that generated lots of referrals and repeat business (remember, I'd been told that wasn't possible with boudoir photography), I learned over time that the approach I share in Parts II and III positioned me perfectly for both. I discuss ways to build your referral engine in Chapter 18.

As you go about planning the steps to building your boudoir business, don't forget to continue to self-assess. As a boudoir photographer you must be:

- memorable;
- likeable;
- a great communicator;
- comfortable with emotions;
- capable of instilling trust;
- dedicated to the client's complete happiness;
- skilled at building her confidence and esteem;
- able to establish meaningful relationships with a diverse range of women throughout your precious time with them; and above all
- **passionate about what you do**—because this passion will carry you through all the rest, and it's your passion that will inspire her to share you with others.

Define Your Own Flow

A last piece of advice I'd like to share with you is to define your own workflow—make sure it makes sense within the scope of your brand, your philosophy, your vision, and who your clients are/why they come to you in the first place. It's easy to simply follow what everyone else is doing. But what everyone else is doing may not work for you or your clients. Check in with them regularly, get feedback throughout

the process, and assess what's working for you and what isn't.

For example, I learned a few years in that offering a few select packages clients signed up for before we even began our work together just didn't make any sense for me in how I work with my clients. Although packages are popular among photographers, they just weren't working for me or my clients. Most had never experienced a boudoir shoot before, didn't know what they were going to do with their images coming in the door, or *thought* they knew but then changed their minds once they saw the images; only after they saw their images were my clients able to say, "Ah, now that I see the images, here's what I want to own." There are many other ways I've tweaked my process to suit the needs of my business; you will do the same as you build a boudoir business that works for you and fulfills your mission.

Self-Assessment Questions for Chapter 5

1. Is boudoir photography the right niche for you given where you are in your photography career?

2. If you are ready to move forward, who will you be in your market?

3. What might your tagline be? What kind of client might be drawn to you as a result?

4. What underlying needs might your ideal client have?

5. What kinds of messages might you want to put out there about your vision, mission, and the service you provide?

6. What qualities (aside from technical skills and expertise) might you look for in staff and freelancers?

7. Review the steps to plotting your path to success. What might you have accomplished already? Which steps are you ready to take next?

8. On a scale of 1–10 (10 being the highest) how passionate are you about pursuing a business in boudoir photography and delivering a meaningful service to your clients?

PART 2

ENGAGING YOUR CLIENT BODY AND SOUL THROUGHOUT THE BOUDOIR PROCESS

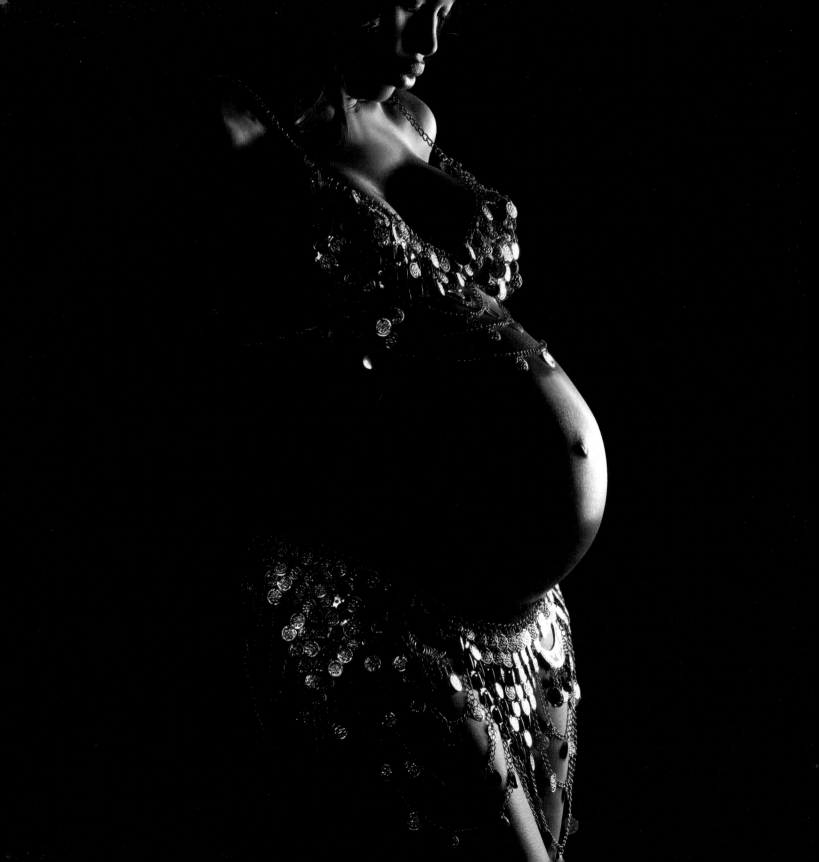

6

Grabbing the Reins
from First Contact

People have entire relationships via text message now, but I am not partial to texting. I need context, nuance and the warmth and tone that can only come from a human voice.

Danielle Steel

Email, SMS, PM, IM, VM, Text—oh my!

Maybe I'm old school, but I don't really like receiving inquiries that read like this:

> *Email price list.*
> *How many outfits?*
> *Do I get all the images on a disc?*

Aside from the fact that my website provides a comprehensive overview of how shoots work at my studio and even includes general price ranges, how impersonal are these messages?!

My reply to these curt emails whose sole purpose is to get a hold of my price list is always roughly the same:

> *Hello [Insert prospect name]! I'm glad you found me. Thank you for your message. I'd be happy to answer all of your questions and provide you with a comprehensive overview of my services (and accordingly how pricing works). I want you to be equipped with all the info you need so that you can make a fully informed decision. Email is so impersonal and yet boudoir is so very personal! Let's set up a brief chat when you can find a few minutes.*

Those who will not take a few minutes to engage in a person-to-person, live discussion are not my clients. This I've learned well. What's more, immediate requests for price lists are generally indicative of one thing: if it's not another recently established photographer merely trying to disguise themselves in order to figure out my price list, it's a prospect who is simply price-shopping, who may care little about the experience or the quality of what she's getting, and who may instead be focused on the bottom line above all else—i.e. how much she can get for how small an investment. Unknowingly comparing apples to oranges, she's assuming that all photography services are the same and decides that comparing pricing from one photographer to another is the way to go. This type of consumer is unwilling to give you the time of day so that you can educate her about the value you offer along with your price tag. And in today's supersaturated market, one thing is for sure: a price war is always, without fail, a lost war.

In order to succeed in the competitive boudoir photography industry you have to be comfortable with this very important fact:

> *Not every prospect who comes your way is or should be your client.*

When you leave room on your calendar for the clients who will respect your process, appreciate the artistry of what you do, and compensate you accordingly, then you will find that, like parting water with your hands, new clients will indeed fill your schedule—just be sure they're the right ones!

*Less than ideal clients only beget other less
than ideal clients.*

You know that old saying: birds of a feather flock together? Make concessions for one, and you can be sure her friends will follow demanding the same concessions. So, knowing where you stand on your pricing, your offerings, and your place in the market will prevent you from taking on clients who only prove to be a waste of your time; who will fight you every step of the way; and who, ultimately, still won't be happy because in their heads there's no difference between your work and that of uncle Bob—offering photographs shot with a consumer level camera, charging a fraction of what you charge, giving away all his files, operating out of his basement, and still using a lamp to light his subjects.

Well, you might argue, *if my work is good enough, they'll see the difference . . . right?*

Maybe yes.

Maybe no.

Here's a rough script I've run through time and time again. Though the specifics might vary a bit, the general message is always the same:

Prospect: *Hi. I saw your website and had a few questions. I get the rights to all the images from the shoot, right?*

Me: *Hi. Well, did you know that photographers own the rights to their images as per NY State Law? Can you tell me a little bit about what it is that you're hoping to have?*

Prospect: *Well, how much does the shoot cost?*

Me: *It ranges, depending on what type of shoot you'd ideally like to have and what you'd like on the back end. Why don't you share a bit about what you envision for your shoot?*

Prospect: *Well, another photographer I spoke to offers a two-hour shoot, has clothing I can use, and will give me all the images on a disc for $250 so I can make my own book. Can you match that?*

Me: *I'm sorry, no I cannot.*

Prospect: *Why not?*

Me: *[Insert prospect name], I'm guessing, because you are calling me, that you're not completely sold on the photography of this other photographer and that's why you're calling me. Am I right?*

Prospect: *Um, yeah.*

Me: *Well, in this field, just as in many others, you get what you pay for. When I started out, I didn't charge much for my services either—I was building a portfolio. But I'm no longer in that mode. And as you see by my images, I've invested lots of time, money, and effort into honing my skill as a professional photographer. I invest a lot of money, effort, time, and talent into creating the images I do for my clients. I am sorry that I cannot match this other photographer's price, but if you're willing to discuss what I offer and, accordingly, what value I offer at various price points, we can continue.*

Sometimes the conversation will continue and the client will learn something about what's involved in a professional photo shoot, and then finally come to appreciate why professional photography costs what it does. Other times, she won't want to have the discussion because she's purely focused on the bottom line and will simply keep trying to match the price she has in her head with a photographer's work she can tolerate.

I haven't lost anything by letting her go—I've only saved myself from a huge loss of time and effort and most likely numerous headaches throughout the engagement.

And here's the reality about people who buy price only: cheap bastards are also a pain in the ass.

Jeffrey Gitomer

On Choice

What's interesting to note in the photographer–prospect scenario is that many prospects don't realize the selection process is a two-way street. I've had clients express shock when I tell them, "I'm sorry, I don't think I'm the photographer for you. I wish you well in finding a photographer who meets your requirements."

Just as they are weeding out potential photographers, you too should be weeding out the clients who don't match your target client criteria. This may be a scary thought for some photographers concerned about the overly saturated photographer market or worried that their phone isn't ringing enough in the beginning. But to this I say: think and read up on the laws of attraction. You might think it's a little hokey, but that's okay. There's a big-picture lesson to be learned from it.

Each client you take on has a ripple effect in your market. I've always ultimately regretted taking on the low-budget client who, bottom line, really couldn't afford my services in the first place. I regret it because:

- she usually ends up being more difficult to work with;
- she isn't as happy with what she gets for her money, always thinking she should have been entitled to all images on a disc; and

- if she refers others, they are, like her, budget-minded, exhausting negotiators who ultimately do not respect my work, or the value of the artistry involved in photography, and couldn't care less about how much back-end work goes into making beautiful, polished, professional quality images.

In retrospect, I notice a trend: these types of engagements so often begin with an email, text, private message, or instant message—some impersonal method of contact, where curt messages are par for the course, and there is little room for . . . well, personal anything!

Granted, it's so common these days to receive inquiries by email, text, private message (if you have a page on FB), and VM during off hours. But once the ball is in your court, how you respond makes *all* the difference. Requiring that I speak with each prospect before sharing any additional detailed information about my pricing enables me to weed out prospects who aren't my clients and sway those who are in the span of 10 or 15 minutes. (FYI—they can find general ranges and session fees on my site.) In my experience, this is much more efficient than the alternative: never-ending back and forth email or text exchanges involving endless regurgitations of information already clearly outlined on my website.

If you don't want them to drive *you crazy, grab the wheel!*

In speaking with my prospects, my aim is to:

- give them a sense of my personality and set them at ease about the boudoir process;
- get a sense of who they are and share stories relevant to their experience so they feel more confident in my ability to first understand and then to deliver on their goals;
- answer any and all questions the prospect might have about boudoir photography;
- shift focus from pricing to the equally important aspects of boudoir photography—the photographer–client relationship; my skillset; the shoot environment; studio resources; and the overall experience at my studio, which I am well aware is unique in my region; and
- identify and allay any fears or concerns that might otherwise prevent her from pursuing boudoir with my studio. For example, I would hate to lose a prospect solely because my website wasn't clear about her right to opt out of having her images included in my online portfolio, while another

photographer happened to stress this aspect on hers. Chatting provides the opportunity for her to ask about this directly and to receive a nonjudgmental, anxiety-eliminating answer directly from me. Problem solved!

Establishing a personal connection from the very first inquiry is always a winning strategy, given the highly intimate nature of boudoir. Even if the client isn't aware this is necessary, the boudoir photographer should be.

Here's a helpful tidbit: I've had many prospects-turned-clients thank me for being the first photographer to suggest we chat on the phone rather than answer their questions via email.

I've had many prospects say, "I was just beginning my research, but after talking to you, I know you're the one!" And they sign up for a session right then, during our first call. I can't help but think what a missed opportunity this is for all the photographers who only give their prospects exactly what they ask for: a price list.

Why They Buy

Sales guru Jeffrey Gitomer conducted a series of interviews with customers across a range of businesses to arrive at answers to the question: *Why do customers buy?* He found that "The answers are a combination of common sense, startling information, overlooked issues, and incredible opportunity."

Although he lists 12.5 reasons (you can find the entire list in his *Little Red Book of Selling: 12.5 Principles of Sales Greatness, How to Make Sales FOREVER*), the first ten are so applicable to boudoir photography and the information I present in this book that I immediately reached out to

request his permission to share them with you. I was thrilled when he granted that permission. So without further ado . . . following is an excerpt from this inspiring book. (As you read through the list, be sure to insert "photographer" for "sales rep.")

10 reasons "Why They Buy"

1. **I like my sales rep**.

 NOTE WELL: Liking is the single most powerful element in a sales relationship. I got a quote the other day from someone claiming to be a sales expert. It started out saying, "Your customer does not have to like you, but he does have to trust you." What an idiot. Can you imagine the CEO of a company when making a buying decision, saying, "I trusted that guy, but I sure didn't like him." Like leads to trust. Trust leads to buying. Buying leads to relationship. That's not the life cycle, that's the life cycle of sales.

2. **I understand** what I am buying.

3. **I perceive** a difference in the person and the company that I am buying from.

4. **I perceive** a value in the product that I am purchasing.

5. **I believe** my sales rep.

6. **I have confidence** in my sales rep.

7. **I trust** my sales rep.

8. **I am comfortable** with my sales rep.

9. **I feel** that there is a fit of my needs and his/her product or service.

10. **The price seems fair**, but it's not necessarily the lowest.

Note the words he presents in bold (that's not my doing): trust, confidence, feel, perceive, believe, and like. These fall squarely in the emotional realm. Many photographers make the mistake of delivering facts and information. Granted, it's usually in response to the prospect's questions—*How much does it cost? How many pictures will you shoot? How long does the shoot last?* But photographers falsely believe this information will win them over. Instead, it only serves as fodder for the prospect's continued apples-to-oranges comparisons. While, of course, you can provide this information, aim to appeal to your prospect's emotions from the beginning. By doing so, you'll find yourself moving forward in establishing a relationship with her.

People don't ask for facts in making up their minds. They would rather have one good, soul-satisfying emotion than a dozen facts"

Robert Keith Leavit

A Word about Referrals

When a prior client takes the time to refer someone, I have to respond in a way that confirms every great thing my client might have said. No matter how stressed, busy, or preoccupied I might be, I have to be sure that our interaction is inviting, warm, and customized to her. And no matter what kind of shoot her friend might have had, I start from step one—letting her know that anything we do is completely a result of who she is, what she wants to achieve, and has nothing whatsoever to do with her friend's shoot.

Referrals are pure gold for a boudoir photographer, particularly if your fees tend to be on the higher end. For the most part, these prospects are prequalified, have already been sold on the service you offer, know your price ranges, may already feel they know you as a result of the stories your past client may have shared, and are simply excited about getting going with their own experience. Generally, all you have to do is sign 'em up!

In addition to the enthusiasm I express for the new prospect, I will also make a point to reconnect with my prior client. This does not come in the form of a brief impersonal email, text, PM, IM, etc. saying *Thank you for the referral*. It's a live person-to-person call where I leverage the opportunity to reconnect, find out what's new in her world, and glean any new and relevant information (e.g. information regarding any new or recent positive effect or outcome the experience and images might have had in her life or her relationship). Past clients will be excited to hear from you—as you are inextricably linked to positive memories and a positive experience. And whether or not they themselves plan to return for another session, the personal attention and appreciation you express serve as reinforcement for additional referrals.

The absolute worst things that could happen after a prior client refers a friend to you are: 1) their friend fails to receive the same warm, personal attention they did, and/or 2) the past client never gets a thank you from you. I'm thinking these are probably the best ways to dry up a referral source.

Is She Your Target Client?

So let's assume a prospect passes your first test. She responds to your email inviting her to chat via telephone by picking up the phone and actually saying "Hello!"

Well, congratulations! Your focus can now turn to the important question: is this a client for you? In addition to fielding her questions about you, your process, your work, and, if you have one, your studio, you also want to be sure to acquire as much information as you can about her. Acquiring this information will help you, among other things, to:

- identify shared experiences and common ground, which can serve as opportunities to immediately bond;
- share stories relevant to her situation that will ease any worries she might have about whether you're the right person for the job;

- visualize what she imagines for her shoot;
- determine if you have a similar aesthetic, or that you understand hers;
- assess her willingness to be guided and yet serve as your partner throughout your process;
- establish whether her goals work within your offerings and that she can work within your price structure;
- determine whether this particular client–photographer relationship might be successful for you (her goals work within the context of your capability, vision, and purpose); and ultimately
- determine whether she is or isn't your target client.

The first thing I do whenever I get a call from a prospect is to ask an open-ended question so that she can share as little or as much as she wishes to share. So I might ask:

- Tell me what leads you to me at this time in your life . . .
- Tell me a little bit about what you're looking to do . . .
- I'm passionate about helping women rediscover the power of their beauty, so tell me how can I be of help to you?
- Whomever do I have the great pleasure of speaking with, and however did the glorious fates manage to bring us together?—okay, I'm kidding on this last one, but you get the point.

Once she gets going, I LISTEN. And I take notes because some clients will go radio silent after the initial contact for weeks or months before you hear from them again. In the meantime, you may have spoken to 35 different prospects, including five Michelles, three Kristens, and six Jennifers! But your loyal prospect—who never forgot about you and still remembers your conversation as if it happened yesterday—will pick up right where she left off. If you take notes on the highlights of your conversation the first time, you won't be left struggling to remember what her story was.

When learning and practicing to become a psychologist, you soon realize that institutions of higher learning will endlessly drill effective communication practices into your head. Just about every course reinforces those skills so that it becomes second nature and you find yourself saying ridiculous things to your husband like: *So it sounds like my stealing all the covers in the middle of the night triggers feelings of frustration for you; would that be an accurate assessment of how you're feeling right now? And what is the source of this frustration? What might a stolen blanket signify for you?*

And if you aren't busy getting divorced as a result of your newly acquired skills, you learn just how powerful active listening can be. Contrary to how it sounds, active listening actually involves you speaking as well! But don't be mistaken: your sole purpose in speaking is to check in and be sure you heard and understood everything right. You learn to pay special attention to emotions, to label them, and then ask clarifying questions to ensure that you aren't making inaccurate assumptions about what the other individual is thinking or feeling.

So why am I telling you all this? Well, to a large extent, these same skillsets play a very useful role during that first inquiry. When you actively listen—repeating the main points about where a client is in her life and about how she feels, reiterating what she's hoping to get out of a session with you, and the most powerful act of all: labeling the emotions involved—then your prospect will feel understood. And that is an immensely powerful experience for her. Think about it—here is a stranger who's *really* listened to her, asked interesting questions, and gotten to the heart of what this nervous prospect thinks and feels, and you've done this in a matter of minutes.

Most spouses don't listen that well! Heck, most of us don't even listen very well. But the worst thing is, most people aren't even aware they don't listen well. It is said that most people listen not to understand, but to respond. Think about that for a second. When you're listening to respond, you're not really *hearing* your prospect, are you? You can't possibly be actively listening to her because you're busy in your own head formulating what you're going to say or reviewing the main points you want to be sure to make in this first conversation.

Here's an interesting exercise: next time you're engaged in a conversation—and let's challenge you a little bit, let's make it with someone truly boring—take note of where your head is. Are you actively listening, or are you revisiting your to-do list or, worse, busy drumming up ways to get out of the conversation? Entire books are written on this subject, and for good reason. Listening, and listening well, is perhaps the most powerful and important thing you can do during your first contact with a prospective client.

Active listening delivers these super powerful messages:

- You are important.
- What you have to say matters.
- I understand you.
- You can count on me to help.

That's really powerful stuff! Who *wouldn't* hire a talented photographer who communicated these things?

So, you've actively listened to your prospect, you realize she is indeed your target client, and, thanks to your awesome listening skills, she went from cautious to enthusiastic about working with you too. How do you ensure she becomes your client?

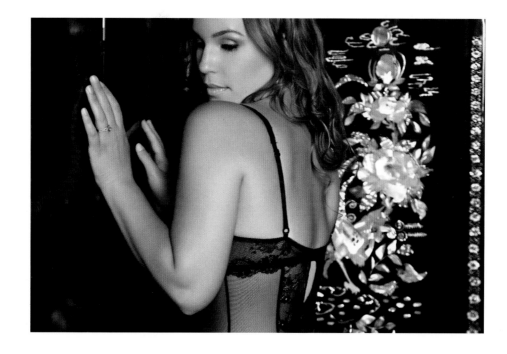

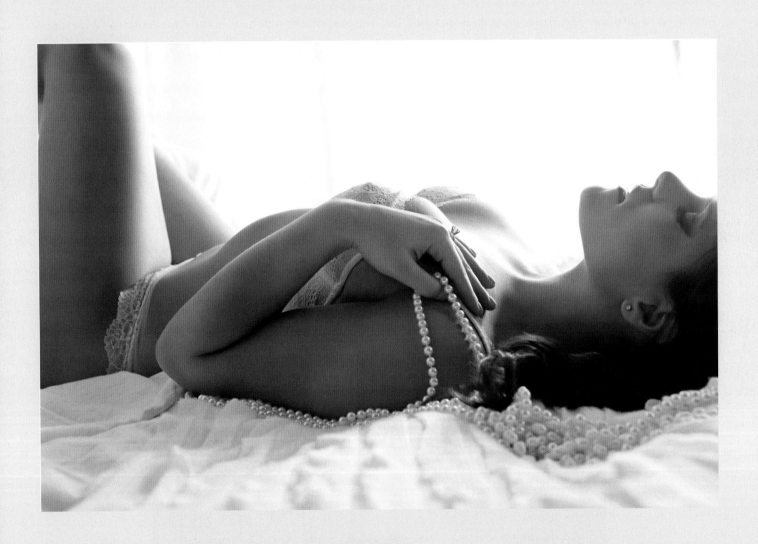

An Interview with Lindsay

Lindsay is a vivacious, fun-loving bridal client I had the pleasure to shoot in late 2014.

What motivates you to pursue a boudoir shoot right now?
I wanted to give my fiancé something special for our wedding day. Honestly, I could have done a watch, or cuff links, or a flask, or shoes . . . but he doesn't need any of that and how much more cliché could I be if I did that? He has shoes, he has a watch . . . when will he ever wear cuff links and, honestly, when he wants a drink, he puts it in a glass. What he doesn't have is . . . professional, gorgeous pictures of me, and I personally think he will love not only the shots but the thought that I really put into his gift.

Heading into a boudoir shoot, how would you describe how you feel?
Honestly, comfortable. Excited. Happy. Calm. I had created a wonderful relationship with you before the shoot so I think understanding how you work, you understanding me, made me feel quite frankly normal. I have also come to appreciate my body. I have worked hard on it, and I am proud of it. I am not afraid to be in front of someone who understands female flaws.

On a scale of 1–10 (10 being most confident) how would you rate how you feel about your body?
6 and growing steadily. I work hard on this body, and I am proud that it's mine, yet I still feel there is room for improvement. I don't ever think I will be at a 10 but that's okay. *(Post-shoot she indicated "8 for sure.")*

What three words would you select to describe the look/feel of the images you hope to create?
Real, natural, personal.

Post-shoot: What did the photographer do specifically that helped ease any anxiety or fears?
What I loved most is that she actually would do the poses the way she would suggest you do them. She would get on the floor, or stand against the wall, or sit on the chair the EXACT way, with the EXACT expression that she wanted. She wasn't afraid to show you and that just put me at ease.

Aside from beautiful images, are there any other positive outcomes from your boudoir experience?
I think this experience was such a "freeing" experience. It was so natural and so beautiful and I really feel that every woman should experience that. It doesn't have to necessarily be for someone else; it could be for yourself!

Anything else you wish to share . . .
I hope that women can understand the full potential of their bodies someday. This experience was truly incredible and I have grown to really appreciate myself because of it.

Here's a checklist of seven things to do to be sure you engage your client now:

1. Listen for cues that she's ready to commit to the boudoir experience with you.
2. Hear her needs and concerns.
3. Address her needs and concerns via your super active listening and clarification questioning skills.
4. Share relevant stories that mirror her situation and let her know that you've got this—you've handled this situation before and had stellar results!
5. Share your motivation for doing the work you do and inspire her with your driving vision and sense of purpose.
6. Inspire confidence in her with highlights from your experience, credentials, and achievements.
7. Then allow her the space to come to a decision. You may even want to suggest that she give you a call back once she decides or realizes she has additional questions.

Did you hear screaming brakes? Sales instructors would probably scream upon reading this last point. *Why wouldn't you pounce? Strike when the iron is hot! Get her to sign in blood NOW!*

Maybe it's a personal style thing, but I have found that with boudoir photography, because it's such a personal act, such a tough decision for some women to pursue this—to decide to grapple with body image issues (*every* woman has them!)—I don't want a prospect to ever feel I'm pushing her into it. It has to be a decision she comes to on her own. One she's super excited about. Sure, I will give her all the information she needs to arrive at that decision to work with me. I will lead her right up to my front door, but the decision to ultimately step into my studio is hers to take.

Regret, particularly when it comes down to potentially spending thousands of dollars on photographs (even though I know the experience is invaluable), is not something I have ever contended with, nor do I ever wish to. And the bottom line is, some women just aren't ready, and only they can know whether they are or not. I've had women follow me for years before they ultimately worked up the nerve to just do it. Regret casts a long, dark shadow and, like happy, satisfied customers, has a ripple effect for your business, only in this case those ripples lead to very bad outcomes.

Does this mean I never sign prospects on the spot? Not at all. There are clients who say, "I'm ready, let's do this. Should I give you my credit card number?" In which case, I'm all ears. But if she's hedging, pausing, then I invite her to think about all the information I gave her, to call if she has any more questions, and I may even offer to put her in touch with current or recent clients so that she can ask questions firsthand from someone who's been through the experience with me. By doing this, I'm listening to *her* needs. I'm attending to where she is emotionally. I'm not putting myself, or my sales goals for the month, first. That is the difference. And it's a huge difference. And prospects get this.

Clients thank me regularly for being a genuine person, not a "sales" person. If it means I'm leaving some money on the table here or there, I've decided that's okay in the context of where I am right now in my business. Because a bigger plan is in place. And I do believe that the greater the number of positive experiences I build, the stronger my foundation, the more secure my business will be, no matter how saturated the market becomes. And so far I've been right about this.

If HE Calls

Sometimes hubby is the one to initiate contact with me. Not because he wants a couple's shoot or a dudoir shoot (although I do get those calls too!), but because he wants to do something nice for his wife and thinks she would get a lot out of a session with me. I love when this happens! It's such a sweet gesture on his part, and tells me she likely has great support from the man in her life.

Assuming it's not some big surprise for her, I will, after giving him all the pertinent information he seeks, tell him that I will need to speak with her. Why? To let him know that *she* is my main client, and to assess her willingness and emotional needs, and check in with her about what she would ideally want her shoot to be like. Even though he initiated the experience, *she* is still my client. All planning takes place with her. He is generally not allowed to be present at the shoot. (Only once have I ever allowed hubby to remain, but I did so because she pleaded and pleaded with me and, for this particular couple, it just felt right; it also turned out to be a great thing because he was so happy with the outcome that he commissioned an eight-foot wall art piece! Boo yah!)

Why do I handle it this way? Well, I am all too aware of power struggles between men and women. The last thing I want to happen is that a man hires me to shoot his girlfriend, wife, fiancé, what have you, and because he's paying for the experience, he then thinks he can call all the shots. That just doesn't work when it's *her* who's in front of the camera wearing lingerie, and expressing what should be her authentic self—not some idea he might want her to play out. That scenario might work for another photographer, but it doesn't for me. It's just *not* a fit with my vision. But again, clarity about my vision is what enables me to know what questions I need to ask when he calls, and what information I need to share with him so that my experience with the couple doesn't turn into an uncomfortable one for either party.

How *you* respond to hubby's inquiry will ultimately depend on your vision, purpose, and motivation, but at least being aware that this is a situation that will present itself to you as a boudoir photographer will allow you to think about and prepare your preferred manner of handling it.

A Word about Inquiries for Couples Boudoir

Whether or not you decide to shoot couples will ultimately depend on your business purpose. Nonetheless, I've provided some key points below on handling inquiries from couples:

- These inquiries are best fielded in person, to the extent possible.
- Observe body language as well as emotional cues from both individuals to be sure there is buy-in from both individuals.

- Make eye contact with both and, to the extent possible, try to be equal in your attention to each.
- Do not allow one person to do all the talking; if one appears more dominant in the discussion, direct some of your questions to the other to engage them and bring them into the discussion.
- Remember: in this scenario you now have two people with whom to get buy-in, and with whom to build rapport.

Shooting couples, with the appropriate guidance and pre-planning, can be a rewarding experience. At the inquiry stage, it's just important to remember that not only must you use your active listening skills, but also you must facilitate dialogue between the two participants in the relationship to arrive at a clear and shared understanding about goals, the vision, and the desired outcome for the shoot.

In Conclusion

No matter who initiates the call, or how, a meaningful relationship with your prospect begins from the first inquiry. How you handle that first call, private message, or email makes all the difference in how your prospect will perceive you and how connected she will feel with your business.

Many photographers tend to rely on the confidence they have in their own work being superior to that of others in their region and wait passively for the right clients to find them.

If your aim is to establish a reputation as a client-centered emotionally intelligent photographer, everything you do must align with that approach from the very first point of contact. That means that you should not simply shoot off a form email with your pricing menu attached in response to every single inquiry that comes your way. Show interest in who they are, and what they envision. Give them a taste of who you are. Share some laughs. Make a friend and build a meaningful business.

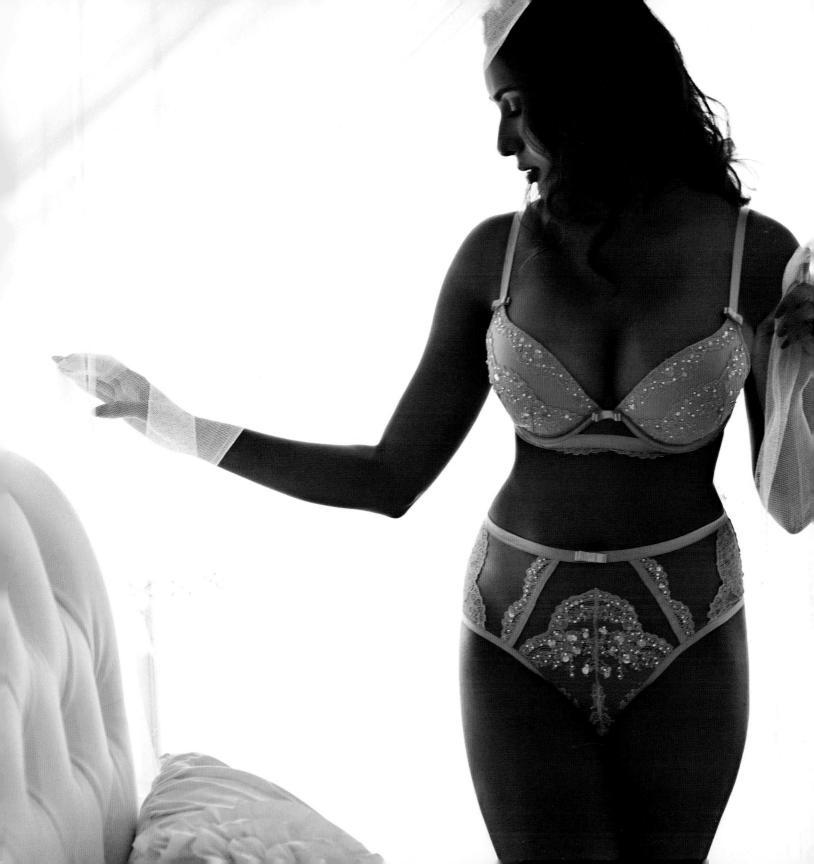

7

Now That You've Earned Her Business

The aim of art is to represent not the outward appearance of things, but their inward significance.

Aristotle

So you've turned your prospect into a boudoir client— congratulations!

Know this: while you're happily checking her name off from your prospect list, she may be thinking, *Oh gosh, what did I get myself into?!*

Quotes from clients on how they were feeling prior to their shoot:

- I booked my second photo shoot as a way **to help me regain my spirit and rebuild myself**; as a way of healing.
- The afternoon of the shoot as I was driving to the studio, **I must've thought a hundred times to make a U-turn and go home**. But I'm so glad that my motivation to honor myself won out over my fears. Fears are only as big as we allow them to be. Doing my very first real photo shoot with you on that Sunday afternoon in August of 2011 was the best decision I ever made.
- Words used to describe their emotions:

The positive . . .

- excited
- focused
- full of high hopes
- proud
- confident
- focused on the mission
- grateful
- honored

- determined
- comfortable
- happy
- calm
- empowered
- liberated
- cautiously optimistic

The challenge . . .

- nervous
- unsure
- extremely vulnerable
- anxious
- scared out of my mind
- freaked out
- self-doubting
- full of trepidation

- shy
- unworthy
- apprehensive
- terrified

Prospective clients I've spoken to over the years will often articulate that very thought once a date has been set and the credit card information handed over. In response, I chuckle and assure them, "Well, now the fun stuff begins, of course!" Your confidence as an experienced boudoir photographer goes a long way toward allaying any sudden panic or self-doubt that can start to creep in for her. But given that the shoot date may be weeks or months away, it's even more important that she continue to feel connected with you, that you are an accessible resource, a partner in the process on whom she can rely.

Experienced boudoir photographers will do that any number of ways, but the key thing is to know that you should have a strategy for keeping her engaged. You can't just fall off the face of the earth once the contract has been signed, because here's what just might be happening in her world:

- She might have told a friend or two she's doing this thing called boudoir photography and gotten a "Why would you want to do that?" scrunched-face kind of response that's not exactly supportive . . . which would leave her feeling unsure about her decision.

- She might have stepped on a scale and realized she's gained a few more pounds than she thought she did over the last weekend away . . . which would leave her feeling unready and desperately seeking a reason to postpone the shoot.

- Or, she might have gone shopping for lingerie in some high-end department store only to encounter herself in a cube of mirrors revealing every possible angle of her body—lit, of course, by hideous fluorescent lights—and panicked, believing that no outfit could possibly make her look good . . . which would leave her reviewing her contract for exit terms.

Granted, not every client is going to experience these doubts, second thoughts, or moments of panic. But, as these are all real-world scenarios, know that some will. The goal is to know about it so that when it happens you can be a helpful partner who gently eases them back into excited mode!

So what are some ways to keep the boudoir client engaged and focused on prepping in a positive way for her shoot?

- Make prepping resources available to your clients— keep her busy with posing guides, links to helpful YouTube videos, prep tips, outfit style boards, dos and don'ts lists, etc.

- Schedule Touching Base appointments—which can be brief phone calls, in-person visits, or email chats—these become increasingly important if you don't hear from her much after initial signup.

- Share a Pinterest board (*if* she is familiar with Pinterest and inclined to use it) so you can stay up to date on her activity and direction, and let her know you're following her activity by hearting or commenting on her pins.

- Above all, let her know you're there as a resource.

It's hard to be so diligent with each new client when you're juggling shooting, editing, marketing, feeding the hungry social media monster, communicating with clients you've already shot, and managing day-to-day business operations.

The bonding you do with her now will carry forward into the day of the shoot and beyond.

Assuming your conversations up to this point have gone well, your client may already be feeling comfortable and bonded with you. But you must ensure this is the case prior to the shoot. My goal is to have every client walk into her shoot feeling like she's seeing an old friend, not making a new one for the first time. And I know I'm successful at this because more often than not clients will say upon walking into the studio for their shoot, "Oh, I feel like we're already BFFs!," or "Let me give you a hug!" or "I'm so nervous but I already know I'm in good hands!"

Having their trust walking in the door means:

- Our shoot will be much more productive.
- She will be a willing, valuable partner in the process.
- She will be much more likely to reveal her true self during the shoot (which will of course make for more powerful images and, by extension, a happier client and higher sales).

Developing trust all begins in the pre-shoot phase.

The One Thing

Just as it was important to let the client know she was heard and understood in the very first inquiry, so it is in the pre-shoot phase to let the client know that her vision is understood. And that you are truly in sync.

While there are many different ways to go about achieving this, my approach is to guide my client in finding her voice, her style, her ideal vision.

Now, this is important. As an experienced photographer, I am willing to set aside my preferred shooting style, my favorite lighting techniques, popular posing approaches, etc., so that I might deliver images that capture how a client sees herself or how she wants to be seen. I want to place her squarely in her ideal vision for the shoot, *as she sees it*, *not as I interpret it*. This is a key distinguishing characteristic in the service I provide. In fact, I believe it is *the* distinguishing factor that has enabled me to establish a boudoir photography business that continues to survive and grow despite several challenging factors:

- I live right outside a major city several well-known boudoir photographers call home.
- I'm on an island with a supersaturated photographer market—one where long-established wedding studios have even taken to offering boudoir photography services.
- I'm in a small market where every year there are new boudoir photography studios popping up.

I do not spend much time and money marketing my boudoir photography services simply because I don't have much time to do so. After several years in the boudoir photography field, most of my business comes by word of mouth, client referrals, repeat client business (I get a ton of that), and client testimonials posted on various websites and forums, which has also assisted in boosting my SEO rankings.

What I hear over and over again from my clients and referrals is that they came to me because I am successful in capturing women's souls.

When they say this, they are referring to the care I take in crafting concepts, sets, lighting, and posing strategies that will result in images that tell their unique story—where they've been, where they are now, or maybe even where they're going. It's up to the client to decide what story she wants to capture and tell. But the best part is that she can keep coming back to tell different parts of her story—all through the amazing tool and experience that is boudoir photography. Even if a client chooses to re-create images already in my portfolio, she must feel that the shoot was customized specifically for her and that

any re-creations were by choice, at her request, and with her vision in mind.

So what is the one thing, the single most important goal, a boudoir photographer should have at this stage of the client engagement? It's developing an understanding of your client's vision, her story, and how she wishes to tell it. Most clients are willing to share their stories, to tell you their fears, their insecurities, the challenges they've overcome and the things they most wish to convey about their strengths, and where they feel the source of their beauty lies. You just need to ask.

Have them show you images that inspire them because they tell similar stories or evoke similar emotions to those they wish to convey. And then weave the threads of her story into the concept for her photo shoot. Help her choose outfits that will speak to the personality she wants to communicate. Prepare to guide her actions and movements to tell the story she wants to tell. Use the emotions driving her to determine the lighting choices you make, not the other way around.

Even if it means learning to shoot natural light (if you're a studio shooter), or learning to shoot with strobes (if you're a natural light shooter), you'll be better off for having a wider skillset at your disposal.

In short, shoot your creative photography work for yourself as you see fit and to define your personal style. But if you want to give your boudoir client a transformative experience, the boudoir photography experience must be tailored for and driven by *her*—who she is and what her vision is.

An Interview with Sandeepa

Sandeepa is a repeat client I've had the pleasure of shooting and getting to know over the last several years; she views her shoots as a journey and each one is distinct and different from the one that preceded it. As a result of our work together, I am proud to call her a friend. She is a deep thinker and very articulate about her journey; for this reason I invited her to participate in this book project.

What motivates you to pursue a boudoir shoot right now?

I want to acknowledge and celebrate the woman I've evolved into. After a decade's long struggle with my low self-esteem and poor body image, I'm finally in a place where I can look in the mirror and like what I see. To me, boudoir photography is a celebration of the uniqueness and beauty of the female form. However, it's not simply a woman's curves, lines, shapes, and color that make her beautiful; it's also her essence and her spirit and the stories woven into her life. Boudoir photography, in its purest form, is an art that captures not only a woman's physical beauty, but her entire soul.

On a scale of 1–10 (10 being most confident) how would you rate how you feel about your body?

I would rate my feelings about my body an 8. My body has served as a vehicle to achieve some awesome feats including two natural births. My body has withstood physical pain and illness and battled danger, but it has emerged stronger than before. The scars it bears are testaments to my journeys. I'm finally learning to love it, honor it, and nourish it so that it may remain my temple for many, many years to come. *(Post-shoot she indicated a 9, saying: This was a remarkable exercise in learning to love my curves more and more and feeling fortunate to have them. It was a celebration of my uniqueness.)*

What three words would you select to describe the look/feel of the images you hope to create?

Elegant, sensuous, and captivating.

What, if anything, would make you feel more comfortable and confident heading into your shoot?

Knowing I'm shooting in a safe, warm environment with genuinely caring people who have my best interest at heart. That has always been the case when I have worked with you and your team members, so I'm feeling very positive about the shoot.

Aside from beautiful images, are there any other positive outcomes from your boudoir experience?

I came out appreciating . . . that sometimes in order to create meaningful art, you simply have to overcome apprehension and face up to challenges or obstacles . . . your compassion and dedication to your art transformed an otherwise ordinary space into something otherworldly and magical, and transformed me into someone

who's inner essence shone as brightly as her outer beauty. Whenever I work with you, without a doubt, I experience a super surge of self-confidence, and this time was no different . . . when I came home from the shoot, I didn't want to remove my makeup because in a sense I didn't want the experience or my day with you to end. I loved looking at myself as that elegant, sensuous, and captivating woman. The greatest part was that when I did remove all the makeup, change into sweatpants, and put my hair up in a ponytail, I still felt like a knockout! You truly gifted me the experience of feeling like a goddess and that feeling stayed with me and built a permanent residence in my heart.

Anything else you wish to share . . .

I did start this journey (back in 2011) in part as a gift to my husband, but each collaboration with you has always been primarily a gift to myself. For me, creating these stunning photographs with you is a testament to all I never deemed possible but made happen for myself by letting go of my fears and taking a chance. It's the healing salve to decades of poor self-esteem . . . The biggest gift to myself from this shoot, from previous shoots, and from ones to come, is that I am reminded to embrace myself and own what is unique and special about me, so that I am capable of giving love to my husband, children, and people in my life that matter most to me.

Get to Know Your Client Inside and Out

There are many ways to acquire information about your client. Some photographers use downloadable questionnaires; others set up in-person shoot planning meetings. But to me, the right answer is to use whatever tool is going to be best received by the individual client you're working with at that time.

Some clients, more than likely the introverted ones who are more inclined to look within, will be receptive to a questionnaire. Others, for example the extroverted among us, might see that questionnaire as a job—one more challenging to-do task to add to an already overwhelming process. And while the extroverted would more likely appreciate the interpersonal nature of an in-person planning session, the introverted client might feel put on the spot, preferring to have had time to reflect and think about the answers to your questions.

So how do you know who your client is? In the beginning, when you lay out the process for moving forward, simply ask: "What's your preference? Would you like to meet in person to go over a strategy for the shoot or would you prefer I send you a questionnaire you can fill out, and to which I can respond with suggestions?" She'll let you know her preference. The onus is then on you to show flexibility to work with her in a manner that suits her style. But the bottom line here is that *you must first be aware of your own style!* Are you the introvert who would prefer the questionnaire method or are you the

extrovert who would love to meet in your client's home over coffee? If you're aware of your natural inclination and preference, then you'll be able to identify if you are the one pushing for a method that may or may not work as well for your client.

Regardless of what method(s) you use to gather information from your client, the goal is nonetheless to develop a clear understanding of what she hopes to achieve during her photo shoot and in the resulting images.

I'm convinced that you're able to look inside my soul and see me for the woman I am and help me be an even better woman.

Sandeepa

Concept Planning: KISS

So after your client gives you her story and shares her hopes and dreams for the shoot, it's your job to come up with a concept for her shoot. And sometimes that old rule about "Keeping It Simple, Silly" is pure gold.

While some clients are more forthcoming than others, the goal is always to distill all the information you've gathered down to its purest and strongest form. I will often ask my clients to identify three words that will sum up the look and feel of the images they want to create during their shoot. Most have to think about it for a bit. But it's a worthwhile exercise, because it can also serve as a checkpoint throughout your engagement with your client.

A perfect example: One client I worked with was a beautiful professional and mother of little ones. The inspiration images she shared were very bohemian—lots of lace, hazy light, a soft palette of pink, ivory, white, and blush. She wanted her images to feel *pretty, natural,* and *feminine*. We were in sync . . . until she purchased a corset in a violet shade.

While the corset was definitely feminine, it didn't exactly fit in with her goal of looking *natural*, or what I believe she was referring to when she said she wanted to look *pretty*. I wasn't sure how the corset fitted in with her vision, so I called her. I suspected she'd chosen the violet corset because she felt obligated to incorporate something that felt "boudoir-ish." And when I asked her if that was the case, she admitted it was (no surprise there) and called me psychic. While I don't think I'm psychic, I do know that I did pay attention to all the information she'd given me up to that point, and at no point did any of the indications lead to the integration of a violet corset in her shoot.

Of course, I gave her the test . . . letting her know that I would shoot her in it if she wanted to wear it. But she backed out, saying she wouldn't recognize herself in the images and wasn't exactly thrilled with it anyway. I believe the corset went back to wherever it came from. And we went on to have an amazing shoot that exceeded her expectations in that it very much fell in line with who she was, her style, and the story she wanted to tell about herself at that moment in her life. As a side note, this client has already expressed interest in a second visit to my studio, which I'm

really excited about. Moral of the story: it's common for clients to get carried away during their shopping excursions and lose sight of their goals.

It's your job as photographer and keeper-of-the-concept to keep them focused.

Playing devil's advocate, you might want to ask, "Why not let them just wear whatever they bring?" And I'd respond accordingly: "If she doesn't see herself, or the most compelling part of her current emotional story, reflected in the images you take all because of an impulsive/irrelevant styling choice, or because it was a styling choice that was influenced by external factors (e.g. a friend thought it looked great or that it just screamed "boudoir"), then your client will not be emotionally moved by the images."

If she's not emotionally moved by the images, then we've achieved one step below our ultimate goal of capturing her soul. Maybe we've made a pretty picture; we just haven't made a meaningful one. In missing the high mark, we've potentially diminished the perceived value of our images.

If the value of our images is diminished, then likely the sales potential is as well.

Photography is a visual art. The best way to ensure you are on the same page with your client prior to the shoot is by summing up all of your pre-planning work using visual language: a concept board. Concept boards address many key points for the shoot and can serve as a useful roadmap for your work together because ideally they:

- include her key inspiration images and group them into shoot concept(s);
- match images of her outfits with the concept(s) you aim to shoot—have her snap cell phone images and forward them to you;
- help her visualize more closely how you intend to translate the inspiration images in the context of your studio by including sample images shot with your furniture/backdrops/sets; this is your opportunity to expand on her vision and take the concept to a more creative place.

Be sure to provide sample poses within each concept for her reference. Note: some outfits may best be shot standing, while others look great while lying down or sitting. Make sure you have a nice blend of sitting, standing, and lying poses represented across the board. For each concept, include images that show the style of lighting/mood.

While my mini shoots include two concepts or sets, my full shoots include up to four sets/concepts. These may be as similar or distinct from one another as my client wishes them to be. However, by creating the concept board, we ensure we remain focused, accomplish precisely what we set out to within the timeframe we have, and minimize opportunities for later disappointment.

Usually, as in 99.9 percent of the time, the client reacts to the concept board with unbridled excitement. To her, it seems you've climbed inside her head and read her mind, when really all you've done is listened carefully, organized her thoughts and inspirations into coherent themes, and provided a compelling, suitable vision for her shoot.

Keeping clients focused on specific goals for a given shoot allows the client and photographer to explore a clear set of

Set 1: "Morning Light"
White Bed Set, Soft Light

Set 2: "Nighttime Beauty"
Living Room Set, Chair, Edgy Lighting

WWW.LIBOUDOIRPHOTOGRAPHY.COM

Set 4: "Angelic"
Soft Hazy White Light

WWW.LIBOUDOIRPHOTOGRAPHY.COM

Set 3: "Runway Vixen"
Grey Seamless with Gel Lights
(Feather sleeves avail. in studio)

themes more fully and deeply than if the goal had simply been undefined or, worse, included everything but the kitchen sink. Also, having a clear focus on a particular theme enables the client to think about others she might want to explore in future shoots. And often that's exactly what happens in my shoots! Before she's even finished with the first session, it's common for my client to already begin suggesting themes for her next.

A perfect example: One of my clients came to me in 2014 after a weight loss journey. She said she'd never felt pretty in all her life. She wanted the shoot to be soft, feminine, and romantic. She gathered inspiration images and shared outfits she'd been considering. Together we created a board that reflected a light color palette, flowing fabrics, soft lighting, and feminine poses. It was a huge success, so much so that she called me six months later to set up her next session.

In early 2015 we shot again. This time she wanted to explore her tough side. Life had dealt a few challenging blows to her in the time between this session and our last. She decided she wanted to highlight the strength and tenacity she didn't realize she'd had all along. Sure she was soft, feminine, and romantic, but she could also be a tough girl when push came to shove! Needless to say, this time the concept board looked very different! Darker colors, edgy lighting, and strong poses depicted a radically different side of this client. She was beautiful in her soft grace, but also beautiful in her strength. This is a powerful point of awareness for a woman to have about herself. She was so happy when she saw the images that she began, once again, talking about concepts for a session in 2016!

That E-Word

I refer to the client's emotions throughout this book because women are emotional creatures, and because the boudoir experience can be a highly emotional journey. Of course, it is more so for some than for others, but if you can learn to use boudoir as a tool to create a transformative experience for your clients, you will be able to reach a rewarding and loyal market that you might never have anticipated even existed. And your business will thank you for it.

You can't operate in a bubble, oblivious to what's going on in her world. You must be aware of the emotions your client may be experiencing throughout her engagement with you. At the pre-shoot stage of the client engagement, your client is most likely riding a roller coaster of emotions. There could be one or more of the following:

- excitement for the pending shoot;
- uncertainty about what to expect (if she's a first-time client);
- insecurity with her ability to pose well;
- nervousness about how she'll look;
- panic resulting from unachieved goals for her body;
- frustration with her perceived flaws;
- embarrassment about the prospect of being semi-naked or nude in front of someone else;

- pride in overcoming her fears to give it a go;
- hope that the resulting images will look like the beautiful images she saw online and in your portfolio . . .
- . . . leading back to excitement for the pending shoot . . . and round and round it goes.

Stay in touch with your client by whatever means you choose with encouraging or inspirational words and prepare her as best you can for what to expect on the day of the shoot. By doing these things, you'll help ease the roller coaster nature of her journey, and build the trust required to have a successful, productive shoot.

How to Work with Last-Minute Lucys

Clearly, the pre-shoot approach I discuss in this chapter and up to this point presumes you have sufficient lead time before a shoot in which to do planning, brainstorming, and concept-building with your client. But what happens with last-minute shoots?

First, I'll share it's rare that I'll book a last-minute shoot. In part, that's because I find most last-minute Lucys are also looking to have their images yesterday, and aren't exactly aware of the normal post-shoot working timeframes, and frankly I can't stress myself out like that. I also cannot move this person ahead of everyone else I'm working with in good conscience simply because she didn't think to book sooner.

That said, I have on occasion taken on a client who, through no fault of her own, was in a real bind. I am well aware that it sounds funny to say, "She had a boudoir emergency!!" But trust me, these do exist.

One particular case: Last year, I came to the rescue for a bride who'd hired her wedding photography studio to shoot her boudoir images. Her wedding was only three weeks away and she'd finally gotten an appointment to view her boudoir images. Let's just say, no happy ending there. She contacted me in a panic. She had nothing to give her fiancé on their wedding day

and she'd set up a whole plan around giving him this boudoir album. She pleaded with me to help her out.

Normally, this would not have been possible in the thick of wedding season, but it just so happened that I'd had a client request to reschedule an appointment three days out from this phone call. I felt for this bride's story and told her this opening would be the only opportunity for me to shoot her. She said she would move mountains to become available and did so.

Before we locked in the date, however, I did let her know that because we wouldn't have much lead time with which to plan, we'd have to really put our heads together to ensure we didn't end up with a similarly disappointing outcome. I let her know that I was stepping a bit outside of my comfort zone with regard to having limited pre-planning time and also the need for back-end rushing of the editing and work required to create a high quality album. I prepared her for the possibility that the book might not be available in time despite my efforts. She insisted she understood and would appreciate any help on my part to make it happen for her big day.

Well, we pulled it off. Thanks to an amazing partnership I'd developed with the Boudoir Album Company based in Canada, I got her the album in time and she was thrilled! In her feedback

to me, she mentioned a few valuable points of differentiation between her two boudoir experiences, but most notable (and most pertinent to this chapter on pre-shoot preparation) was the meeting of minds session we conducted upon booking, where we shared visuals and discussed the "mood" and "feel" of the images she was going for. This step, combined with regular check-ins during the shoot, ensured we got on the same page and remained on the same page throughout the shoot. And whereas she said she could not find a single image she liked from her first boudoir experience with the wedding studio, she was over the moon when she realized she'd have a hard time narrowing our images down to a feasible number given our tight deadline post-shoot. She loved so many of the images we created together because *she* was the inspiration for what and how we conducted the shoot.

The point to this story is that, regardless of how much time you do or don't have with a client before a shoot, this very important pre-planning step should never be abandoned. If your client cannot or will not make time for it, it just might be better to postpone the shoot and avoid a total disaster.

You never want to be that *studio another photographer has to rescue your client from.*

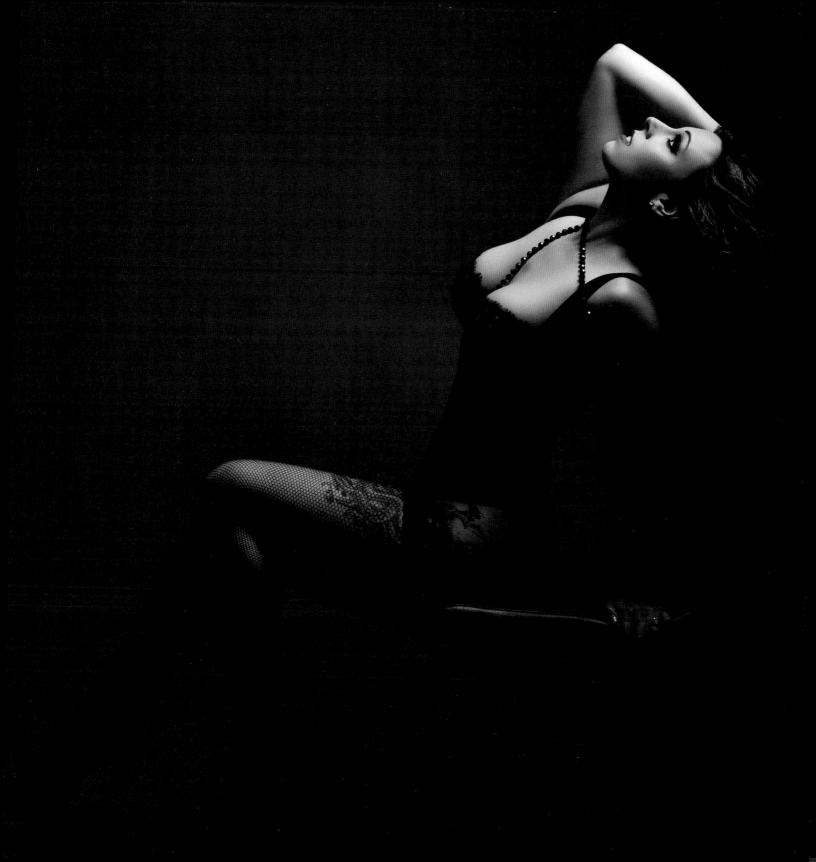

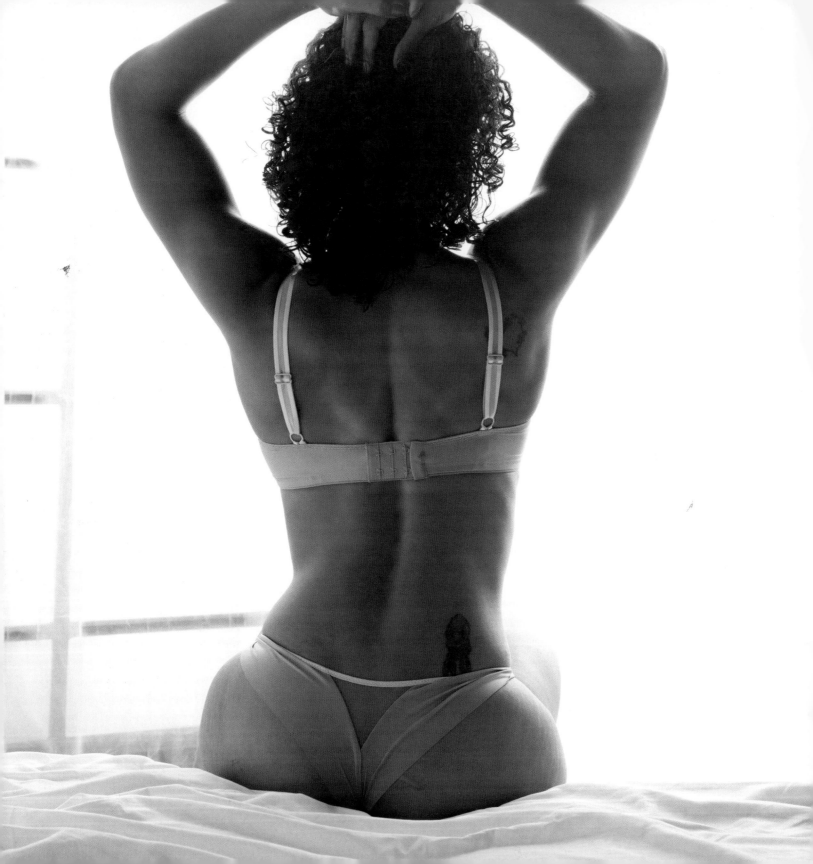

8

The Sensitive Stuff
A Woman's Ever-Changing Body Image and the Link to Self-Worth

A woman's life can really be a succession of lives, each revolving around some emotionally compelling situation or challenge, and each marked off by some intense experience.

Wallis Simpson

Throughout a woman's life there are a series of critical moments that ultimately shape the way she will see herself and her body as an adult. When I interviewed Dr. Laura Ellick—a Long Island psychologist specializing in body image and eating disorders (see Chapter 20 for a summary of the interview)—I asked her about those moments. She made me aware of several things. For one, I hadn't realized just how early our ideas about our bodies begin to form. Dr. Ellick also helped me reflect on this important consideration: more often than not, the messages girls receive about their bodies are negative, or stem from a place of fear. There is much less that is discussed about the power of our bodies, the amazing beauty of a woman's body in its ability to create and sustain life; instead there is more, so much more, that revolves around what she calls "shaming."

Following is a brief overview of some of the important moments in the life of a female, times when she receives messages that will directly influence how she feels about her body for years to come. It is important to note that while these experiences may vary from one person to another, and from one culture to another, there remain common threads that distinguish the experience of girls from that of boys. To further add to the dynamic, Dr. Ellick notes: "Body image is frustrating in that it is never stable; a woman's body image is always changing."

As a Child . . .

. . . the focus is on what her body can do. Development speeds along. Every day, it seems, she learns new skills, gathers more strength, finds her balance, and this body is her means of exploring and interacting with the world around her. As she develops her ability to use it, she gains independence. Walking means she can reach new spaces. Running means she can break free from those who would hold her back. Successes are things to celebrate, like feeding herself and learning to dress herself. But somewhere around three or four years of age, she might begin to explore new areas on her body.

Children commonly identify the source of pleasure that is the genital region at this early age. And how parents react to this discovery can forever shape their ideas about that part of their body. Body shaming is what happens when a parent finds their child exploring this region of her body and reacts with panic,

anger, and/or discipline. Dr. Ellick says that parents should learn to react in a nonshameful manner such as calmly informing a child, "That's something we do in private." But more often the reaction is less calm and much more frightening.

As a Teen . . .

. . . puberty is a source of embarrassment for a girl, particularly if it comes early. She becomes the subject of all the boys' stares. Her changing body becomes the subject of negative attention. Other girls, jealous of her development, may treat her cruelly. If her parents haven't taken the time to make her aware of all the changes about to take place, getting her menses could be a traumatic event. And just as damaging, if a parent has presented her menses as a "pain in the ass," something to be loathed, something negative, rather than as a normal sign of womanhood, she may begin to resent the changes her body is forcing her to endure.

"Bodies change before the emotions catch up," Dr. Ellick points out. As a young teen she may not be ready to deal with all the changes that are happening to her; more than likely, she's also ill-equipped to handle how others react to her body . . . so she may come to believe that her body is something abnormal, something that needs to be hidden.

Dr. Ellick says during these years it is common to see the start of eating disorders. "Eating disorders such as anorexia," she says, "are an attempt to stop development because it's way too scary. Development is normal, but we treat so much about it as abnormal." And this cultural attitude severely affects young girls.

Statistics on Anorexia among Girls

According to the National Association of Anorexia Nervosa and Associated Disorders website:

- Anorexia is the third most common chronic illness among adolescents.
- 95 percent of those who have eating disorders are between the ages of 12 and 25.
- 25 percent of college-aged women engage in bingeing and purging as a weight-management technique.
- The mortality rate associated with anorexia nervosa is 12 times higher than the death rate associated with all other causes of death for females 15–24 years old.

In Her Twenties and Thirties . . .

. . . a woman may face the challenge of finding a mate; the reality that she may never achieve society's impossible beauty ideals; scrutiny as she swims among the many other fishes in an overcrowded dating pool; marriage; and body-changing pregnancy.

"Every stage of development comes with some level of judgment," says Dr. Ellick. In this stage a woman is plagued with feelings of self-doubt and possible outright rejection. She may wonder: Am I thin enough? Pretty enough? Marriage material?

In Her Forties and Fifties . . .

. . . a woman faces menopause and maturing looks, but she may also mature in her way of thinking: she may find liberation in a wise and defiant redefinition of what it means to be sexy. Dr. Ellick makes an interesting point about our culture and its interpretation of growing older. She says, "Our culture tends to focus on the losses and the negatives. For women facing menopause, we focus on what we've lost—like the ability to have children," she says. "But what about what women gain? As a woman gets older, her children grow and become more independent, and she gains something exciting—the freedom to do the things she wants to do."

My experience with clients in their forties and fifties supports this notion. Many of my clients have said that they didn't truly feel sexy until they hit their forties and began, once and for all, to feel comfortable in their own skin.

"Sexy is a frame of mind," Dr. Ellick says, and photographers should be aware that behind every woman who walks into your boudoir studio there may follow years and years of cultural and physical shaming, the instinct to hide her body, and the idea that she is less than perfect as she is.

A Special Note on the Maternity Boudoir Client and Body Image

Speaking about a woman's ever-changing body, the maternity client comes to mind. I love it when a maternity client specifically sets up a boudoir shoot. That she's choosing a boudoir shoot as an alternative to a regular portrait session lets me know she wants to celebrate her body and the miracle that pregnancy represents. While this is all positive and good, the boudoir photographer must be aware that the client may still grapple with issues of body image.

In pregnancy, her normal hourglass shape has been inverted. While she may have cherished a narrow waist and curvy hips, her belly now steals the show. Conceptually, a maternity boudoir shoot seems like a great way to say, "I still feel sexy!" But realistically, the images may tell a different story. The photographer must take every step to ensure that the beauty of pregnancy is captured and that the client's beauty and femininity are preserved.

Following are a few points to consider:

- Timing of the maternity boudoir shoot should be carefully considered; do it too soon and the client could look as if she's merely got a fat tummy and you could deflate her confidence; wait too long and risk that she might suddenly take on a lot of weight or the belly might become so large that it compromises her comfort and ability to hold poses. Know that any time she might start to retain water, which will make her face and limbs look puffy and make her feel unattractive.
- Maintain communication with the client and be flexible with the shoot date, as needed; sometimes clients assume they'll go all nine (more like ten) months, but end up delivering early. Keeping the lines of communication open will ensure the shoot takes place at the best possible time.

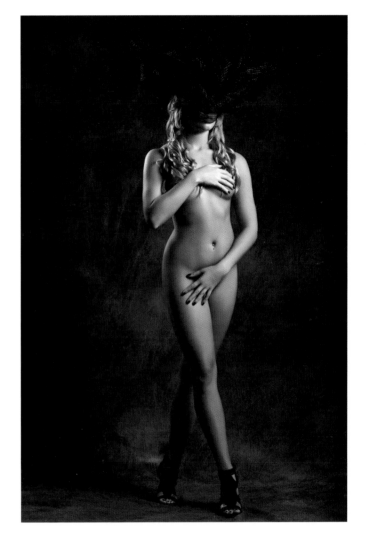

- Clearly communicate about how much skin she wants to show; sometimes as bellies grow, the maternity client can suddenly find herself with angry red stretch marks and feel insecure about them. Work together to arrive at the best possible scenario for flattering images.
- Be prepared to give her lots of breaks; pregnant women use the bathroom . . . a lot!

- Study poses for the pregnant body to ensure flattering angles for her face (which may have recently developed a double chin) and expanded midsection.
- Keep her focused on the beauty of what her expanding body represents and she'll feel beautiful and just like a goddess!

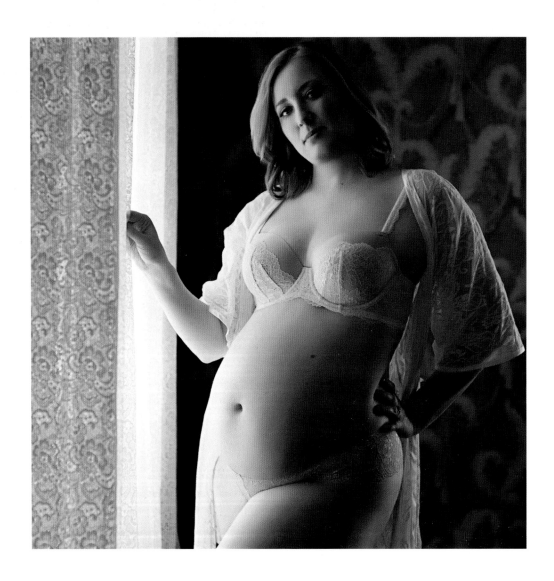

An Interview with Candace

My client Candace was diagnosed as a child with body dysmorphia. To her, the idea of a boudoir photo shoot was terrifying, but she was brave in facing her fears. And when she provided me with permission to tell her story, I felt so inspired by her strength.

What motivates you to pursue a boudoir shoot right now?

I have never had a positive view of myself. In fact my self-esteem was nonexistent. Everybody always tells me how beautiful I am, but I never believe them. I have gone through serious episodes of depression and self-loathing. As a child, I was even diagnosed with Body Dysmorphic Disorder, which means I truly do not see what others do . . . I don't feel beautiful and I believe all women should feel beautiful. It certainly doesn't help that I'm a fuller-figured female (who by the way comes from a family of skinny minis) . . . As a woman in her thirties I needed to change this. I figured boudoir photography would hopefully make me see myself in a different way, that it would capture my beauty so I could see it. This decision was tremendous for me. The fact that I now had to trust someone enough to take flattering photos of my larger body was terrifying. Improperly taken photos can be harsh.

Heading into your shoot, what concerns you most?

Ugly photographs that will make me regret my decision to try and capture my beauty. Also that the photographer is going to be judgmental and make me feel uncomfortable.

On a scale of 1–10 (10 being most confident) how would you rate how you feel about your body?

1. I cannot believe I am as beautiful and astonishing as a skinny person. *(Post-shoot she indicated an 8.5, saying: This journey has been eye-opening for me. A true learning experience. Not only did I accomplish the goal I made to gain confidence, I learned that you do not have to be a size 2 to be sexy. Originally I told [my husband] he would not get to see my photos. When I was done reviewing the photos I kept thinking, I couldn't wait to show him. So it turned out that it was not only a precious gift to myself, it was a gift for my husband and marriage as well.)*

What three words would you select to describe the look/feel of the images you hope to create?

Sensual. Confident. Beautiful.

What specifically might the photographer do to help you feel more comfortable and confident heading into the shoot?

It is important that you have a positive and understanding photographer who takes it slow. Slowly peeling the layers of defensiveness away. Honesty as well, being open to the fact that certain positions are unflattering to specific body types and certain positions make those nice body parts "pop."

Please share any other insights or information about your thought process, fears, hopes, etc.

I hope the photos don't look generic and staged. It terrifies me that the photos are going to be unflattering and make me feel even worse about my self-image.

Some clients describe the boudoir experience as a roller coaster of emotions. Was it so for you?

Once we started I was so insecure and embarrassed at how I looked in my first outfit. It was tight and showed all of me . . . after a couple of shots she showed me what I looked like on the screen of her camera, I was in awe of what I looked like. She had captured raw beauty. I could not believe what was not focused on. I couldn't see any of the things I am insecure about, no huge stomach, no fat thighs, no double chin. She had guided me on where to put my hands, on how to curve my hips and where to direct my face and it made my insecurities disappear. It was magic.

Once you saw the images from your shoot, what was your reaction? Did they capture the three words you identified?

When I saw the images I was speechless, completely stunned. They captured everything I wanted and more than I had ever wished. I had tears in my eyes, literally. I could not believe I looked so good. As shallow as this may sound, it really changed my view of myself. I now feel confident and beautiful.

Anything else you wish to share . . .

My boudoir shoot has taught me so much. I learned that I am a strong and beautiful full-figured woman, that you don't have to look like a flagpole to be sexy and seductive. I own that feeling now and am so proud of that.

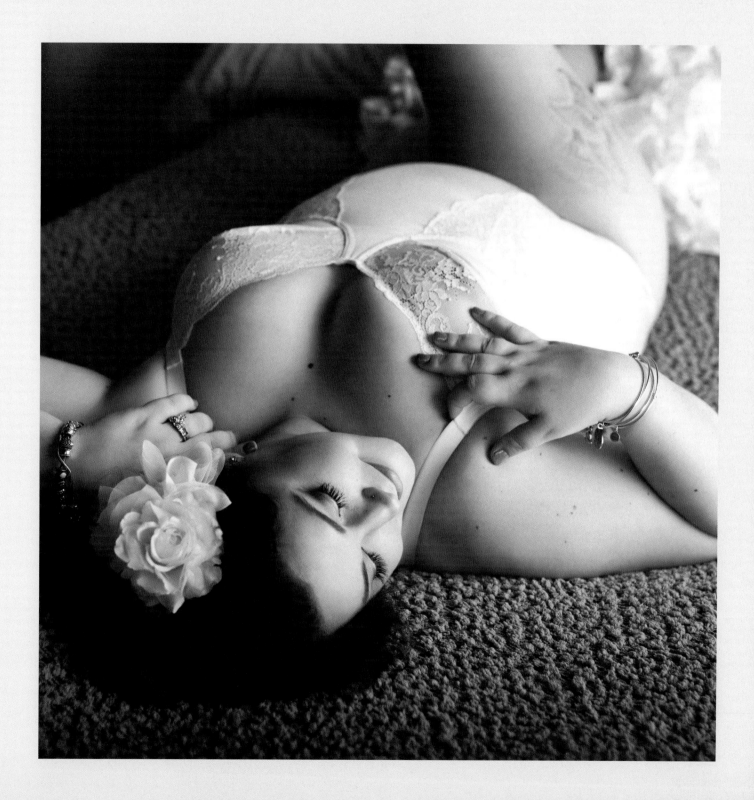

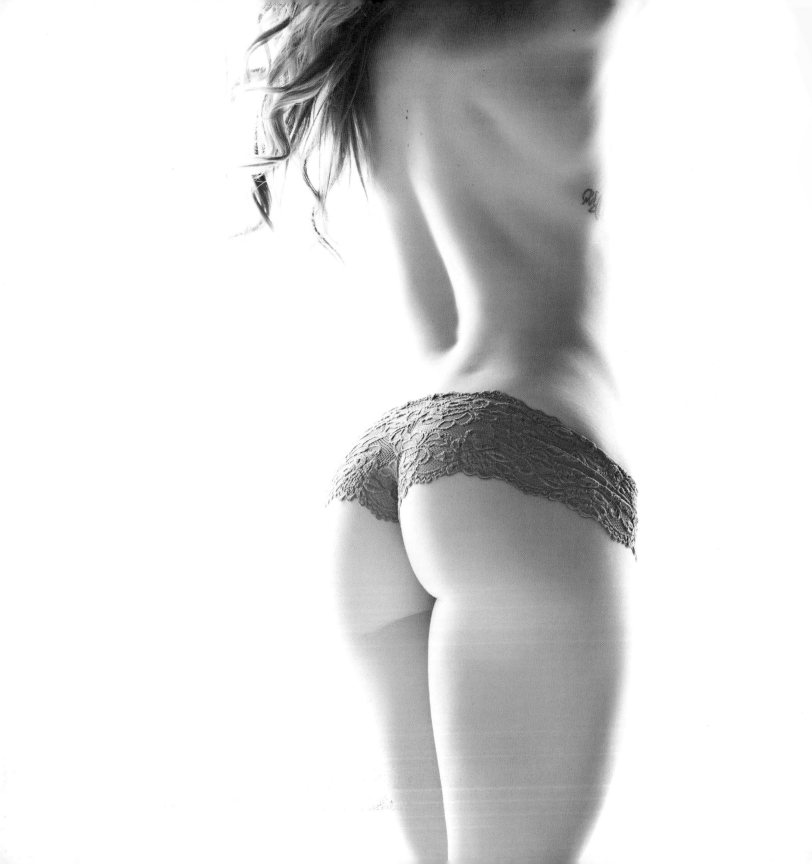

9

The Shoot
The Beginning of Her Transformation

I am woman. No disease, weapon, or wound can take that from me.

Jan Greenwood, *Women at War*

It's finally here. Her big day . . . and your opportunity to shine and validate her decision to work with you. Assuming all has gone well up to this point, she will arrive anywhere from a wee bit nervous to insanely nervous—either way it's quite normal. Put yourself in her shoes and imagine standing in your skivvies before a stranger wielding a camera. Ummm . . . yeah, most of us can imagine how uncomfortable that would feel. Thing is, no amount of planning can ease her nerves and allay her fears. It's just something she has to work through, all part of the process. It *is* your job, however, to make sure you create an environment that begins to relax those nerves from the very second she steps into your space.

You will know that you've done everything right up to this point if, despite her nerves, she reacts to your presence as if it is a welcome source of comfort. Think of it this way: assuming this is her first time doing a boudoir shoot, you could be the single *known* element in a situation that is otherwise overwrought with anxiety-producing unknowns.

How you welcome her into the experience can directly affect her ability to manage the fireworks going on in her nervous system and put out the fires raging in the pit of her stomach.

Even if she looks calm and relaxed, don't make the mistake of reading it as an indication that everything is just fine, that she's a cool cat. She may just be hiding it. I've encountered many women who'd appeared super relaxed walking in, but who later confessed they sat in their car for about 15 minutes prior to making an entrance, debating whether or not they should drive off and call me with some emergency as an excuse for bailing.

It was about a half hour drive to the studio and the whole half hour I was questioning myself about what possessed me to do this. When I finally arrived I actually sat in my car for a while debating whether I should go in or not. Well I did. My photographer, Susan, was so down to earth and comforting. She understood that I was so scared and reassured me that I could do this.

Candace (read her client interview in Chapter 8)

Make it your goal to extend a warm welcome to each and every client and immediately foster a "hanging with the girls" type of atmosphere so she can settle in and begin to feel like a member of the team. Albeit a VIP member!

Pampering Should Begin Immediately

Most clients will arrive at your studio weighed down with duffle bags, clothing on hangers, boxes of shoes, a handbag, and more. The first order of business is to relieve her of the burden of all her stuff. Take her jacket and hang it neatly. All the while, engage her in chitchat about other things to keep her mind off of the immediate reality—she's arrived for a boudoir shoot. Chitchat is super important because it also gives her the opportunity to re-establish a connection with you now that you're together in person. Whenever possible, make sure the makeup/hair professionals are also available and involved so that their bonding can begin immediately.

Find out if there is anything you can do to make the client feel more comfortable. Maybe she's just had a long drive and desperately needs to use the bathroom but feels awkward about asking. Maybe a glass of water or a cup of tea would be appreciated. Even if she has no requests, she will appreciate the inquiry. Making the inquiry will communicate the message that this experience is indeed all about her, and at the same time validate that, for the next however many hours, she is in good hands.

It is important to note here that your makeup/hair team must absolutely without a doubt personify the experience you wish your clients to have. Their personalities will undoubtedly reflect on you.

Whenever I interview new prospects for hair and makeup, I tell them: "Your talent at your profession is only half of the equation in determining if there's a fit here; the other half is how you engage with the client." I will always test a makeup or hair professional on a creative, nonclient gig first. It's a critical step because it's not all that uncommon to find that while a professional may be really great at what she does, her personality or manner of interacting with her subject may not be a good match. Maybe she's too quiet and doesn't engage with the subject enough—which would spell disaster for a nervous client who's left to sit with her ever-building anxiety. Or maybe her communication skills aren't the best in that she doesn't let the subject get a word in edgewise, or she interrupts constantly, or she feels the need to best her subject on every topic that comes up. Or worse, maybe she doesn't really listen to what the subject is asking for, what the subject describes as her preference and aesthetic, or when the client politely tries to provide constructive feedback about what she'd rather the artist modify. All of these are characteristics I've encountered in otherwise talented artists. But talented or not, these traits mean the artist is, ultimately, not a fit for my business.

These are some characteristics I've found to be invaluable for work with my boudoir clients:

- warmth;
- ability to engage the client quickly in effortless discussion;
- empathy for the client and ability to address and ease her anxiety;
- expertise in soliciting client aesthetic, preferences, style requirements/wishes/wants;
- ability to integrate client's vision within artist's expertise;
- excellence in hair and/or makeup (licensed pros);
- deep understanding of what's required for camera—what shoots well, what will last through the shoot (applying makeup and hair for an event or wedding is very different from applying makeup/hair for a photo shoot);

- ability to communicate the above difference to clients who may not be familiar or experienced with styling for camera;
- effectiveness at soliciting and responding to client feedback;
- graceful acceptance of constructive feedback;
- efficiency (able to adhere to my working timeframes);
- flexibility—able to work with a diverse clientele who vary in terms of age, race, ethnicity, sexual orientation, and culture.

I will commonly observe a new artist a few times or quietly listen to the dialogue that takes place between my client and the new artist until I have confidence in her ability to handle a range of situations appropriately. It is better to interject and redirect as appropriate than to have to back-peddle and try to undo any potential damage that might have been done. I also make it clear to my artists that I am to be consulted immediately if they should ever encounter a situation that might result in a client being less than 100 percent happy or confident. Sometimes I can be helpful to the artist by merely serving as a second voice on an issue—such as when a client unfamiliar with makeup for camera doesn't understand why makeup must be applied in a particular way. Hearing that second opinion from someone the client trusts (she's seen my images and knows the quality of my work) is often enough to allay her fears. And I am aware that my client may be unsure about whether or not she can trust this artist whom she's never met and whose work she may never have seen.

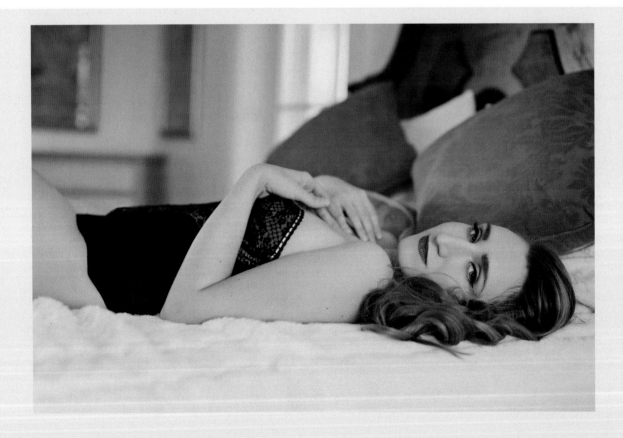

An Interview with Dominique

Owner of a vintage clothing shop, Paper Doll Vintage, Dominique has a unique sense of style. I invited her to participate in this project, knowing that, like many women business owners, she seldom takes the time to allow themselves to be pampered and celebrate their femininity.

What motivates you to pursue a boudoir shoot right now?

I'm not always in touch with my femininity because I'm so caught up in work. My career revolves around making other women feel beautiful and I often don't take the time to do so for myself. I know seeing your photographs of me will make me feel beautiful, sexy, and feminine when I usually am on the other end of that dynamic . . . I love the idea of being in a piece of art.

Heading into your shoot, how would you describe how you feel?

I feel excited and nervous! I know I'm in good hands with you and that the pictures will be beautiful. I love getting dressed up, made up, and posing . . . But I'm nervous about having gained some weight recently and not being prepared enough for the shoot.

On a scale of 1–10 (10 being most confident) how would you rate how you feel about your body?

I would rate my body at a 7. I really appreciate my body because I'm healthy and it's the body that allows me to do everything that I do. *(Post-shoot she indicated an 8, saying: "I do feel more confident after the shoot. I saw that gaining a little weight didn't make me look any less feminine or pretty.")*

What three words would you select to describe the look/feel of the images you hope to create?

I would like my photographs to convey my love for **vintage** and classic glamour, to be **playful**, and to convey my love for **adventure** and risk-taking.

Some clients describe the boudoir experience as a roller coaster of emotions. Was it so for you?

I loved getting my hair and makeup done because that's where the transformation begins. Once I had my hair and makeup done, it allowed me to feel comfortable posing.

Once a makeup and/or hair artist has transformed my client's appearance, I will check in with my client more than once. I will check in with her while she is still seated with the artist(s). And because my artist(s) may or may not remain in the studio while I am shooting every client, it is important that I check with the client once more, privately, to be sure she is fully satisfied with her look. I present any complaints or requests for tweaks made privately by my client to the artist(s) as *my* concern or request. Presenting it this way "saves face" for my client and allows her to comfortably resume working with the artist in question until the desired look is achieved. It also has the effect of further bonding us, making her feel I am on her side and that I have her best interest at heart.

As a final note on makeup and hair artists, please remember that the list of invaluable characteristics mentioned above is directly relevant to the nature of boudoir as I define it; to the needs of women going through the boudoir experience as I've experienced it; but also to the culture of interaction I've established as part of my business brand. In assessing the type of experience you want to provide your client, you may wish to modify or add to the list so that it will reflect your specific goals and brand.

The Client's Emotional Needs during Transformation

The first anxiety-filled step for your client was making the phone call to you to inquire about your services in the first place. Once you sold her on your services and your ability to deliver great images via an unforgettable experience, she has been on a roller coaster ride of emotions. Sticking with that analogy, her arrival at your studio on shoot day is like approaching the highest climb knowing that it is to be followed by the steepest drop. Her anxiety has probably been building for days. She may not even have eaten that morning for fear of looking puffy during her shoot. And if she has been sneaking around gathering clothing items and props for her shoot, and telling little white lies about where she'll be for the next few hours, she may be somewhat stressed out and exhausted from all the superspy logistical moves that ultimately enabled her to be right where she is now: in your studio.

Now add to that your likely request that she show up with a clean face (no makeup) and her hair undone. Doesn't exactly make for the most confident woman now, does it?

Your client will need to be made to feel that embarking on this journey was the right step. That choosing you and your team was the right decision. That trusting in your makeup and hair team will make her more beautiful than she's ever looked. And that working with you will result in images more beautiful than she could have ever imagined.

She will want to know that her unique beauty will be seen and celebrated: that her best features will be expertly highlighted and that her imperfections will be masked. She will want to feel comfortable sharing her concerns about her facial features, hair, and insecurities about her body. And she will not want to be judged.

She will want to make known the unknown: be told what to expect; be given an overview of how the day will go; and be assured that she will be guided throughout every step. And your makeup/hair team plays a critical role in delivering all of these things.

While I work with a few different hair and makeup artists, I do have a lead hair and makeup pro who is my go-to first and foremost every time I book a session. Having her as my lead means having a partner who is intimately familiar with my process, my manner of conducting business, and my brand, and who can therefore answer most questions my clients may ask.

I make it a practice to also provide a boudoir photography experience to the pros with whom I regularly work. And I encourage them to share their experience with each client early on. This strategy accomplishes several very important things:

- It enables the artist to speak firsthand about her own experience as my boudoir subject, and therefore lends way more credibility to anything she says about the experience.
- It serves as something the artist and client have in common and helps them to bond quickly.

- It gives the client permission to ask the makeup artist questions about me or the experience that she might not have otherwise asked.
- It provides a full arc to the boudoir photography experience— the stylist is able to share her own roller coaster ride of emotions and assure the client that the artist also felt as the client does now sitting in the makeup chair, while, more importantly, emphasizing and shifting focus to the positive outcomes.
- By sharing the positive outcomes from her experience being a subject for my boudoir photography, she is going a long way toward helping the client transform her feelings of nervousness back to excitement.

This strategy is so effective that nine times out of ten, by the time my client is done with hair and makeup, she is an altogether different person!

Whereas she may have walked in shy, reserved, and a bundle of nerves, she is now a bubbly and enthusiastic bundle of energy ready to get going with her shoot!

Things to Watch For

As you can probably already imagine, the transformation stage of the shoot is a very delicate and important time. Just as first impressions are everything, so it goes with your client's first step into your studio. Your client is likely drowning in waves of emotions like anxiety and self-doubt upon arrival, so every detail of your environment and interactions must be aligned to make sure the emotional flow travels in a single direction: toward the calming waters of trust and confidence.

Following are some things to watch for at this stage:

- Ensure the studio environment does not make the client feel exposed or like she's on display (result: if you don't, the client may feel uncomfortable and mention this when sharing her experience with others).

- Be sure the client's expression of concern or anxiety is met with empathy, so she doesn't shut down (result: if not, the client may remain guarded throughout the shoot).

- Ensure the makeup/hair team engages the client during the transformation, so she heads into the shoot feeling better than she did when she arrived (result: if not, the photographer may have to spend a lot more time trying to get the client to relax and ease into the process).

- Ensure the client's aesthetic and style preferences are consulted so the makeup/hair team doesn't waste time having to fix things (result: if this happens, the client may lose confidence in the team and possibly in the studio overall).

- Be sure the client likes the hair/makeup and has the opportunity to provide feedback at several junctures so she doesn't proceed into the shoot unhappy with how she looks (result: if she remains unhappy, regardless of the photographer's approach and talent, the client may very well not like any of the images).

It is imperative that all members of the studio team work together to address the emotional needs of the boudoir client. For the photographer, part of the focus is on ensuring your hair and makeup team is equipped with information, tools, and experiences they can use to anticipate and address your client's emotional needs so that you can carry on the work of making meaningful images.

The Idea and Importance of Privacy

On shoot days, there is no one else present in the studio aside from the makeup and/or hair pro. No random people wander in and out of the makeup room while my client is getting ready. In fact, I even step out of the makeup room and into the studio (which is separated by a door) while they're working on her transformation. I may check in once or twice briefly, but the goal is to ensure that there are never extra eyes on my client when it's not absolutely necessary.

This focus on privacy even extends to the type of space I chose for my studio. There is no storefront or signage announcing that she is entering into a boudoir photography studio. And I do not list my business address online, not even on my website, to further guard the privacy of my clients.

When my clients enter the space, they are entering the feminine equivalent of the man cave—and this further adds to the playful mystery and secrecy that so often surrounds the boudoir experience for women. Even lighting is kept soft. Instead of using the overhead fluorescent lights so common in commercial spaces, I have lamps strategically placed to spread soft light and encourage relaxation and a comfy, homey feel. By avoiding bright lights, I enable clients to settle into the space and into the idea of being in this space in lingerie or nude without feeling as if they're stepping into a spotlight (which

would undoubtedly highlight all their flaws). The difference may seem insignificant, but it's really huge. Imagine standing nude before someone in a room where there's a single soft lamp on in the corner versus standing nude in a clinical environment where everything is really white and super bright. Now while ideally you might not opt for either scenario, I'm thinking most people would probably choose the first scenario over the second.

Soft lights, camera, action . . .

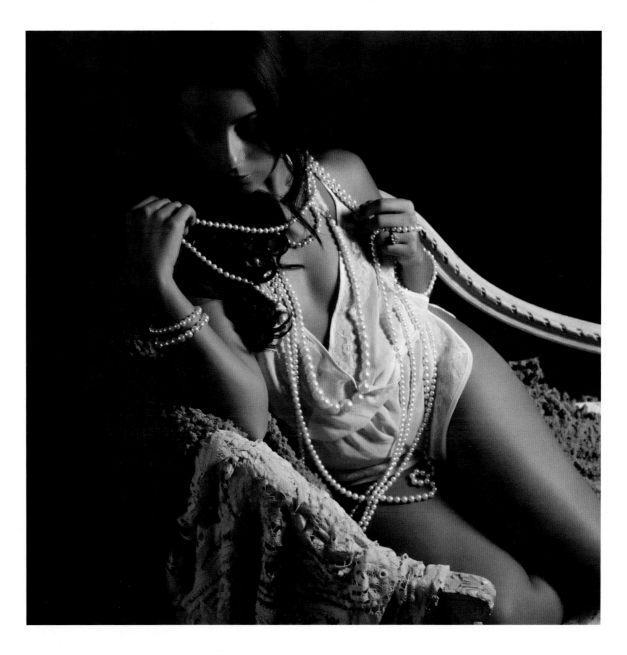

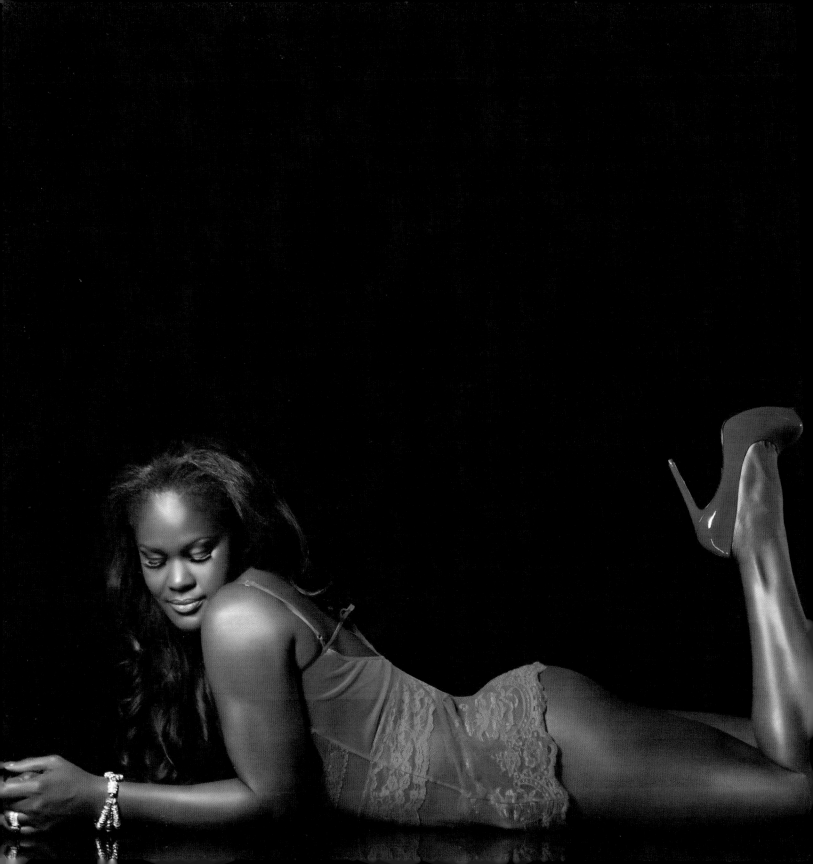

10

The Shoot
Preparing to Address Your Client's
Emotional Needs during the Shoot

The body doesn't know how to lie.

John Suler, *Photographic Psychology: Image and Psyche,* on how photographers can benefit from learning body language patterns

Understand Her Emotional Needs at This Stage

Sometimes prospects will follow me for years before they ultimately take the next step and sign up for a session. When they confess they've followed me for years, I like to ask what held them back for so long. The answer is seldom something as concrete as finances. More often than not, it pertains to their complex inner world of emotions:

- lack of self-esteem—will they look okay in front of the camera given their age, weight, etc.?
- lack of confidence in their abilities—will they know how to move and pose?
- self-doubt—they don't often see someone who looks like them (their age, size, or ethnicity) in magazines or in boudoir photographer portfolios;
- lack of self-worth—they don't feel they deserve to spend time, money, and attention on themselves, and on looking and feeling attractive.

Being aware of the potential and power of these internal struggles can make you a more supportive and successful photographer. So let's take a closer look at each of these emotional needs your client may bring to the shoot.

Wanting to Feel Sexy Is Not Silly

Heading into her shoot your client needs to feel that she's not silly for wanting to feel and look pretty, feel and look sexy. If you're new to boudoir or women's portraiture, you may wonder if this is even an issue, but I assure you for many women it very much can be an internal struggle. In our society, women are taught to be good mothers, great wives, and capable employees. The right to feel and be sexy is reserved for professional lingerie models, actresses, and celebrities. So we think. We ordinary women are expected to put the needs of others first. There is a tremendous amount of guilt that enters into a woman's mind along with the thought that she might invest time and money into feeling good about herself. Whether these needs are spoken or unspoken by your client, addressing just how natural it is for every human being to want to look and feel attractive can go a long way toward easing any internal strife she may be dealing with during the shoot.

She Belongs before the Camera

Your client may also need to know that whether or not she looks like a supermodel, she belongs right there, in your studio, and in front of your camera. I keep a gallery of images in my

studio—mounted on a wall, and also in easels on a table by the entrance to my studio. I want my clients to see the diverse range of everyday women I shoot. Not all women allow me to post images online, so this display area becomes especially important. Without having to verbally address it, my clients are able to see for themselves that their age group, ethnicity, shape, and size are represented among the beautiful women I am proud to have worked with and therefore display.

You See HER Beauty

Sold on your talent, your client needs to be assured that you will see *her* beauty, and that you will be able to capture it. Talented photographers have the gift of sight. They see how golden light transforms even the most mundane objects into visions of beauty, and how shadows can sometimes bring magic to a scene that would otherwise make for a boring image. Boudoir photographers have to have that gift of sight. You must be able to look at every single woman who walks into your space and see what is beautiful about her.

Only if you see her beauty can you capture it . . . and once you capture it, you'll be able to show her how beautiful she is.

I am so flattered every time a client says, "Every woman in your portfolio looks so beautiful. I want to see me the way I know you will see me." Or "I've never felt pretty a day in my life; now that I see what you see, this is the first time I've ever seen myself as pretty." I also love the challenge some clients present when I tell them they're beautiful and they insist I *have* to say that, implying I'm not being genuine. My response is always the same: "Fine, you don't have to believe my words. Soon enough I'll prove it by showing you with the images I take." And then I do!

She Can Rely on You to Be Her Guide

An immediate concern you can quickly address once you get going with your shoot is this last point: your client will need to know that she can rely on you to guide her in flattering poses that will show her in her best light. Make sure to ask her early in the process about her likes and dislikes regarding her body and then shoot her in a way that highlights the features she appreciates; this will convince her that she is safe in your hands. Don't miss the important step of checking in with her by showing her images—doing so will allay any fears about whether or not you are shooting her in a flattering way.

Make Her Comfortable

Once your client has been transformed with expert makeup and hair styling, she's aware it's now go-time. She's likely giddy with excitement but equally anxious about performing well in front of the camera. I ensure her comfort by attending to the details:

- I am aware that, for many first-timers, studio lights and sets can be daunting to say the least, so I ensure there is separation between the prep and studio areas (in my studio they are two separate areas). Even if the separation comes in the form of a thin, strategically placed sheet of seamless

background paper, introducing her one step at a time into the boudoir experience can help keep her jumpy nerves in check.

- I ease her into the studio experience by showing her how the sets we created conceptually up to this point have come to life. This makes the direct connection, yet again, between her vision and how it's come to fruition. The unspoken message is: you've trusted me to understand your vision up to this point, and here we are—you can see it's come to life

. . . now you can also trust me to guide you through the shoot.

- To enhance the "at home" feeling of the studio, I will always ask a client for one or two musicians or bands I can punch into Pandora so that her music preference will serve as a familiar backdrop, and set the emotional tone, for our work.
- I engage her in a discussion on shoot strategy and review her clothing, accessories, and props to make any final tweaks.

Quickly Build Her Confidence

In the last chapter I mentioned a client who'd had her boudoir images shot by her wedding studio and, after weeks of waiting for her reveal, finally saw them and hated each and every one. I wondered, what went wrong? And then I shot her and realized how surprised she was that I was asking for feedback at important junctures on each and every set. According to her, the wedding studio photographer never showed her a single image during their shoot.

I am aware that some photographers choose not to show images to the client during the shoot. Though I have to say, I'm not sure why they make that decision. As I see it, showing images to your client from time to time as you progress through a shoot builds her confidence like nothing else can. It also accomplishes many other great things:

- It helps the client see how a set or environment is translating on camera; particularly during studio shoots, I am aware that clients don't always have the whole picture in their heads

when they first see the sets I've created because lighting is such an important element. Once lighting is in play, the sets come to life. There's no way for a client to understand how a particular set will look on camera unless she gets a peek.

- When helping clients settle into flattering poses, I often find myself repeating the same guidance as people have a tendency to do certain things over and over again (e.g. make fists of their hands, keep their shoulders high, cock their head to the side, place their arms tight to their sides); showing them the effect of their habit on camera provides a deeper level of understanding and inspires them to discontinue whatever unflattering behavior they have a tendency to repeat.
- Seeing is believing: a client will feel unsure about how she's looking—no matter how many times you tell her she's doing great—until you show her a gorgeous sample image.
- Some poses feel awkward and clients can't imagine how they are going to look good on camera . . . until you show them; this also builds trust, and they will be much more likely to follow your direction without question going forward.

- Clients can sometimes seem distracted or they won't emote especially well because they're caught up in negative internal self-talk. Showing them stellar images in camera can help them quiet that internal voice and prove it wrong.
- Showing her images and getting her real-time feedback keeps her an active partner in the shoot experience—as an active partner she will feel she played an important role in the outcome (i.e. great images) and be more invested in the resulting images.

- Getting her real-time feedback also gives you valuable feedback about how she sees herself and her body; it provides great information that can help you tweak your angles, lighting, or other elements in order to ensure her greater satisfaction with the images.
- Lastly, showing her how great she looks in camera will build her enthusiasm and excitement, spark her creativity, and validate yet again that she made the right choice in hiring you to shoot her boudoir images.

Make Her a Co-creator

From the very beginning of a client engagement my goal is to make the client a co-creator or partner in the process. The shoot is no different. I will ask the client before switching to another set if she feels we've fully explored the one we're on. I will pay close attention to her verbal and nonverbal cues, and if I suspect she isn't 100 percent thrilled about a particular set, lighting style, or outfit choice, I'll ask her directly if she'd prefer to switch things up. I'll ask if there are any additional poses she'd like to try before we leave a set. And I let her know that if she has any ideas at any point, I'm open to hearing them.

Inviting my client to participate in the decision-making process as we go through the shoot confirms that my ultimate goal is to make her happy, that she is the center of the universe and the driving force for my efforts.

Approaching the shoot in this way increases her level of engagement, but, just as important, it also prevents any later surprises (e.g. *I didn't really like that set, or I don't like the images because I don't like the way that outfit looked on me,* etc.). Give your clients lots of opportunity during a shoot to share what they do like and also what they don't and you'll reap the benefits: higher sales, 100 percent satisfaction, and more referrals.

Use Humor as an Icebreaker

In my opinion, nothing relaxes nerves and tension like a good laugh. I'm no comedian by any stretch of the imagination, but I am playful, and I invite my clients to be

playful with me during the shoot. Sometimes giving a ridiculous voice to what you suspect is going on in a client's head can break a tense moment as she giggles

in recognition. Or rolling on the floor in an attempt to demonstrate a pose might give her permission to chuckle and feel something other than nervous. Also, if she's feeling silly and you're showing her it's okay to be silly, then suddenly feeling silly isn't such a bad thing anymore—it's playful banter between two friends.

You cannot deny the power of laughter as a universal bond from human to human and from human to sales order form.

Jeffrey Gitomer

When incorporating humor into a shoot, my goal is to find a way to elevate the client's self-esteem, shift her affect, increase the amount of energy she's putting into her poses and movements, or catch her off guard so that I might capture an authentic moment. While everyone reacts differently to humor, the one thing to be sure to avoid is making your client the subject of your humor.

Listen, Listen, LISTEN!

When I first started shooting, I would sometimes participate in group shoots and I would observe other photographers—how they interacted with models and each other. Even now when I participate in a workshop that involves shooting time, I will watch other photographers and how they work. One thing I've noticed repeatedly is that some photographers don't really communicate very well. They don't communicate what they're looking for to the models. And they don't really listen—to the questions their subjects ask and, equally important, to the nonverbal body language that may be speaking just as loud and clear.

Body language can speak just as loudly as words spoken out loud. In fact, given our tendency to soft pedal our words, I believe that nonverbals often speak louder! As photographers, we must train ourselves to pay attention to both the verbal and nonverbal cues our clients provide. If your subject looks tense or unsure . . .

Pause!

Put the camera down.

And talk to her.

If someone looks vacant or far away, I will not keep shooting. I will stop. Put the camera down. And ask, "What are you thinking right now? Where are you?"

Most often, once confronted, clients will laugh as if they've been caught with their hand in the cookie-jar. They'll acknowledge they were somewhere else or, worse, that their thoughts had wandered to a self-defeating place. This is very common. But it must be dealt with. "Sexy can't live in the same headspace with negative self-talk," I'll tell them. If they need an ear, I'll listen. Then, I'll suggest strategies for changing tracks.

Once my client manages to change the record playing in her head, we continue. But I remain ever vigilant—always attuned to her emotions and energy.

Know That Pacing Is Everything

For a long time, I resisted doing boudoir marathon day shoots or anything pertaining to high-volume shooting. As I saw it, it just didn't work with my business model. How could I provide a deep transformative experience in such a short period of time when the goal was to get them in and get them out? And then it hit me: first of all, not every client is seeking a deep transformative experience. And even those who are may want to dip their toe into the proverbial pond first and see how they might feel about returning at a later point to engage in the boudoir experience in a more meaningful way.

Deciding to give the shorter, less-intensive marathon experience a go, I realized I needed to be clear in presenting the two different kinds of experiences to prospective clients:

- The mini shoot provides a quick, yet compelling peek into the boudoir experience.
- The full shoot is designed for the woman who wants to go all in, enjoy the full experience, and is willing to invest lots of time, energy, thought, not to mention funds, in co-creating an experience that will be a one-of-a-kind and have tremendous meaning and value for her.

When prospective clients call to inquire about a session at my studio, I take time to carefully explain the difference between these two experiences. Often, a prospect who intended to sign up for a mini shoot will change her mind and opt to go for the full shoot once she's heard my description of both. Sometimes she's moved by the passion she hears in my voice and the stories I share; she comes away with a clear understanding of just how powerful the boudoir experience can be, and she learns what drives me: my mission to provide a meaningful experience to each and every one of my clients. She then decides she too deserves to have that kind of meaningful experience.

Pacing for Longer Shoots

Pacing is particularly important for clients who engage in a full shoot. While my tendency is to start slowly and spend more time on our first set in order to help my client acclimate, I also recognize that each and every woman is different. Some will have a limited attention span or tire easily, and others will take longer to warm up and get past the nervous jitters. Ideally, however, I will start slowly, allowing her to relax and enjoy the experience. My aim is to shoot around two hours in order to cover a range of looks and poses across four sets. Sometimes, however, we'll run over, although once we hit the two-hour mark, I know our time is limited. She will begin to feel emotionally and physically exhausted at this point. And I never want her to get to the point of exhaustion.

I remain hyper-attentive during the shoot, checking in as needed. And I design the experience so that it offers flexibility and readily accommodates the many different personalities coming through my studio door. I cannot emphasize enough how treating your clients all the same—with rigid standard formulas and limited flexibility—can hurt you more than you know, particularly when it comes to a niche as intimate and personal as boudoir.

Pacing for Shorter Shoots

Even clients who participate in the 45-minute mini shoots must walk away feeling they received more than they expected from the experience. Setting clear expectations early on in the engagement and reiterating mini-shoot day guidelines become especially important in achieving this. Time flies during photo shoots, so having well-structured mini sessions can make all the difference between a stressful experience and a rewarding one for both you and your clients. Unlike with full shoots, I am more of a director during mini shoots—we have a limited timeframe in which to accomplish the goal of having an adequate selection that is diverse enough that she can decide to upgrade to an album even if it wasn't initially her plan to do so. Providing clear direction and instilling confidence from the very beginning become highly important during mini shoots. She must feel from the start that she is in good hands and that the images you are capturing will meet her expectations. However, don't forget you must still partner with her. Allow her to provide feedback and make suggestions so she'll remain invested in the outcome and proud of your collaboration.

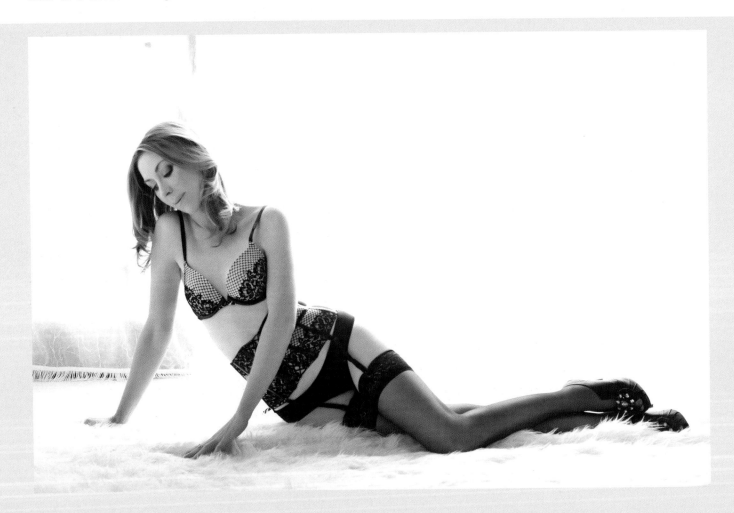

An Interview with Lauren

Lauren is a repeat client. While she remained in touch after her first shoot—which took place back in the days when I was shooting out of my living room—it was only during our second shoot several years later that we really deepened our connection and she opened up in a more meaningful way.

What motivates you to pursue a boudoir shoot right now?

My husband was one of the victims of 9/11. I was 37 with three children, eight, six, and two. As the years passed, the challenges just seemed to keep coming. A fire, serious medical conditions for myself as well as two of my children, seven surgeries between the three of us, estrangement from family, educational battles with the school. I was mom, dad, aunt, uncle, and grandparent rolled into one, fighting off the crises one after another, like Wonder Woman blocking blows with her iron cuffs. At some point I stopped feeling like me, stopped feeling like a woman and more like a frumpy old hausfrau. I had always been attracted to the sensuality of belly dancing and so I started dancing as a way to reclaim my femininity . . . I delighted in finding muscles I never knew I had and soon realized that I was physically and psychologically stepping into this sexy image I had of myself but had never really had the strength or conviction to claim. Boudoir seemed like a natural progression of owning and celebrating my sexuality.

Heading into your shoot, how would you describe how you feel?

Of course there's going to be a sense of trepidation. We women are constantly judged and valued by our appearance, even by other women. And as you emerge from the dressing room, scantily clad, trying to remember that you felt pretty and sexy back in your own bedroom, it's hard to not do an about face and claim temporary insanity.

What concerns you most?

I tend to photograph horribly. Really, I'm like a living caricature of myself. I was afraid I would look stiff, goofy, unattractive, clumsy.

On a scale of 1–10 (10 being most confident) how would you rate how you feel about your body?

Haha . . . is that naked or dressed? That's a question that changes so often . . . Our society practically demands that we women remain archetypical princesses and it's challenging to gracefully step into our queen. But I think for 51 I'm doing okay so I'll give myself a 7.

Aside from beautiful photographs, what else do you hope to get out of the experience?

I speak a lot about journeys and this session was a milestone along that path. It represented to me a shift from what I

was not to what I had become . . . a smart, witty, strong, sexy, confident, daring, multifaceted, empowered woman.

What three words would you select to describe the look/feel of the images you hope to create?

Sensual. Deep. Strong.

Some clients describe the boudoir experience as a roller coaster of emotions. Was it so for you?

When I emerged from the dressing room, the butterflies began. Was I being judged? Would I look silly? What if the images were downright awful? Susan and I had spoken at length before the shoot, and she was so sweet and authentic and laid back when I arrived . . . yet she works with MODELS, for crying out loud! Would she be fighting the urge to roll her eyes? Within the first few minutes of my session she had me relaxed and confident . . . and having fun!

What did the photographer do specifically that helped ease any anxiety or fears?

Susan began our session with a few test shots which she eagerly shared, exclaiming, "See how fabulous you look!" As someone who's last good picture was somewhere circa a 1990 wedding photo, she put my mind at ease because I really did look fabulous. Susan continued to offer positive, encouraging feedback during our session.

Are there any specific or recurring thoughts you remember running through your head during the shoot? How did these make you feel?

I imagine that every little girl wants to know that they are pretty. I grew up in a situation where when I asked, my face was dissected . . . my eyes were too this, my nose was too that . . . I often felt like a caricature of myself. I did have to remind myself that those were not my views. My thoughts of myself are different . . . kinder and more appreciative.

Once you saw the images from your shoot, what was your reaction? Did they capture the three words you identified in your pre-shoot questionnaire?

Really, I was blown away. And there was such variety. I was strong, sexy, flirtatious, passionate, vulnerable . . . the real me shone through . . . I didn't want to part with the book! As a single mother, my efforts and resources are generally geared to the benefit of my children. It's easy to put aside my needs or to rationalize that they are not important . . . but they are. This shoot was a "bucket list" item, a reminder that I am a mom AND a woman. The photos captured a stage of my blossoming into myself.

Build Trust Throughout the Experience

Trust is a big word. It's critical if you are going to get the most out of your client during the boudoir photo shoot. And it's particularly huge when it comes to sales. Self-doubt plagues us women. You can see it when your

client second-guesses her outfit choices, expresses uncertainty about her ability to carry a particular pose, or asserts things like "I'm awkward; I have no clue how to be sexy!" Since she will likely not have a BFF by her side throughout the experience, she will need to rely on you for advice, guidance, and feedback. Her trust in you will allow her to do that comfortably.

Above all, she will need to trust that, throughout your interactions with her, you are being 100 percent honest and acting in her best interest.

But you'll need to make sure that everything you do maintains that trust. Although trust is hard to establish, it's unfortunately very easy to lose! Telling her she looks great when she's in a pose that accentuates her problem areas is dishonest. Allowing her to pose in an outfit that clearly doesn't fit her well is going to compromise her trust in you the minute she sees the images. Speaking negatively about a prior client will make her wonder what you'll say about her to your next client and will only raise her guard and/or keep her walls up. All of these things will work against you in your ability to build trust with your client.

When it comes to creating emotionally meaningful images in which she'll want to seriously invest, her trust in you is THE key ingredient.

Things to Watch For

During this important phase of easing our client into the shoot, we must:

- avoid dictating standard poses that do not accentuate the features she wishes to highlight;
- attend to verbal and nonverbal cues that indicate unspoken reservations, or lack of certainty about certain aspects of the shoot experience;
- obtain buy-in and feedback throughout the shoot;
- allow sufficient time for clients to acclimate to the shoot;
- show clients images in camera or as shot on a tethered monitor;
- address the client's emotional needs heading into the shoot;

- partner rather than direct;
- communicate honestly.

If our goal is to provide a transformative experience for our clients, and by doing so advance beyond the task of making pretty pictures toward the higher goal of creating meaningful images via a transformative experience, we need our clients to show up, be present in the moment, and fully engage in the experience. And this dynamic must be established from the minute she enters the studio.

If she merely shows up, follows your instructions, and goes through the motions, then you haven't met your goal. Not by a long shot.

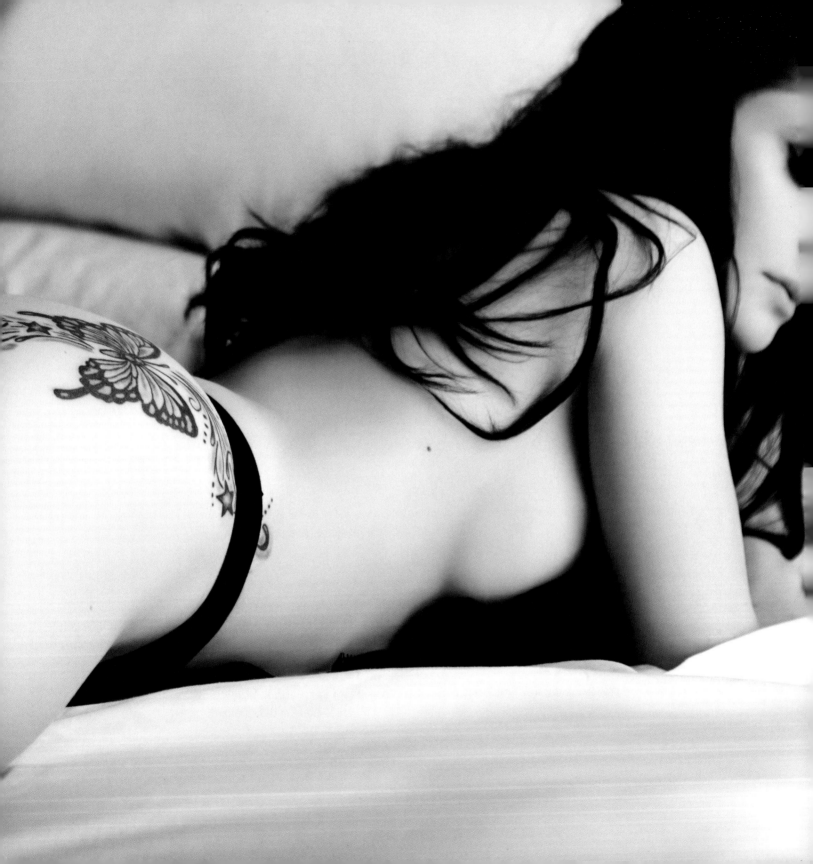

11

Evolution of a Shoot
Your Ever-Changing Role as the Emotionally Intelligent Boudoir Photographer

Too often we are so preoccupied with the destination, we forget the journey.

Unknown

As my client is busy changing into her first outfit within the privacy of our studio's dressing room, I am making any final preparations for the shoot: positioning lenses, memory cards, etc.—anything I anticipate needing during our shoot—so that it's all within reach. There is a rhythm and flow to each and every session, and while each may vary in terms of how much time the client needs to settle in, what her starting comfort level is, what her posing skills are, or what her emotional journey involves, there is a general evolution that takes place in my role every shoot.

When I interviewed the clinical psychologist and expert on body image Dr. Laura Ellick for this book (see Chapter 20) I described the evolution of the boudoir photographer's role as I experience it. "It's interesting how in several ways," she said, "it parallels the arc of the therapy session!" We were both surprised to learn how closely this evolution of the emotionally intelligent photographer followed the path of a psychologist engaged in a therapeutic session. And as she listened to the ways in which the emotionally intelligent boudoir photographer can transform throughout the shoot in order to accommodate the client's emotional journey, she then began to understand the therapeutic value and potential healing power of a boudoir

photography session conducted in the manner in which I describe.

Now, that said, an important point to make here is this: I am not asking *you* to be a therapist. Dr. Ellick clarified her thoughts on what she saw as a parallel by saying, "While you [the boudoir photographer] are not a therapist or providing therapy, your role is certainly therapeutic!" And herein lies the key difference. I am not advocating that boudoir photographers should suddenly step into the role of therapist for the client.

I encourage my clients to share their experience, thoughts, and challenges faced during the shoot with their therapists (if they admit to having one). And should I encounter someone who seems to struggle with a severely distorted or negative body image, I may gently ask if she's ever thought about chatting with a specialist.

I am well aware, however, that it is not within the scope of my role or responsibility to cure or fix my client. BUT, if I can provide an experience that boosts her confidence, esteem, self-image, and self-acceptance, then I have created something that is undeniably therapeutic, helpful, inspiring, and meaningful. And I'm totally okay with that!

The following sections describe the evolution of the boudoir photographer role as I experience it.

Stage I: Photographer as Instructor

In the beginning, I am the instructor. If she's never experienced a professional photo shoot before, I must be sensitive to and address the inevitable discomfort that stems from her lack of awareness and uncertainty about what to do, how to move, and how to position arms, legs, head, etc. Even if she has experienced a professional photo shoot before this one, I must never assume that 1) she remembers what to do, or 2) her prior experience has adequately prepared her to deliver on my expectations. So I start with the basics. And while I am doing so, I reduce the pressure for her to perform immediately by letting her know that I too am settling into the shoot—tweaking camera settings, for example, to arrive at the right look/feel based on our concept.

I will show her select images in which she already looks great, but I will direct her focus to the lighting, the depth of field, the set, etc. By bringing her into the decision-making process early, I am giving her an opportunity to focus on something other than her nerves. Of course, I am also well aware that in showing a preview of the set I am also allowing her to see how she's coming across in camera.

The absolute best thing to happen is that the very first shot is a total winner and that upon seeing the very first shot, where she already looks amazing, her nerves immediately and completely turn to excitement.

Throughout this first stage, I am tuning in to her emotional states. I will encourage her to label how she's feeling and what emotions she might attribute to the images I show her. I want to be sure that the emotions she identifies in the images I capture are reflective of her three words—her main goal for pursuing a boudoir photo shoot.

Stage II: Photographer as Cheerleader

As we progress, I become her cheerleader. I may instruct her less, but I am still sure to tweak her movements so that I can achieve flattering angles, emphasize the features she prefers to play up, while downplaying those she'd rather de-emphasize. My goal is to build her confidence and communicate the critical message "She's got this!" Once she begins to feel capable in posing and emoting for the camera, she is better able to let down her walls, reveal her true personality, and achieve her goals.

I continuously consider the information she's provided in the planning stage and use it to guide my captures:

• Who is she primarily doing this shoot for? (Sometimes it's for herself; sometimes it's for a significant other—be careful not to assume it's a man.)

- What does her significant other love most about her body?
- What does she herself love most about her body?
- Are there any particular tattoos or other features on her body she'd like me to focus on and highlight?
- Are there any parts of her body she'd prefer not to highlight?

Each step relaxed me . . . the makeup application, the photographer's experience showing through, and the professional boudoir sets. As we began . . . I seemed to emerge as the 60 year old sensual woman I had been feeling I was and in partnership with my photographer we were creating my photographs . . . I was both exhilarated and exhausted at the end of the shoot. It was rewarding work.

Barbara (read her client interview in Chapter 2)

Also throughout this cheerleading phase, I am providing lots of encouragement and feedback. I'm aware that she's reading me like a hawk whenever I pause to review my captures, so I am mindful of my expressions throughout. If something is simply not working, I enthusiastically shift away from what we're doing to something I think will work better.

She never needs to know that a pose, expression, or light setup didn't work.

Stage III: Photographer as Creative Partner

As my client settles in and finds her groove, I then become her creative partner. And here is where I find other photographers may sometimes miss the mark. If you see your client merely as someone you must direct, and you leave her blind to your process, your thoughts, as well as the outcomes, you are severely limiting the extent to which she can emotionally engage in the experience. While you are busy playing the puppet master, she has no choice but to play the role of the puppet. And as we all know, puppets don't think or feel.

They simply do what they're led to do and move as they're made to move.

This is so important: if you want your client to be emotionally engaged in the process, you must enable her to become a partner in the process.

We will expand on this in the next chapter because it is a critical point.

Stage IV: Photographer as Friend

By the end of the session, if I've managed to establish a strong connection with my client, I transcend the role of instructor, cheerleader, and partner. I become something far more valuable: a trusted confidante, a valuable guide, a supportive coach, and an inspiring mentor, someone they just might want to call a friend.

As clients go about the difficult psychological work of breaking down their internal walls and facing down their insecurities and vulnerabilities, they require support and a kind voice. If in you they find that inspiring voice of support, it is not uncommon for clients to open up about their personal lives, their struggles, their fears, hopes, and dreams. It is not uncommon for clients to confess secrets or say, "Not even my husband knows this about me," as they open up their hearts and souls.

If by working with you and trusting in you they find the courage to push themselves to be someone they've only dreamed about becoming, they will inevitably reveal their true selves to you and your camera.

It is here, in these precious moments, that a golden opportunity lies—you will find you have been gifted with the opportunity to capture a woman's soul.

The following chapter addresses this last stage in further detail.

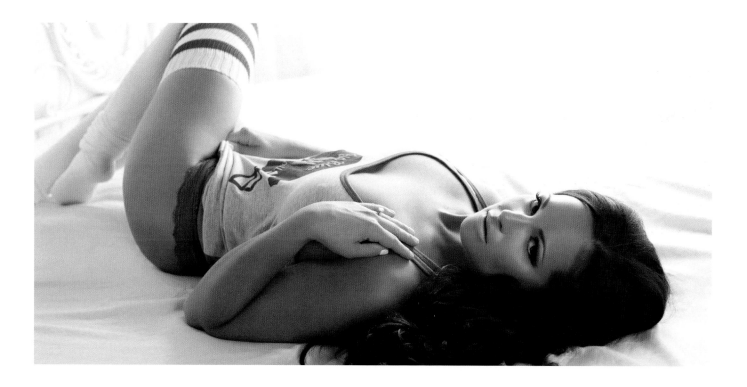

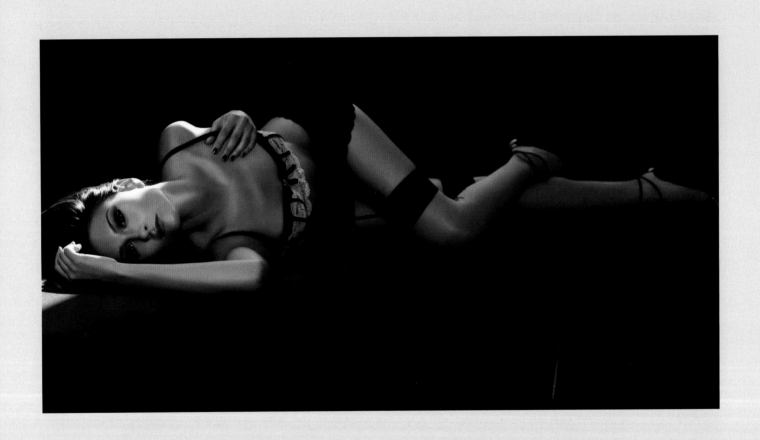

An Interview with Nicole

Nicole is an aspiring model and a beautiful soul. I invited her to participate in this project to provide a different kind of voice—that of a young beauty who, while more confident than most, can still speak to the nervousness and self-doubt that can creep in during boudoir shoots.

Heading into your boudoir shoot, how would you describe how you feel?

On my way to the shoot I felt excited and the least bit scared. I love lingerie and I love being in front of a camera. I was looking forward to having fun and showing a little bit of my sexy side.

What three words would you select to describe the look/feel of the images you hope to create?

Confident. Independent. Feminine.

Some clients describe the boudoir experience as a roller coaster of emotions. Was it so for you?

I could most definitely agree it's a roller coaster of emotions for some people. I was very excited at the beginning, I was also a little anxious. During the shoot I felt sexy and concentrated on making sure my poses were good. After the shoot I felt accomplished and excited to see the photos.

Once you saw the images from your shoot, what was your reaction?

That is me?!

On a scale of 1–10 (10 being most confident) how would you rate how you feel about your body post-shoot?

10. *(Pre-shoot she indicated a 9.)*

Anything else you wish to share . . .

Susan is an amazing photographer and woman! She's very positive and knows how to make anyone feel comfortable and/or sexy in front of a camera. Working with her is fun and she always digs out that confidence in me somehow which allows me to give my all in front of the camera!

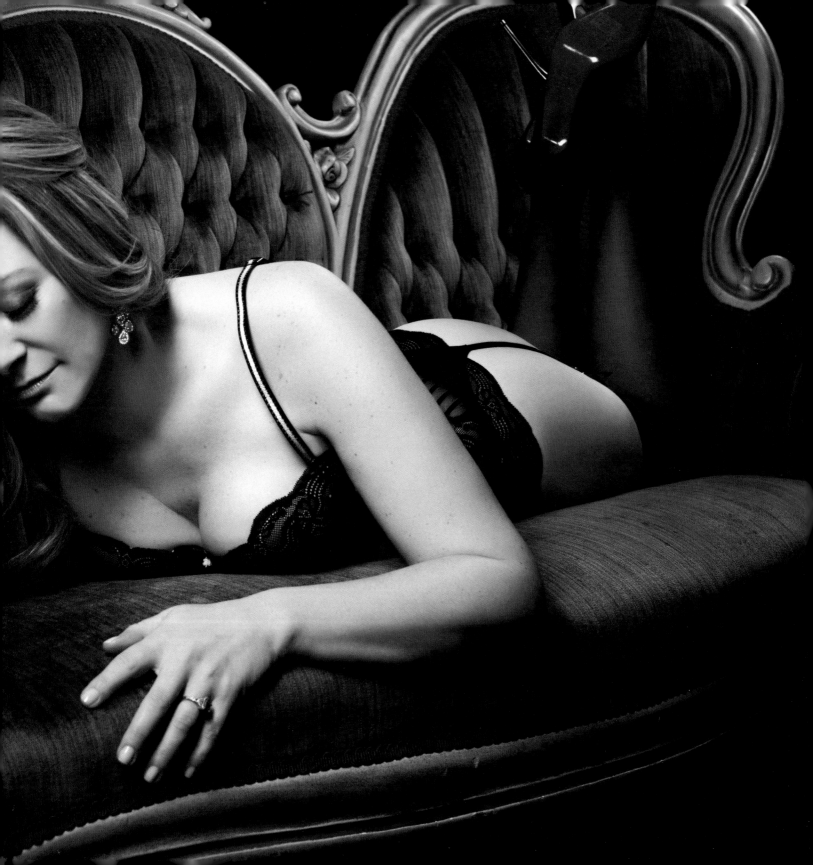

12

The Shoot
The Final Phase—Moving beyond Pretty Pictures and Facilitating Her Transformative Experience

If you decide to just go with the flow, you'll end up where the flow goes, which is usually downhill . . . You'll end up doing what everyone else is doing.

Sean Covey, *The 7 Habits*

Up to this point, the shoot has probably gone as most shoots do—with her acclimating to the boudoir shoot and you establishing the best angles for her and figuring out how best to guide her in the development of pretty pictures. You may have even led her through common and familiar poses as a means of covering your bases and providing her with popular, albeit standard, images. But if this is where the shoot always ends, you're missing an amazing opportunity to elevate the shoot experience to the next level and give your client a life-changing gift.

There's also your missed opportunity: in this highly competitive photography market where most prospects (not knowing any better) use price as *the* point of comparison when researching photographers, you're only hurting yourself if your portfolio looks just like every other boudoir photographer's portfolio in your area. How can you set yourself apart if you do what everyone else does?

If you're all shooting in the same hotels in your area, and you've all taken the same posing workshops, how different will your images really look to the prospective client?

Prospects will regularly tell me that they felt compelled to pick up the phone and call me because the images I include on my website are powerful in that they seem to authentically capture the individuals within them. "It doesn't look like you just put her in a pose and directed everything about it," they will tell me. "There's emotion there; and although the images can all be so different from one another, it feels natural—like each woman belongs there in that image."

At the same time, I've read heated debates on multiple Facebook groups and forums about what classifies and what doesn't classify as boudoir. It seems there is a vested interest in narrowing the definition to such a degree that a bed and lingerie absolutely must be present, otherwise you risk being called out for not belonging in the boudoir photographers' camp. The result, as far as I see it, is so often a slew of boring, repetitive imagery. Because my goals are focused first and foremost on my client and on having my skills serve as a vehicle for *her* self-expression, I don't really care if another photographer thinks my images aren't technically boudoir. To me, boudoir is about how a woman defines and sees herself in her private and personal space—lingerie not required. In fact, clothing is totally optional!

The bottom line is this: in my studio she is the ultimate boss in determining whether or not a concept will fit within her boudoir experience.

Push Her . . . but Gently

So once we get the basic poses in, then what?

I'm glad you asked.

The goal is now to bring her heart and soul into the shoot.

Once the client feels safe in the boudoir studio environment and she's gotten the hang of moving and interacting with the camera a bit better, I want to push her a bit more—to get her to a place that might feel a little bit more vulnerable, but that will nonetheless reap greater rewards. We've already captured her physical beauty. Now, I want to infuse her heart and soul into the images we capture, and note: I can only do that if I've earned her trust up to this point.

During the pre-shoot planning stage I will often ask a client to choose an outfit or concept that says something about who she is right now, today. I don't really care what that outfit is but it must be important to her.

By giving her this opportunity to emotionally invest in the shoot, I am bringing the experience to another level for her—it goes from being a nice experience to one that is absolutely unforgettable.

This personal concept must be well thought out and carefully planned. Every detail must align so that it tells a coherent story. Your part, as the photographer, is to turn her story into a series of inspiring visuals: to ensure the lighting sets the mood for the emotional journey she wants to express; to plan the setting/props/etc. so that they make sense within the context of her story. She may not be able to visualize exactly what she wants, but if you listen for the emotion, you will be able to suggest sample concept images, settings, props, and themes that will bring her story to life.

A few examples of personal stories I've shot:

- One woman brought a fitness outfit, weights, and chains to tell her story: she wanted to acknowledge years of hard work in becoming fit, and celebrate a major achievement in conquering decades of depression resulting from her overweight condition; we shot against a gritty black chalkboard wall in my studio to represent her tenacity, but when I suggested contrasting the grittiness of the chalkboard with very feminine hot pink gel lights, I brought her personality into the mix. I've shot this client again since that first shoot, but at the second shoot she made mention of this particular series of images; out of the four sets we'd shot, this was the most memorable because it was this set where her personal story was most clearly represented. (The image is included in this chapter.)

- Another client chose to celebrate a second marriage to a wonderful man and show her support by posing in his fireman's bunker pants (trust me—we made it smokin' hot!); I suggested a mottled grey backdrop that recalled smoke and used moody lighting that highlighted the bright colored suspenders attached to the pants and made her pop off the background.

- Still another client chose to show her hard-fought acceptance of her curvy figure after years of struggling with body dysmorphia (a disorder characterized by the perception of/exaggeration of flaws that are often not based in reality—for example perceiving oneself to be the size of a 300 pound

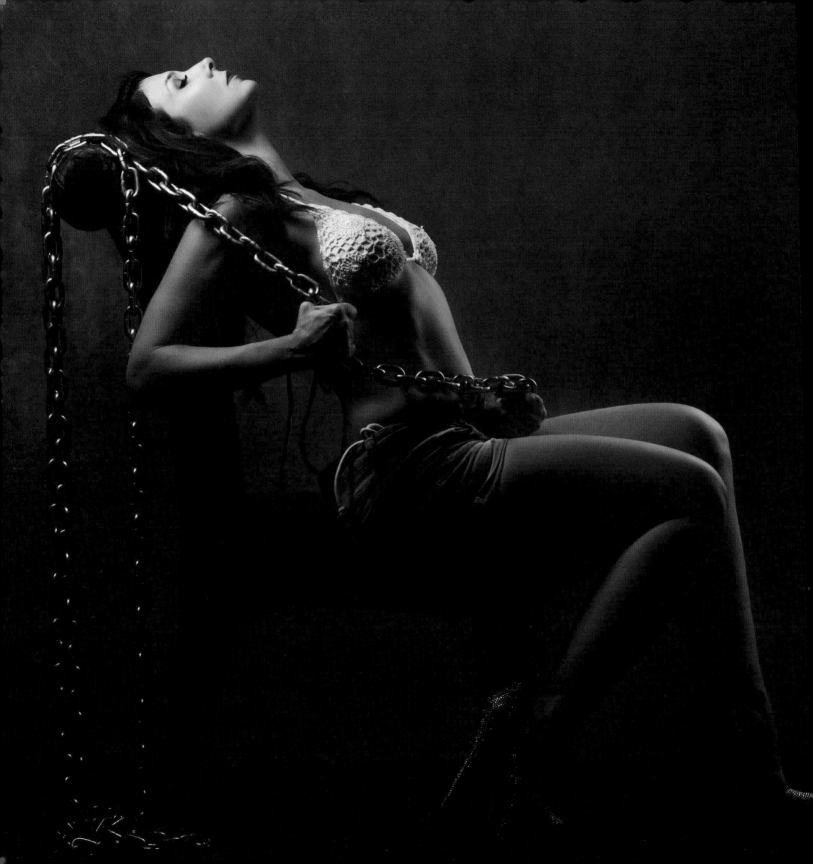

woman when she is an average weight for a woman). She chose to brave a nude session at the end of her shoot; for this delicate situation, I ensured studio lights were low and incorporated a beauty dish to highlight her beautiful face, and strip boxes that would purposefully direct the light while sculpting her hourglass figure.

Can you imagine how rewarding it was for each of these women to tell her unique story; to be able to trust me as her photographer as she revealed her heart and soul; and to have her experiences, fears, challenges, hopes, and dreams forever documented in a beautiful way? These are only a few of the stories I've accumulated over the nearly seven years I've been shooting women and boudoir. Each and every one is powerful because it involves real women with real stories, represents a deeper and more meaningful experience than any of them expected to have, and is a far cry from your mother's glamour shoot back in the day!

Doing a boudoir shoot is much more than just standing in front of a camera. It's a look inside someone's soul.

Jean

Coax Out the *Real* Her

While the pressure of looking pretty and "acting" sexy in front of the camera is enough of a stressor for most women, asking her to reveal her heart and soul rather than merely mimic a pose is even more of a challenge. How your client interacts with your camera can vary widely. Think of the effect this way: it's like the difference between reciting a written speech in an unfeeling monotone way and feeling and acting out the strength of each word as it passes through your lips. Most women, not being actors, unfortunately err on the side of being conservative in front of the camera. But that conservative nature prevents them from creating images with emotional impact, images where elements of their souls are beautifully revealed.

Consider this: even if she's doing the shoot as a gift to someone else, *she* is still your primary audience. The degree to which she sees herself reflected in the images you capture will determine how she feels about the images. And how she feels about the images will determine how many and what she chooses to own, how much she will invest. And what she chooses to own will determine how those who know her well—her significant other, family and friends—judge you and your ability to capture women.

In order to coax out her feelings, emotions, and authentic personality, I will gently initiate dialogue about her story. I will ask her how she feels standing in that outfit she chose in order to express her story. I will ask how her husband will feel when he sees she's absconded with his fireman pants in order to create these images for him. I will ask her to name the emotions she wants to see in these images . . . how does she want these images to feel? I will ask her all these questions while she stands before me and my camera . . .

. . . and then I will show her some images and ask if she sees herself and her story reflected. Sometimes the client will decide that she's holding back and she will take it upon herself to do better in conveying the emotions associated with her story, and so she'll ask me to shoot more frames . . . because it's important to her to tell her story well! Other times, depending on her nature and her story, she will either tear up or shriek with excitement because we've nailed it.

If she is quiet or not especially communicative, I may ask her direct questions. *Do you see pride in this shot? If you didn't know this woman, what would you say she is feeling in this image? What message is she conveying?* This dialogue can help her first connect with the emotions associated with her story, and then show those emotions to the camera.

On rare occasions, you may encounter someone who just doesn't seem able to connect, isn't willing to bare her soul, or can't seem to overcome her sense of vulnerability. If your rapport and interactions have been great throughout the pre-planning stage, consider that your camera might be serving as an obstacle. Get it mounted onto a tripod and be ready to trigger it while your face isn't buried behind it. It may simply be that she needs to connect with you without the camera in the middle. Some people are so frightened by the camera that it can serve as an impediment to those natural images we really hope to capture. Removing the camera as a distraction is a common technique with child photographers, who recognize that the interpersonal connection is so important to capturing those magical images. While you might not need a sock monkey to disguise the camera in boudoir photography, the concept is nonetheless the same.

If, however, despite all your efforts, you haven't been able to establish great rapport with your client in pre-planning or during your shoot, then it may just be that you have someone before you who is very closed, not ready to reveal herself to you or your camera. In this instance, don't interpret it as a personal judgment against you or your abilities as a photographer. For some, it takes years of soulful, psychological work to be able to connect not only with others, but even with their own inner worlds. Some people lack self-awareness—they aren't used to doing the hard work that is looking within and expressing oneself authentically. As a result they feel disconnected from others but, most unfortunately, disconnected from themselves. There is little you can do as a photographer other than encourage and support them in taking the huge step already represented by the current scenario: here they are standing before you and your camera.

Going into this experience I expected to see nice pictures. Going through the experience has given me so much more than that. It's given me a renewed sense of myself. Susan and the way she works made this experience something I will never forget, and something I am so grateful I had the opportunity to do.

Jean

Speak in a Visual Language

Body language is so important in communicating emotions and moods. Just as some people are great at acting, while others aren't, I find it's the same for the ability to marry emotions with body language. Some people are great at it, while others . . . not so much.

Mirroring is an important technique that's taught to graduate students of psychology. It's also a skill that is taught to job seekers. And, interestingly enough, whether or not someone may ever have officially been taught how to mirror others, it appears to be a natural human tendency to some extent.

On the phone with a prospective client, I may mirror the pace at which the prospect speaks in order to set her at ease and let her know that I can bend to her style. In a shoot, however, that mirroring is taken to the next level with body language and movements. I will mirror her so that she feels comfortable in the easing in phase of the shoot. But then, as we progress, my goal is to get her to mirror me. I will set my camera down as I provide guidance in expression through body language. But I don't rely on verbal instructions. I am providing visual cues and oftentimes doing exactly what I want her to do. I am showing her what tension looks like in the body versus what flirty playfulness might look like. An important part of my guidance throughout the shoot is my willingness to get down on the floor and place myself in positions the client may wish to use as inspiration for her next series of movements. In this way she takes the visual cues and can turn the body movements into something wholly her own. She is also less likely to feel insecure about taking risks in using her body to express herself because she is not the only one doing so.

There are certainly times when I'll try out a pose or body movement and it's a total flop. In those instances, it's a source of bonding. We get to laugh a bit, and then if she's the one to figure out a creative alternative to my flop, well, she's better than me for having done so and that's a confidence booster!

As I mentioned in the last chapter, as we progress through the shoot my guidance becomes less important. I may begin to use more nonverbal cues to influence her movements, and because we've become more in sync with one another, she will begin to mirror my movements without my having to provide verbal instructions.

Gauge and Acknowledge Emotions Throughout

In this last phase of the shoot, it becomes more important than ever to attend to and gauge your client's emotions. You want to gently push her to give you a peek into her heart and soul, but you never want to push her to the point that she either shuts down, drowns in her emotions, or ends up crying and ruining the beautiful makeup job your team has done! Women are emotional creatures. Sometimes tears are happy tears,

but even these will still ruin the makeup. And this is why I leave the personal story concept for the last set. I will also check in with her often so that I know when it's time to switch things up, and if we're dealing with a heavy subject, lighten the mood.

Be aware that clients may get emotional even without any prompting from you. A client of mine once stood before my camera a whopping three minutes before starting to hyperventilate, saying, "I don't know if I can do this." The issue of body image is *such* a powerful one and it affects women of all ages, shapes, and sizes, so never assume that a fit, statuesque beauty can't possibly be dealing with those issues. In this scenario I've just mentioned, she was!

"For me that was the most important part—to be viewed and photographed as a human being with real emotions and dreams, hopes, and fears. I knew I could be completely vulnerable yet confident at the same time because I felt protected and loved.

Sandeepa (read her client interview in Chapter 7)

Think: Interval Training

Many clients describe the boudoir shoot experience as a roller coaster. But I like to think of it in terms of a fitness technique called interval training. You can't keep the intensity too low throughout the shoot or your images will be just blah. You also can't keep the intensity too high throughout the shoot or she'll either get exhausted before you've had the opportunity to fully explore different ideas or burn out emotionally; or you'll find all the images kind of look the same.

You have to vary the intensity, at times raising it and at other times keeping it light and filled with laughter.

Revisiting the three words she's identified for the look and feel of her shoot will give you the opportunity to purposefully shift gears throughout the shoot and allow her to follow along. It also provides another connect back to her vision for the shoot. Another bonus: the outcome will be a diverse array of images that vary in mood, emotion, impact, and look.

Things to Watch Out For

Given the emotional nature of the shoot overall, and in particular the personal story part of the shoot, it's important to attend to the client's needs at all times—whether spoken or unspoken:

- **Always check in:** if your shoot lasts more than an hour, check in with her to make sure she's comfortable and not in need of water, a bathroom break, etc.; I know it's easy for me to get "on a roll" and I never eat or drink during a shoot

because my energy is high, but she may feel differently, so I take care to check in with her to make sure she's doing fine throughout the shoot; some women will prefer to just work straight through, while others will want or need a break.

- **Remember she's your partner:** revisit your goal in capturing images that reveal a piece of her heart and soul (this discussion should take place in depth during the planning session); if she's to be your partner in the process, invite her to give feedback on whether or not your collaborative efforts are achieving the desired results; allow her to own her part in putting forth the emotion and energy required to create the magic she'll ultimately treasure.

- **Allow her to determine how best to tell her own story:** get her input on body language, poses, and movements that will help tell her story; sometimes clients come up with unusual poses or fun ideas that are unique, but perfect for their situation; doing so also has the added advantage of avoiding running your clients through the same old routines because that's what you're used to.

- **Respect her boundaries:** although you are bonding with your client, never lose sight of the boundaries; if a question is likely to take her to a sad place in her head, don't ask it; remember the goal is to empower, to inspire, and to help her celebrate her achievements and strength.

- **Do your best to see her through *her* eyes:** because body image is such a challenging thing for most women, and we don't always know what she *really* struggles with, refrain from insisting she looks great when she has already indicated she is not comfortable with certain aspects of her body. An example: I shot a tall, beautiful woman with an hourglass shape. She hated her hips, felt they were too big, and would reject any image that showed her hourglass figure straight on. Now, while I thought she was beautiful and I knew many women would kill to have that shape, it wasn't ideal for *this* client, so I shifted my shooting angles, modified her movements, and paid attention to how her figure was coming through in the images going forward; after all, it's about shooting her in a way that she'll feel proud and confident of.

- **Watch for signs of exhaustion:** While my mini shoots are short and sweet (45 minutes), my full shoots involve two to three hours of shooting time. In my experience, posing for boudoir doesn't feel all that different from Pilates! You're engaging the core (aka—sucking in the gut), creating long lean limbs, supporting yourself with your arms in some instances, balancing on a hip . . . you get the idea. Imagine doing Pilates for two hours—it's work! I find that two hours is fine for most people, but three hours tends to be the limit. Being aware of your client's energy level is key, otherwise you may miss important nonverbal cues—the eyes will go flat, the poses have less punch, etc.—and you'll only end up wasting time on images that won't matter in the end.

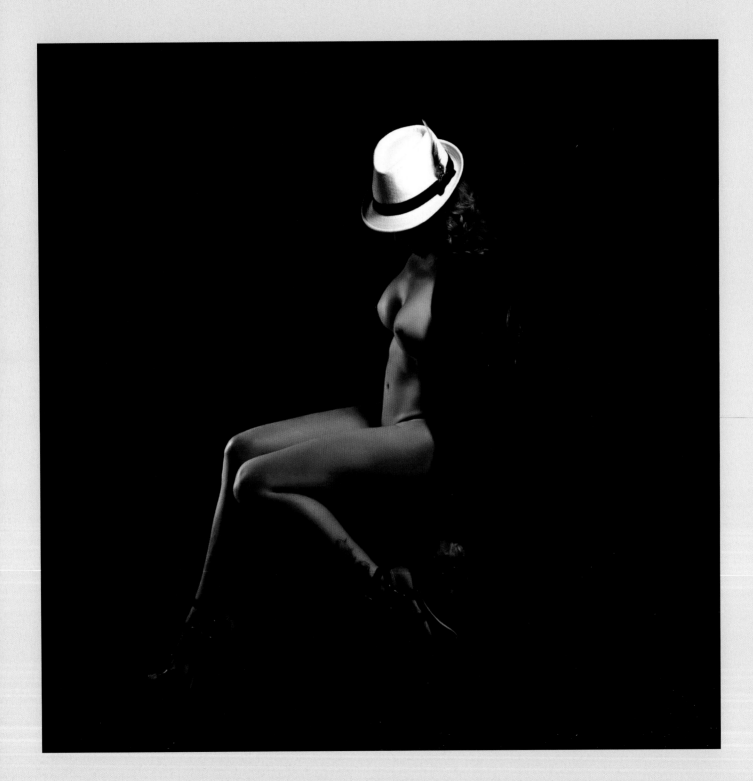

An Interview with Jean

Jean came to meet me several months before she decided to do a shoot. She'd been diagnosed with Multiple Sclerosis, but, just as important, her best friend had been diagnosed with breast cancer and was about to undergo a double mastectomy. Wanting to capture themselves as they were before their illnesses transformed them, we set up a shoot for both women on the same day.

What motivates you to pursue a boudoir shoot right now?

I guess I should start at the beginning. I have always been what I hear people call "body conscious." Never really secure with my looks . . . My booty had always been the one thing I considered an asset. Then I gave birth to my beautiful son, and that changed . . . Also, all of my life my breasts have been very small, and I have always wanted to have an augmentation, but never had the courage. In 2010 at age 41 after my mother passed away, I finally decided that life is too short for regrets. I decided to take the plunge, and have it done. I suddenly loved clothes, shopping, and putting on things that finally looked good without the help of a "miracle bra" and padding. I was finally happy to put on a bikini . . . It still amazes me that with a wonderful and supporting husband, that always tells me how beautiful and sexy I am, that I am still so self-conscious. As an adult I know that magazines and other people's views on beauty should not affect how you see yourself, but yet, here I am at 46 years old, still affected by what I think other people may perceive . . . In August of 2014 I was diagnosed with Multiple Sclerosis, I have a good friend who also has the disease and has for 20 years. When I told her about my diagnosis, she said to me, "Your body will never be the same." I looked at myself and said I want to remember how I look today. I want to see the woman my husband tells me I am every day . . . "beautiful."

Heading into your shoot, how would you describe how you feel?

Feelings heading into the shoot for me were very mixed. I was extremely excited! The day of the shoot brought very different feelings. I found myself packing clothes I wanted to wear, and thinking, "Am I crazy, do you really want to see what you look like on film?" I became very nervous. What if my stretch marks show, what about the cellulite??? Will my breasts look nice, or will my uneven nipples take over the pictures? And GOD what about your nose??? Really? As I got to the location and had my hair and makeup done, I started to settle in, I talked to the makeup artist and started to calm and get excited again. I decided to stop thinking so much and just go with it . . . Susan the photographer completed the equation. She made me feel comfortable and as the shoot went on "Beautiful." The photo shoot was the best decision I ever made.

What concerns you most?

My concerns were like the series of "Rocky" . . . endless. How would I look? Would my butt look wrinkled, would my boobs look crooked, would my nose outshine every picture? Susan brought to the lens and the pictures what I never felt but now see. A confident, sexy, and beautiful woman.

On a scale of 1–10 (10 being most confident) how would you rate how you feel about your body?

Before my first photo session I would say I felt like I was a "5 or 6" on the body scale. Now after the session I feel like numbers don't make a difference. You are as sexy and beautiful as you feel. And I feel more like a 10.

What three words would you select to describe the look/feel of the images you hope to create?

Confident, alluring, and strong.

What did the photographer do specifically that helped ease any anxiety or fears?

Susan helped take away my anxiety by talking to me as if we were old friends. We talked about our kids, our work, our men. We talked about my disease (MS) and my concerns. She put me at ease continuously . . . We giggled and laughed like school girls during the shoot, and that helped so much. The way she spoke to me helped make my facial expressions more natural looking . . . she would show me how to pose using herself and not telling me "put your hand here, move your foot . . . " etc. . . . I think Susan's style and personality are what put me at ease the most, her natural ability to be happy is contagious.

Are there any specific or recurring thoughts you remember running through your head during the shoot? How did these make you feel?

I kept thinking to myself during the shoot "Susan has seen and photographed so many beautiful women, I can't believe she's photographing someone as ordinary as me." But every time these thoughts came up Susan took them away with her easy style.

Once you saw the images from your shoot, what was your reaction? Did they capture the three words you identified in your pre-shoot questionnaire?

When I received my pictures, all I kept saying was I can't believe that's me. I look so beautiful. My pictures captured everything my husband has always tried to get me to see, and I was too self-conscious to believe. I looked sexy, alluring, beautiful, and so many more things I can't even put into words. I have never been so happy in my life that I finally stepped outside of my box.

Anything else you wish to share . . .

This journey turned out to be more of a gift for myself. It's given me the courage to stand up to this disease and say I will always be myself. Even if I end up looking different, I will always be beautiful.

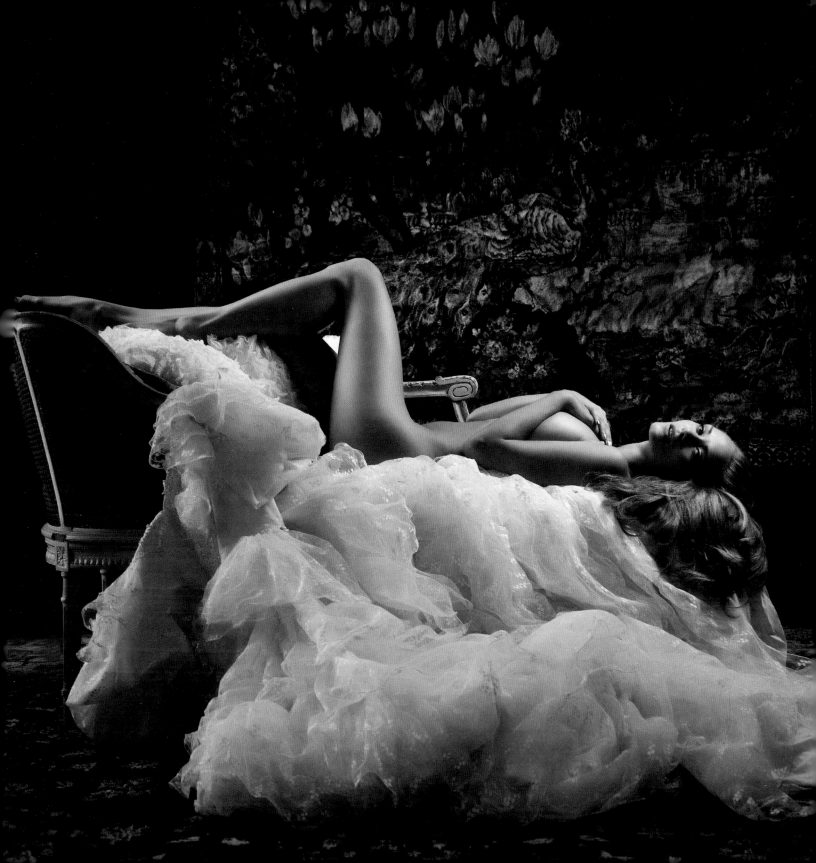

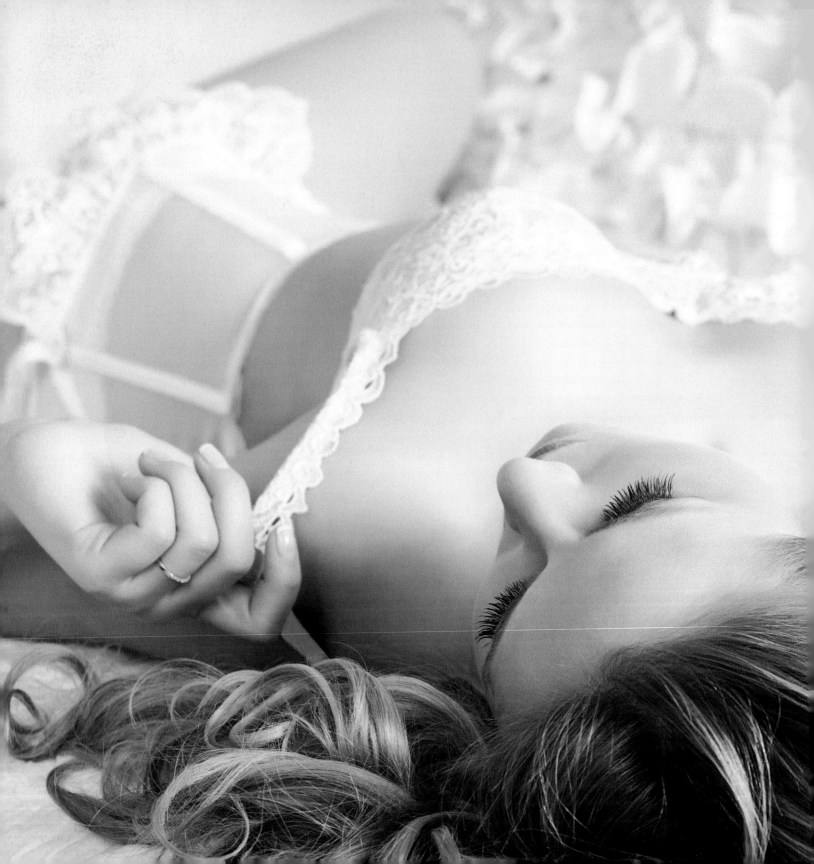

13

The Wrap
Celebrating Her Accomplishment

Caring about others, running the risk of feeling, and leaving an impact on people, brings happiness.

Harold Kushner

To revisit our fitness analogy, the shoot's wrap is the cool-down phase of the shoot experience. And if you've ever followed an exercise video, or participated in a class at the gym, then you know that the instructors seldom stop you cold.

You don't go from a level 100 in intensity immediately down to a 0; just like you don't suddenly stop a treadmill when it's at its highest speed.

The Shoot Cool Down

I follow the same model in the studio. Our last push through the personal story set might have taken a lot of energy—emotional and physical—for her to pull off. So the last thing I want to do is call, "It's a wrap!" when she might still be firmly embedded in a deeply emotional phase of the experience.

Unless we've been celebrating something fun like a new marriage, and she's a naked woman posing in an oversized pair of fireman's pants, I'm likely to end the session only after I've introduced Improv Time. Improv Time means she gets to mimic a supermodel (in a comical way); show me her Blue Steel face (ugh, I date myself here!); play the role of Mrs. Universe; or perform her version of whatever character is going to allow her to be silly, loosen up, share some laughs with me once more, and show a completely uninhibited, fun, vivacious side of herself. Although we only spend a few minutes doing this, it's worth it.

If you're thinking, *What a waste of time*, let me assure you it's not! It's very common for clients to include an image or two from their Improv Time in their final collections, which is great, because when they look back on the experience, they clearly remember how much fun they had. Not only that, but this playful, no-pressure fun enables you to end the shoot on a high note, and provides yet one more opportunity to further solidify your bond. Any awkwardness she might have felt knowing that she just spent an hour or more half naked in front of you and revealing her emotional world disappears more and more with each chuckle and giggle.

Be the Prepared Professional

After the shoot, the client will return to the dressing room where she will get back into her street clothes and gather her belongings. I will offer her cold beverages and snacks to replenish her energy, and we'll meet in the front lounge/makeup room where we can curl up on cozy chaises and debrief the session.

As we review the highlights of the shoot, I perform an informal feedback gathering session: I gently probe her for her thoughts on what was helpful; what she wished were different; and what she liked best. We continue our light banter as she fills out my client data sheet; adds her signature to the contract (if she hasn't already provided that); and signs the model release if she chooses to allow usage. I prepare all of this paperwork prior to her arrival. Having logoed forms and paperwork presents a professional appearance and lets her know that I ask the same information of every client who comes through the door.

Manage Emotions and Set Expectations

Most often, by the time a shoot wraps, my client is on cloud nine, full of energy and emotions. She's:

- reeling from the experience;
- surprised at herself for managing to get through the vulnerabilities involved in standing half naked before someone she barely knew;
- proud of herself for having expressed herself emotionally throughout;
- proud of having co-created beautiful concepts based on her vision;
- excited to see the kind of images she only dreamed about come to fruition.

By far, though, the overriding feeling is eager anticipation! All the sneak peeks you provided throughout the shoot will play in her mind over and over until the day you sit down together again for the big reveal. But for now you will perform the fine balancing act of supporting her enthusiasm and excitement for the images, while managing her expectations.

Just as it's important to set clear expectations prior to the shoot during the planning phase, it's equally important to reiterate your process and set clear expectations post-shoot. For one, she's probably forgotten all about your timeframes. And for sure, she's most likely unaware of all the work required to get from where you are now—sitting in the office post-shoot—to the day she finally gets to hold her completed album, files, or print collection in her hands.

In the positive glow of her shoot experience I prepare her for what's to come; enlighten her on the work I have to do prior to the selection meeting; and if she has her calendar available, we set the date for her review session. It is important that I let her know that the post-shoot production timeframe I clearly mention on my site begins only once our review session has taken place. In general I aim to have review sessions within

three days after the shoot, but sometimes clients get bogged down by commitments, work, children, etc., and postpone. I let them know ahead of time, at the shoot, that if they postpone the review session, they are also postponing the date by which they will receive their final materials.

Although it doesn't happen often, I know that those who are inclined to postpone may be doing so because their nerves have kicked in; self-doubt has crept back in; and as they go about their days, looking in the mirror without the benefit of pro makeup, expert hair styling, and my fabulous lighting, they can't help but wonder if they really did look as good as they thought they did during the shoot.

To avoid this shift, or what I call "fading of the glow," do your best to have the review session as quickly as possible after the shoot, while your client is most likely still basking in the intoxicating effect of her experience.

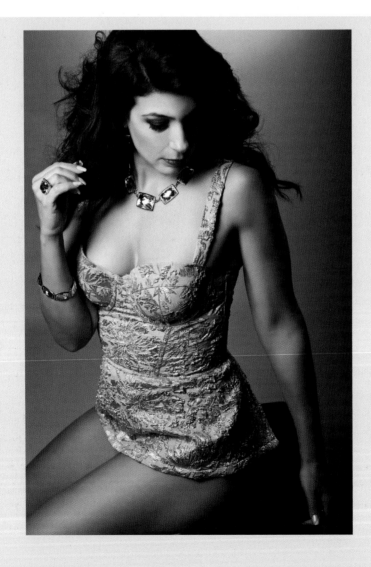

An Interview with Marianne

Marianne is a repeat client who plans on returning annually because of the emotional benefits she receives from our shoots.

Some clients describe the boudoir experience as a roller coaster of emotions. Was it so for you?

The reason for this shoot, which was my second one, was to heal after being through a very rough personal experience. I decided that I was going to have fun with this shoot, and to use it as a symbolic "Phoenix rising from the ashes." At the beginning of the shoot, this second time, I felt ready to let go of all the negativity that I have been through and enjoy every minute of the shoot. During the shoot I felt all the stress just lift away, and I genuinely laughed for the first time in a while. I started to feel like my old self again. By the end of the shoot I truly felt like the Phoenix I wanted to be.

What did Susan do specifically that helped ease any anxiety or fears?

Susan had given me say in the overall vision as well as helped me in the planning. I didn't feel nervous with Susan, I felt quite comfortable, as this was my second shoot. Susan and I laughed often, and that put me at ease.

What was most challenging for you during the shoot?

My body image is always my biggest challenge. I was constantly wondering how I looked in the photos. I am very self-conscious about my weight and how I look in pictures. I had that on my mind a lot during the shoot. I also never like how I look in pictures. I felt letting that go was a big challenge.

Are there any specific or recurring thoughts you remember running through your head during the shoot? How did these make you feel?

For sure, wondering how I looked. I felt very self-conscious but as Susan showed me the pictures in between, I was at ease.

Once you saw the images from your shoot, what was your reaction? Did they capture the three words you identified prior to your shoot?

Absolutely!!! I was over the moon when I saw the images! They were exactly what I had envisioned, but so much better!!! I kept asking, who is that? I looked like what I could only dream to be! I was speechless.

Aside from beautiful images, are there any other positive outcomes from your boudoir experience?

The entire boudoir experience was exactly what I needed to heal. I truly feel that every woman should do this at least once in her life. It brought positivity and self-esteem and confidence on so many levels. I plan on doing a boudoir shoot annually, to capture myself emerging as a strong, sexy, confident woman (I am now 46 years old). I want to leave a beautiful legacy of femininity, empowerment, and

confidence. I want to embrace growing older and have it captured in the beautiful way boudoir photography can do.

On a scale of 1–10 (10 being most confident) how would you rate how you feel about your body post-shoot?

9. *(She noted a 7 prior to her shoot.)*

Did you get what you hoped out of this experience?

Yes, I did! And so much more than I dreamed!

How might the experience have been better?

It was perfect!

Anything else you wish to share . . .

Each shoot is a self-journey in its own right. My first one, I worked through body image and negative thoughts. This current shoot, it was about becoming the superhero I needed to heal myself. Wonder Woman, Badass, Phoenix. I did it! This shoot really did help me to rise above and conquer.

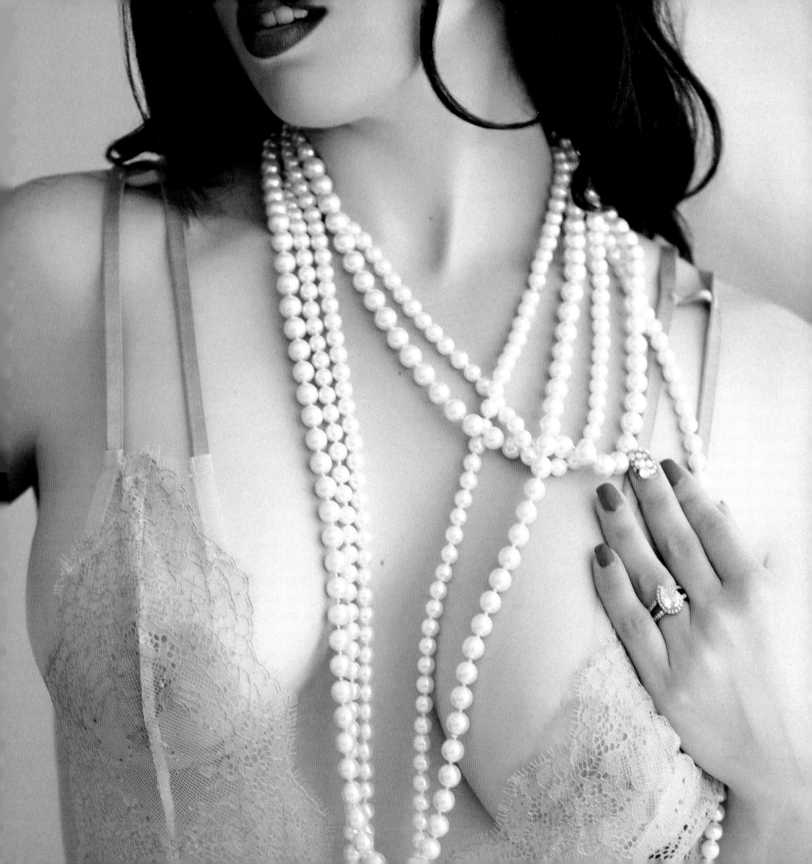

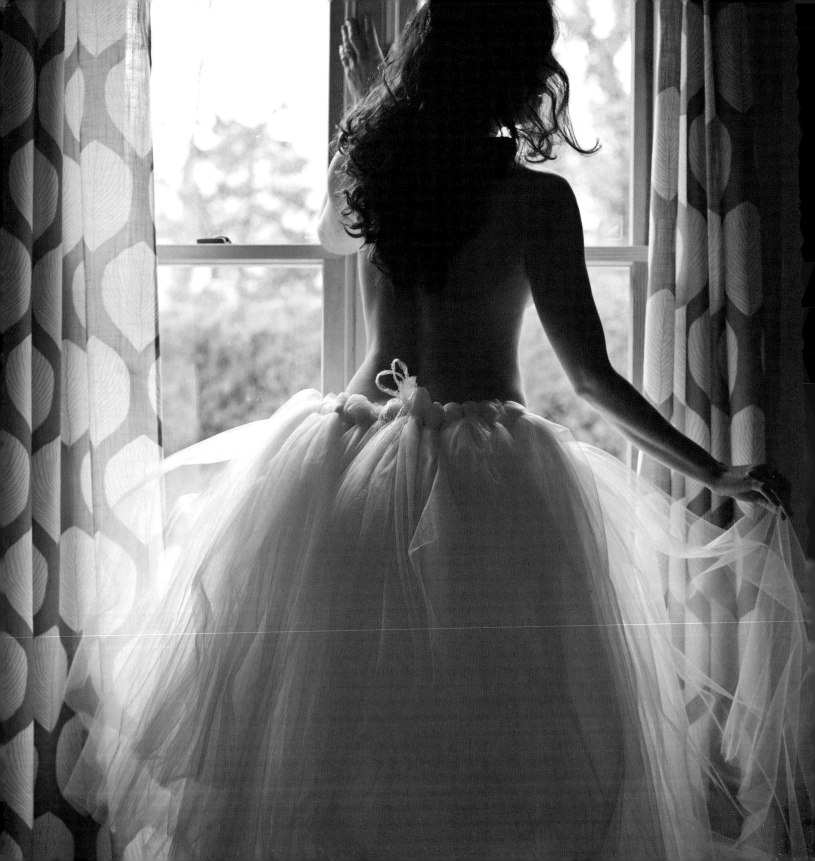

14

Marrying the Emotional with the Technical

Lighting and posing should highlight her personality and help her say what she wants to say.

Early on in the process, usually once a shoot date has been set, I begin to focus on understanding my new client's goals. I will ask her to distill her vision down to a few simple words—words that will capture, in a nutshell, how she wants her images to feel. What does she want her images to say about her, about how she feels, about her emotional journey (where she's been and where she's headed), and about who she is right now, today.

To guide her in narrowing it down to the essence of what she seeks, I will ask the client to give me three words. Just three. (And if she's absolutely unable to simmer it down to three words, three short phrases will do.) In most cases, she will laugh and respond, "Good question! Let me think about it." But in all cases, it's a great little exercise, and clients usually can't wait to share their three simple but powerful words once they've settled on them.

Armed with a client's vision (her three words), I begin to visualize how I might incorporate the feeling behind the words into her boudoir shoot. Throughout the process, these words will guide every decision that's made, from wardrobe, to styling, to lighting and posing. Trust me, it's not always easy to do. Sometimes the client will make choices that conflict with her own vision for her shoot. It then becomes my job to check in with her.

If she suggests an outfit that I don't feel is a fit with her goals, I might ask: "Do you feel this outfit conveys the mood of your vision?" Usually, once she is asked to refocus on her goals, she will change her mind about the decision she's made, and will instead continue her search for something that serves as a better fit with her vision. In most cases, the client is grateful for having been encouraged to reflect on the conflict. In her eyes, such a scenario can further confirm that you, the photographer, are a capable professional. And the great news is this early development of trust can extend to later instances, for example during the shoot, when your client's trust in you will become super-important in overcoming fears and inhibitions.

To demonstrate how powerful having a clear vision can be, imagine this scenario:

A 45 year old mother of three learns that she's beaten the breast cancer she'd been battling for some time. To celebrate her body's triumph over the disease, she wants to do a boudoir shoot. She chooses you as her photographer. You ask her to select three words that will sum up the message she wants to convey through her images. She chooses reflective, tough, and alive.

How might you capture these words in a boudoir shoot? If you're a highly visual person (as most photographers are), your brain probably immediately conjured up certain styles of lighting and maybe even poses to convey those qualities.

Now imagine another scenario:

A 27 year old who only two years ago had been abandoned at the altar by a no-show fiancé, has now found love again and is engaged to be married to the man she believes is her true soul mate. Although they will be eloping and committing themselves to one another during a private ceremony on a tropical island, she wants to give him a gift that represents how

happy she is to have found him, and that symbolically represents that she is handing herself over to him body and soul. Her three words: natural, flirty, fun.

Now how might you capture these words? In your mind's eye, does this shoot look different than the one in the last scenario? I'm guessing it does.

Take Another Look at Your Approach to Lighting and Posing

Look around at photographers working in your area, giving workshops, writing books, and you'll find that more often than not they talk about lighting in the context of a photographer's arsenal and personal style. How many photographers can you think of who are known for their signature lighting style? Or their signature handful of poses? I'm guessing lots. The great thing is these photographers tend to draw clients who come to them because they appreciate the photographer's style. One client after another may be shot in the same lighting style, using the same handful of poses the photographer has become comfortable with. And this takes place regardless of the reason the client may be pursuing the shoot. But other than saying "I was shot by INSERT NAME BRAND PHOTOGRAPHER," these images won't say much about who the client is, now will they?

What I'm suggesting in this book is that we boudoir photographers might create more meaningful imagery if we flip this around a bit in our intimate boudoir work. After all, it's intimate photography. It's figuratively and literally about shining a spotlight on a usually hidden, or at least private, side of a person's identity. One of the worst things that could happen when a client shows her significant other her boudoir images is that her partner asks, "Who is that?" because the styling,

posing, setups, etc. have nothing to do with who she really is. Ouch! On the other hand, one of the best things that could happen is that the significant other immediately identifies your client at her best, at this very moment in time, and recognizes the deeper meaning of the work you have created together. Yay!

Instead of shooting only natural light, or only studio light, or having three to five poses we wish to become known for, why not become fluent in different styles of lighting and posing so that we can tailor everything to the specific goals of our clients? I have found that, nine times out of ten, there is usually a powerful story, a reason the client is pursuing boudoir in the first place, and if we integrate that reason into the story of her images, we are more likely to create magic—which I define as beautiful images with lots of personal meaning woven throughout.

In addition to lighting, posing is also a very important consideration for boudoir images. But not every pose suits every figure or personality. Clients will regularly show me images they find on the Internet and say, "I want a picture like that." But sometimes the pose does not suit the client; the client's body will not make the same shapes she admires on the model in the picture; or what the client hasn't realized is that in order to get into that pose the model has had to contort her

body to a considerable degree, and perhaps the client isn't able or willing to do the same. How disappointing for the client if she's had her heart set on replicating the image she's gotten so excited about.

And here's something else that happens a lot in boudoir photography: clients will request the same pose they see everywhere else. Standard boudoir poses can seem like a "must have" simply because, well, everyone else is doing it. The pose may not say a darn thing about her story—why she's pursuing boudoir at this point in her life. It may not even be a pose that you the photographer particularly like.

But the answer to both scenarios is this: shoot it anyway. Do it quickly; don't spend a lot of time on either scenario. Do your best to give her exactly what she's asked for. Then pay attention to her natural body movements and give her something better— shoot her exactly the way you feel she needs to be shot in order to tell her story. Even if she loses sight of her own vision for her shoot, you never should. You are the professional photographer. The images that align with her vision will win out in the end every single time.

One last point about posing is that sometimes a client needs to be pushed a little out of her comfort zone, but if there's a compelling reason to push her there (barring any physical limitation or discomfort that may result in injury), then do it. Never be afraid to try something new. If the pose doesn't work out— big deal; most of us shoot digital these days, so what's there to lose? But if the risk turns into a smashing success, then you've made a big win and she will likely thank you big time for it.

Using real world examples, let's take a more in-depth look at the power of lighting and posing. In the following section, I deconstruct a series of images. A brief description of the thought behind each pose and lighting combo accompanies each image and explains why each was used and how it brought the client's vision to life.

Light and Pose to Tell Her Story

Technical Details

1/80sec

f/6.3

250 ISO

Sigma Art Lens 50mm/1.4h

Background

Tiffany was feeling vulnerable as a result of her pending separation. Facing new territory in her life—the prospect of being a single mom—she felt like she was in a dark place and wanted to tap into the idea of hope, vulnerability, and the confidence she already had everything she needed to get

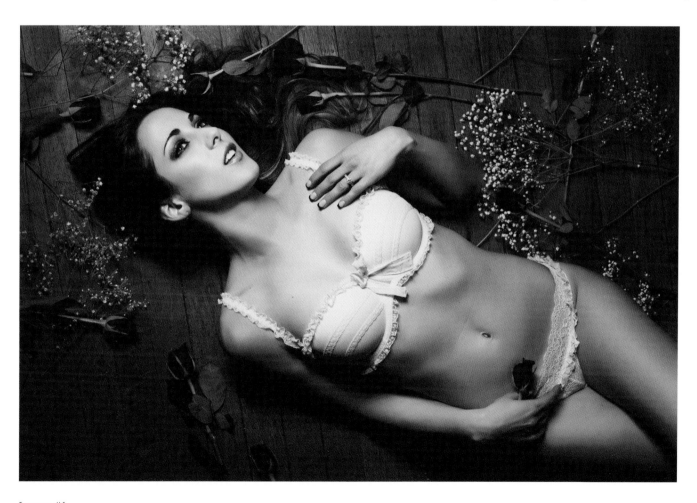

Image #1

through the challenges ahead. She chose a dark attic room for this shot and was surprised to find her emotions coming to the foreground as we shot.

Lighting, Posing, Post-processing

With the exception of a single overhead small bulb, the room was dark. I brought in a single gridded stripbox to create a narrow corridor of light. No other lighting was brought in. Her pose reflects uncertainty and vulnerability. Arms tight to her sides are almost protective. Revealing the wedding ring brings in an important element to her story. The roses symbolize the inner beauty and strength she has as a woman. In post-processing, I added layers of cool bluish tones to depict the cold lonely place she felt she was in at that time.

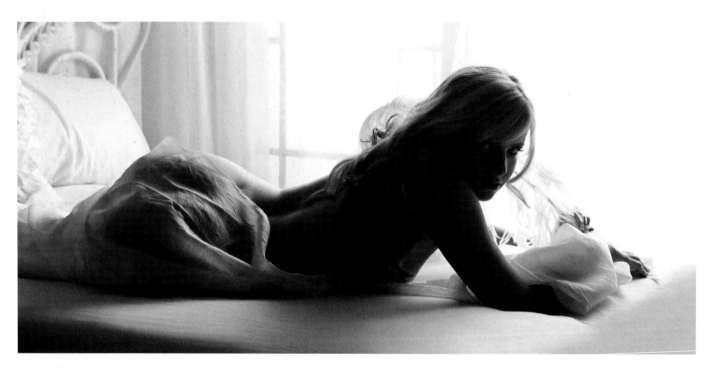

Image #2

Technical Details

1/200sec

f/8

200 ISO

Lens: 24–70mm f/2.8

Background

A single woman, this client wanted to convey the contrasting themes of edginess while also celebrating her soft side. She appeared very quiet and reserved, so we started with the softer set. I will often begin with a soft set if one is to be included

because it works with the client's natural emotional flow—usually they feel vulnerable at the start of the shoot. Using this vulnerability to my advantage in this type of setting can create powerful and beautiful images such as this one.

Lighting, Posing, Post-processing

This set is lit using a single strobe and the 86" Paul Buff Parabolic Light Modifier (PLM) which is set behind two layers of diffusion—a white cloth backdrop and white sheer curtains. This is positioned behind the client. A tall reflector bounced light back in the direction of the model and softened the shadows. Because she was nervous and unsure what to do with her hands, I gave her the choice to play with something—she chose the white ostrich feather. Wrapping the sheer white fabric like a ribbon around her body also mimics the curves of her figure. I had her bring her left knee forward just enough to pop her hip toward me and emphasize her hourglass shape. Peeking back toward me over her shoulder captures a little bit of vulnerability, while the determination in her eyes foreshadowed the edgy set to come. In post, I added opaque layers to enhance the soft, dreamy feeling of the image.

Technical Details

1/200sec

f/8

100 ISO

Nikon Lens: 85mm/1.4

Background

Yvette came to meet me prior to signing up for a session. She was on an emotional journey and, as she was about to hit a milestone birthday, wanted to give herself a gift of self-love.

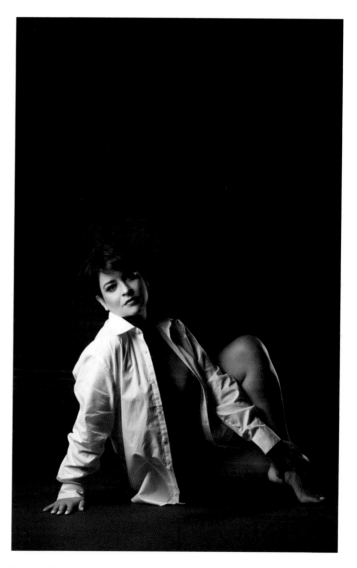

Image #3

The three concepts she chose for her shoot were: Glamour; Unique; and Beautiful at Any Age. Yvette shares, "Self-image was big to me growing up. Never found myself attractive." And yet, when I saw Yvette, I saw a radiant and beautiful woman. We worked together on the concepts that would support her goal. This image stands out for me as it portrays a confidence she didn't think she had. After she received her album, Yvette wrote. "At this time that [inability to see my own beauty] has all changed. I love my images and they make me smile every day."

Lighting, Posing, Post-processing

This is a three-light setup: background light is a 7" reflector dish with 30 degree grid and provides separation from the background; stripbox camera right and aimed toward the client for a rim of light and to sculpt her features; and main light is a larger rectangular softbox with grid set at camera left and angled down toward the client. To create the feeling of strength and confidence, we decided on a strong pose; went with a man's white shirt; and incorporated lighting that sculpts the beautiful strong lines of her face. Shadows were used to strategically minimize emphasis on her least favorite body parts. I shot this image knowing I would convert it to BW in post. As a BW image, the lines of her pose and the sculpting of her features become strong elements in the shot.

Technical Details

1/200sec

f/5.6

100 ISO

Nikon Lens: 85mm/1.4

Background

A shot of one of my spokesmodels, this image depicts glamour, pure sexy, with a little bit of a fashion edge. A mom of two, she doesn't always feel sexy, although, having had the opportunity to shoot her several times over the past couple of years, I can honestly say she is a beautiful woman both inside and out. However, a perfect testament to the wide gap between how others might view us and how we see ourselves is this: when I posted this image on my FB page and introduced her as a spokesmodel, a follower asked if I was going to choose any "real women" as spokesmodels. I challenged her on what she meant by that, as clearly this wasn't a robot posed on a couch. The follower responded: "But she's so beautiful." I let this person know, "We don't always see ourselves the way others do. This model doesn't see herself as beautiful." Although it's hard to fathom sometimes, we as boudoir photographers must be sure to avoid that way of thinking. We can never assume a client sees herself as we see her.

Image #4

Lighting, Posing, Post-processing

This is a two-light setup: a medium rectangular softbox with grid as main, and a 7" reflector dish with 20 degree grid plus blue gel for a pop of cool tones to contrast with the red couch. The pose is edgy and strong and highlights her curves as well as her outfit and heels. She's like a kitten about to pounce. In post, I chose to process color for cooler tones for a more fashion/edgy feel.

Technical Details

1/100sec

f/3.5

250 ISO

Nikon Lens: 50mm/1.8

Background

I met Michelle years ago when a client brought her own favorite makeup artist to the shoot. She and I hit it off. And while she'd always said, "One of these days I'll work up the nerve to do a shoot with you," that day didn't come until 2015 when she opted in on a mini-shoot day (you can read her story in the interview on pp. 66–8, Chapter 5). In line with her goal of creating "captivating" images, we shot this photograph.

Although she'd arrived late, was stressed for being late, wasn't feeling so great, and had a tough time conquering her nerves, this shot captures the inner strength she'd relied on throughout the time she'd been separated from her husband. For this reason, this image achieves its goal.

Lighting, Posing, Post-processing

This is a two-light setup: a small stripbox with grid as main, and a second small stripbox with grid as a kicker. The pose highlights her curves and the shadows lengthen and slenderize her figure. In post, I chose to make the image a high contrast BW because the repetitive patterns in the rug and her outfit became more apparent, and the lightness of her hair, contrasted with the shadows created by the stripbox, provided a stronger separation from the couch.

Image #5

Technical Details

1/250sec

f/9

160 ISO

Nikon Lens: 85mm/1.4

Background

This image is of a bridal client. She was strong, proud of her fitness, and wanted to incorporate the theme of "something blue" using her fiancé's favorite tie. Although I wanted to highlight her strength, I also wanted it to feel soft and feminine (both descriptors of the woman I was shooting). This image achieves both.

Lighting, Posing, Post-processing

Two large octoboxes were set up behind a white backdrop, while two 4x8 reflectors (camera left and right) bounced light back onto the client. I didn't mind flare, knowing it would soften the feel of the image. Her pose shows off her strength and tone, while also allowing for some amount of modesty. The colors (her strawberry-blonde hair against the blues of the tie and underwear) provide a pleasing palette. In post I ensured the blues would be vibrant as they are a main feature within the image.

Image #6

Technical Details

1/250sec

f/2.8

100 ISO

Sigma Art Lens: 50mm/1.4

Background

I met Dayna at a workshop in the fall of 2014, where she had been chosen as one of the models. I was struck by her elegance and how, despite her young age, she had a strength and beauty beyond her years. Only later did I learn her story (you can read it in the interview on pp. 20–3, Chapter 1). After struggling with chemotherapies for two years, Dayna was left without hair. Rather than feel sorry for herself, she directs her energy toward inspiring others! Although she aimed to serve as a role model for others who may be facing a similar struggle, she found her own confidence build through our shoot experience. Her words were: strong, classy, and cool.

Lighting, Posing, Post-processing

Although I'd intended to shoot this segment using only natural light, she found this gothic-style necklace among my accessories and wanted to try wearing it as a headpiece. I loved it! It was edgy, strong, and cool! I wanted edgy lighting to match, so I retrieved a single strobe with narrow stripbox—I knew the light would carve her features and add an edgy feel to the image. The light adds an intensity to her gaze, and highlights the studs on her skirt/garter. To highlight her strong shoulders (and tell the story of her strength in carrying the weight of the world upon her shoulders) I had her pose in such a way that they would appear prominent. In post, I simply played up the contrast a bit and removed the medical port beneath her skin (which she had expressed concern over).

Image #7

Technical Details

1/200sec

f/6.3

250 ISO

Lens: 24–70mm/2.8

Background

I was aware that Liga, a hand model, had been following me for some time on FB. She would comment on my images and reach out to let me know she would be interested in working with me if I ever needed a model. So when she called to sign up for a mini shoot in early 2015, I was excited to get to meet her. She said, "I saw your work online—it had a lot of character—mood, story . . . I wanted to have such pictures for myself, also was curious what my image story would look like." Instead of providing three words to sum up her goal for her shoot, she had one: "Story."

Lighting, Posing, Post-processing

Liga is European and her dark hair and porcelain skin give her a mysterious, almost fairytale princess look. So clearly, I loved the idea of creating an image that hinted at a story! For lighting, I used my 86" PLM behind diffusion material and employed a reflector to bounce light back onto the model. To add to the mysterious feel of the image I shot down from a ladder, making sure to incorporate fragments of a chandelier I'd hung above the settee on which she reclined. In this story, she was a princess living in her underwater palace. In post, I added blue-green layers of tint and soft texture layers to add mood to her story. It was a total success and she loves the image!

Image #8

Technical Details

1/200sec

f/7.1

200 ISO

Lens: 24–70mm/2.8

Background

This client had modeled when she was younger but didn't feel she was as beautiful as I saw her to be. She wanted her images to feel edgy and beautiful, and to reflect her hip personality.

Lighting, Posing, Post-processing

Keeping it simple, I used a single medium rectangular softbox with grid to highlight the lines throughout the image and the contrast in her outfit, hair, and accessories. Although crossed arms can sometimes imply defensiveness, in this instance I'd asked her to embrace herself. The expression of tranquility further adds to the feeling of it being an embrace rather than in defense of something. In post I converted the image to BW in order to emphasize the many lines and areas of contrast in the image.

Image #9

Technical Details

1/100sec

f/2.8

640 ISO

Lens: 24–70mm/2.8

Background

Sandeepa's story can be found in Chapter 7, pp. 94–6. A client I've had the pleasure to shoot several times, I invited her to participate in a shoot for *Body and Soul*—a gift to her for her loyalty. I also knew that her ability to articulate her thoughts and journey, as she had shared them with me several times over the years, would be compelling for readers of this book. For this shoot, her three words were elegant, sensuous, and captivating. As soon as I saw this image, I knew we'd nailed it.

Lighting, Posing, Post-processing

This was shot using only natural light, and a reflector for bouncing window light back onto Sandeepa. A mosquito net hung from the corner of the window allowed her to move on her own, as if in a dance. Having worked with me many times, she knew that I'd be interested in the shapes she could create for the camera. And as everything is white, she pops in the image, so post-processing was a breeze.

Image #10

Technical Details

1/250sec
f/8
250 ISO
Nikon Lens: 85mm/1.4

Background

Jean's story can be found on pp. 154–6, Chapter 12. I'd met Jean about a year prior to our shoot during an inquiry meeting. But when she was diagnosed with MS, she felt an urgency to move forward with a shoot as she'd already begun to feel her body change. When I work with clients who are facing disease or health issues, I want to help them find ways to love their bodies and find peace. Using light to create art from the body is one way to do that.

Lighting, Posing, Post-processing

This image was shot with a single narrow 12×36 stripbox with grid at camera right. The image is simultaneously reflective and artistic. While she approached the shoot knowing she wanted to do nudes, it was tougher to follow through in the moment than she'd anticipated. I shot with my 85mm (the greatest distance the location for this setup would allow) so as to provide her with a bit of privacy and to ease her nerves. I instructed her to engage with the light as if it were sunlight coming in through a window and washing over her body. The result is this image. In post, I opted to go against my natural tendency for cooler tones, and skewed the images warmer to convey the mood we were going for.

Image #11

Technical Details

1/200sec

f/4.5

250 ISO

Nikon Lens: 85mm/1.4

Background

Victoria's story is included in Chapter 21. Shot the week before her double mastectomy, she wanted to capture her body before it would be forever changed. Her three words for her shoot were: memorable, beautiful, and happy. And as a testament to her strength, her entire shoot was exactly that! I was so inspired by her.

Lighting, Posing, Post-processing

This image was shot before a "window set" I have in my current studio (strobe light behind diffusion material). The feeling is one of reflection. She wanted to incorporate this favorite blouse and draw attention to her breasts, which would soon be gone. I shot this crop so that she would forever be able to recall the way her body looked at that moment in time, regardless of how it would look in the future. For this shot, I did not pose her. Rather, I told her to look out the "window" and see what she could find. Holding her favorite shirt against her, her body is attentive and facing into the light. In post, I converted the image to BW, bringing out the texture in her favorite shirt—one that makes her happy, one through which one of her nipples can clearly be seen.

Image #12

Technical Details

1/250sec

f/4.5

200 ISO

Lens: 24–70mm/2.8

Background

Sarah's mother was one of the first supermodels—a beautiful, elegant woman. Although Sarah might best be described as a bohemian, hippy type chic, I wanted Sarah to see the same qualities her mother held in herself. I shot this image to capture her elegance and her graceful beauty.

Lighting, Posing, Post-processing

Lit by two large octoboxes behind diffusion material, with reflector camera left, I encouraged her to interact with the beautiful vase of flowers she'd brought with her to the shoot. This was her pose. In post, I lowered the saturation and applied layers of opaque color to create a soft feel throughout the image.

Image #13

Technical Details

1/200sec

f/5.6

250 ISO

Lens: 24–70mm/2.8

Background

Wanting to celebrate her long-term relationship with a special gift of boudoir images, this client requested soft, romantic images, which reflected her soft-spoken personality.

Lighting, Posing, Post-processing

My 86" PLM set behind diffusion material created a soft backdrop for this image, while a small octobox camera right provided fill. Celebrating her curves, I encouraged her to make slow movements and focus on showcasing the beautiful lingerie she'd brought with her to the shoot. I focused on her beautiful lashes and the result was this shot.

Image #14

Technical Details

1/250sec

f/5.0

200 ISO

Lens: 50mm/1.4

Background

This bride-to-be was a bundle of nerves when we started our shoot! Funnily enough, the shutter on my Nikon D800 decided to combust mid-shoot. Making jokes about the situation, I grabbed my Canon Mark II (which I wasn't super familiar with) and continued on with the shoot. Ironically, this break in tension was all we needed to change the energy in the studio. Right after that, she let her walls down, opened up, and decided to try a fun concept—wrapping herself up in a ribbon and a bow and nothing more. She wanted her images to feel flirty, playful and capture the spirit of her fun personality.

Lighting, Posing, Post-processing

After wrapping my client up in nothing but red ribbon tied with a bow (#lifeofaboudoirphotographer), I decided I wanted the silhouette of her shape without going so dark that I'd lose detail in the ribbon, so I placed her in front of the light source (86" PLM) but this time without the aid of a reflector. The only instruction was that she play with her hair so as to keep her arms up and away from her waist area. Post work was minimal.

Image #15

Technical Details

1/250sec

f/9.0

200 ISO

Nikon Lens: 50mm/1.8

Background

This client wanted to capture retro glamour among her looks. She'd seen a roaring twenties marketing piece I'd created prior to this shoot and decided she'd like to capture that look and feel in her own shoot. It was interesting to watch this modern girl transform into a vintage beauty. But here is an example where having the right team makes all the difference: I'd called in a specialist in retro hairstyles specifically for this look. It went a long way toward helping the client see herself as a vintage beauty and step rather glamorously into the role.

Lighting, Posing, Post-processing

Lit by a large octobox (camera right as main) and a medium octobox (camera left for fill), I encouraged my client to "own" the settee but to allow her curves to steal the show. In post, I decided a vintage toned monochromatic look would add to the vintage feel of the image.

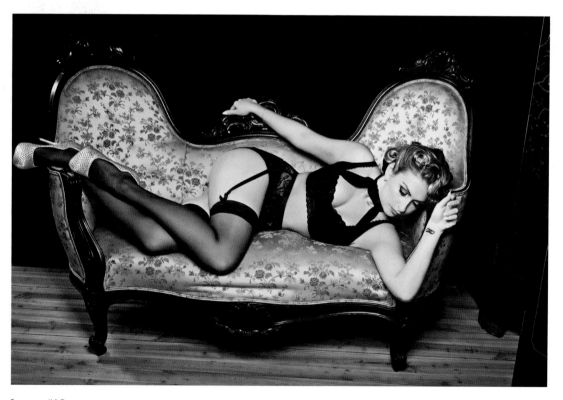

Image #16

Technical Details

1/40sec

f/3.8

2000 ISO

Sigma Lens: 28–70/2.8–4.0

Background

This client makes her living as a professional model. Part of the challenge for models is that you're always being shot to reflect someone else's vision. She wanted to capture her beauty for herself and because we'd met and hit it off during a look book shoot for a fashion designer several years prior, she reached out to me. I was honored by her request as she'd been shot by some serious commercial photographers. However, I knew I offered the unique opportunity to capture her as *she* sees herself. I also knew I had a lot to work with. Not only is she beautiful, but she is edgy, cool, feminine, and, I swear, one of the sweetest people on the planet.

Lighting, Posing, Post-processing

For this location shoot, I challenged myself to work without any strobes. We shot in a rented apartment in NYC for an entire day. This shot was taken as the sun had already begun to go down. Tall NYC buildings blocked any remaining sunlight so there was hardly any to speak of in the apartment at this point, but we were still going strong! Bouncing bathroom light down a long hallway that led to this mirror provided the only source of light for this shot. We were gonna go big or go home! I'd fallen in love with this mirror the minute I stepped into the space but we hadn't yet had the opportunity to

shoot with it. It was in a tough spot as there is very little shoot space in front of it. But the model wasn't ready to go home yet and I figured why not give it a try. We did. And what we saw knocked our socks off. We turned this sweet, cool girl into a vixen. She was tickled pink. And although the image is rather grainy, I think it only adds to the edgy feel of it. And she does too.

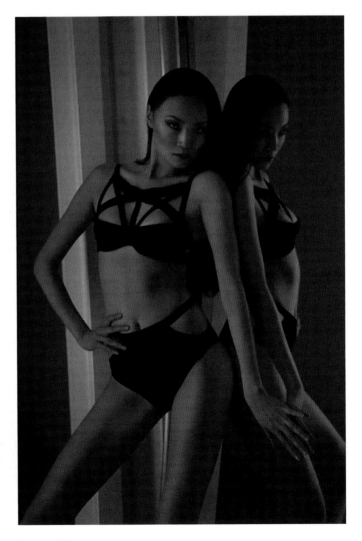

Image #17

Technical Details

1/200sec

f/11

250 ISO

Nikon Lens: 85mm/1.4

Background

This is another shot from our spokesmodel shoot. Wanting to show her she could be "fierce" as well as pretty (which she highly doubted), we created this shot.

Lighting, Posing, Post-processing

For lighting, I set up a strobe with a purple gel behind my spokesmodel at camera right. A rectangular softbox with grid camera left served as the main. The necklace added to the edgy feel and so did the pose—which is unusual. She's lying across a wing chair—it wasn't the most comfortable pose (I know because I tried it first) but as we discussed how a rebel might show she *owned* this wing chair, it's what we came up with. The lighting also accentuates her features and assets. In post, I brought a midnight feel to it by burning a layer of blue over the entire image. Fierce as I knew it would be.

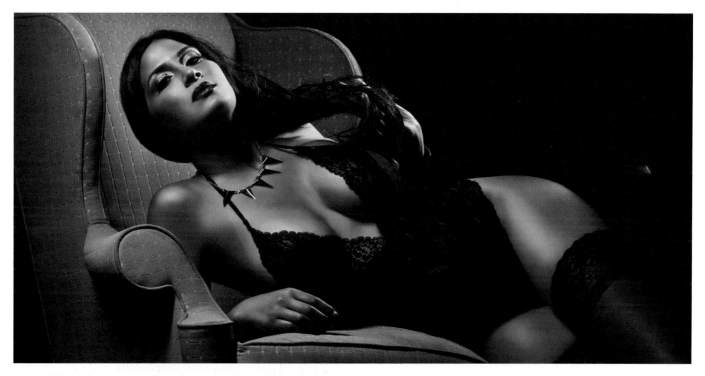

Image #18

Technical Details

1/100sec

f/2.8

1600 ISO

Sigma Lens: 70–200/2.8

Background

When I met Catherine, I was immediately struck by her timeless beauty. I proposed we shoot her in the style of classic paintings I so love. She loved the idea! I wanted the images to feel classic, elegant, and to embrace her curves. She was excited about the prospect and had never seen herself as an artist's muse. She wanted to see what I saw in her.

Lighting, Posing, Post-processing

This image was shot with two narrow 12×36 stripboxes: one above her head and another at her feet. A third strobe lit the backdrop behind the curtains. The pose: I instructed her to mimic a pose in which she might be fainting as the ladies from days gone by were so prone to do (thanks to way too tight corsets). I wanted to capture her curves, but also a bit of mystery, and had her place her hand so her face would be hidden. In post, I applied a vintage tone and chose to go with a monochromatic look. She loved the image and said it gave her confidence and changed how she sees herself. It remains one of my favorite images ever shot by my camera.

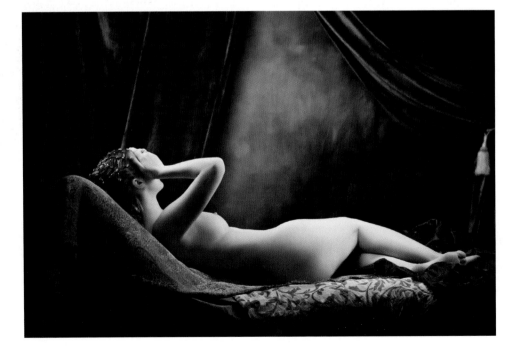

Image #19

Technical Details

1/160sec

f/2.8

1250 ISO

Canon Lens: 50mm/1.4

Background

As a former dancer and modern working mom of two, it's not always easy to feel sexy, pretty, and playful. But that was the goal for this shoot.

Lighting, Posing, Post-processing

Shot in a space between two windows, this image was created using only natural light. I wanted some shadow by her leg on the right side of the image, so I did not introduce a reflector for fill. The unusual stocking pattern adds interest to the legs but also highlights her overall shape. This pose captures her curves while adding interest and intrigue by keeping her face and identity hidden. It's all about her legs! As a former dancer, it's a way of celebrating her past. In post, I felt this image absolutely had to be BW to accentuate the lines and patterns made by the stockings, her shape, and the flooring.

Image #20

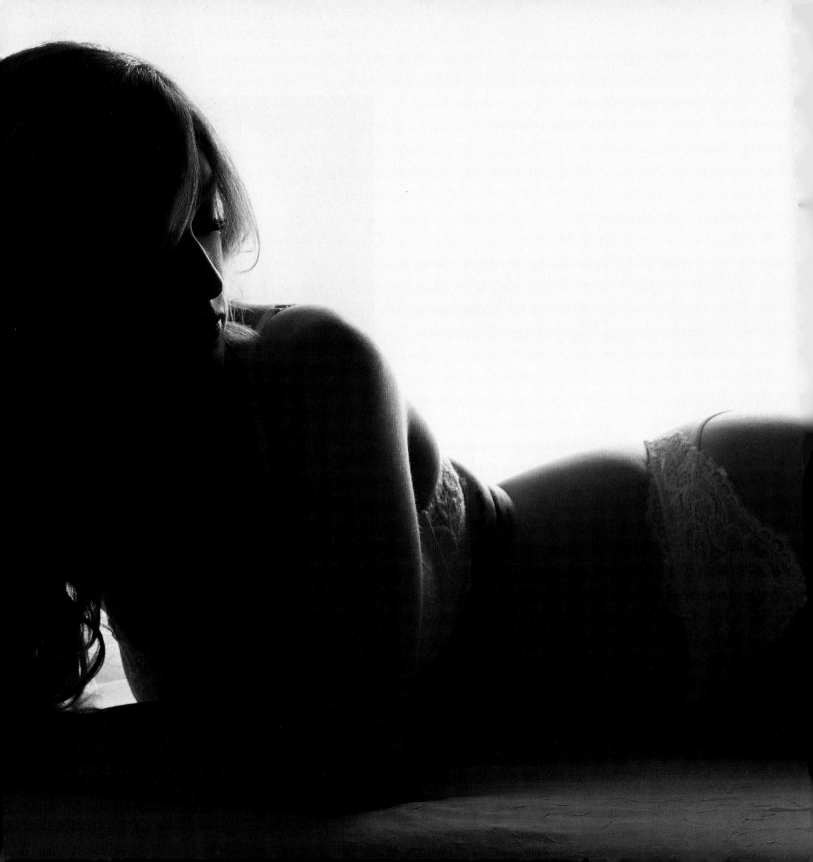

PART 3

AFTER THE SHOOT

Opening the Door to a Long-Term Relationship

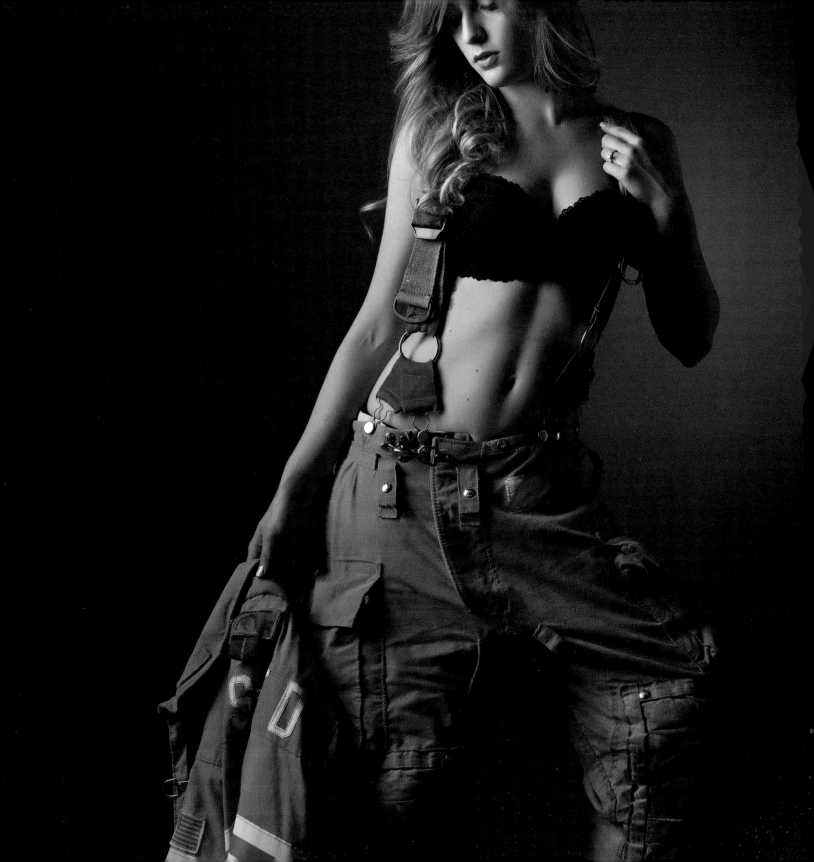

15

Preparing for the Review and Selection Session

A sale is not something you pursue; it's what happens to you while you are immersed in serving your customer.

Author unknown

Between shoot day and the review and selection meeting, your client is on pins and needles. She's excited to see images and can't wait to view the magic you created together. But, with each passing day, she may also start to wonder if they look as amazing as she remembered. She'll be reminded of her body hang-ups and worry these will appear larger than life in the images you captured. She may even, in an attempt to cushion what she perceives as the inevitable blow, lower her expectations and start self-talk somewhere along the lines of, "Well, if I can find at least three or five I like, it will all be worth it."

Don't Forget about Her During This Critical Juncture

Keeping her floating high on cloud nine means reaching out that evening after the shoot, or certainly by the next day, to let her know what a success the shoot was! She'll be curious to know if you've loaded her images; how she performed; and if you think there are any keepers in the mix.

Even if you haven't loaded them onto a computer just yet, take a few minutes to scan through the captures before you reach out so you can honestly assure her that all is well.

I will sometimes send a peek—a snapshot of the back of my camera display if I can manage to get a good one, or a shot of my screen when the first approach fails. When snapping these shots, I make sure to also get the file number in there so we can easily identify it again during the review session.

I never provide files in any form prior to the purchase session. And that goes for online folders full of image files just ripe for the grabbing. Snapshots provide enough of an exciting teaser, while clearly showing they are merely a peek at the real thing. In this way, if she decides to post it (even though she's not supposed to), it's clear to the universe that this is simply a shot of a screen—a proof.

If you haven't yet set a date for the review, now is the time to do it. I've heard horror stories from clients who were left hanging by other boudoir photographers for weeks and weeks, only to find they didn't really like the images all that much once they finally got to view them. I can't help but wonder if part of that disappointment stems from the initial post-shoot excitement having waned to such a degree that frustration then takes over. Women are emotional. For many of us, decisions are predominantly made based on our feelings. It's risky, from a business perspective, to assume a client will still be as excited

about her images several weeks or a full month later. Besides, don't we all know that emotions play a huge role in sales?

People don't buy for logical reasons. They buy for emotional reasons.

Zig Ziglar

Cull and Edit for *Her*

As soon as possible after a shoot I will upload the images onto my computer, and immediately back them up for safekeeping. I shoot in RAW because I never know when I'm going to be asked to create an eight-foot art piece (which I have been). But I also make a duplicate basic JPG version, which I import into ProSelect. If you're not familiar with ProSelect, it's presentation software that isn't exactly cheap, but it's easy to use, and it's one I have found to be insanely valuable. Truth be told, as much as we photographers crave the latest and greatest gadgets, there are, in actuality, few accessories, software packages, gadgets, etc. that I can honestly say have been game changers for me. ProSelect, without a doubt, falls into that category. I am aware some photographers use Lightroom and I have in the past as well, but ProSelect offers other features I find very powerful, for example seeing exactly what an image will look like at a given size on a wall, in a room, or, if you have an image of a space in your client's home, in *her* space. Most clients think an 8×10 is going really big . . . until they see it in actual size on a big wall. If your aim is to sell wall art, and, yes, some boudoir clients do want wall art, then this feature cannot be missed.

Working in ProSelect, I will begin by placing all images in the neutral category. ProSelect is fun to use because it features a smiley face system—favorites go in the smiley face pile; questionable runner-ups go in the neutral face pile; and discarded ones . . . you get the idea. Working in the neutral category, I will quickly go through the images, cropping those I feel might be strengthened by clarifying focus, and selecting BW or sepia for any images I'd like to present in a monochromatic format. I discard the obvious throwaways as I go. I don't yet move any to the smiley face pile, because I don't want to end up with too many similar images in favorites. So once I've worked my way through and dealt with the low hanging fruit, I can now go back and look more closely at the images that remain.

As I sort, deciding which will remain in neutral and which will be moved to favorites (i.e. shown to my client), I am thinking not only about what *I* like best, but about *her*: how will *she* feel about each image? And here's also where taking the time to show her images in camera during the shoot helps tremendously. Over the course of the shoot, she's undoubtedly given me lots of feedback and insight into what she likes and doesn't like. In response to the images she's seen in camera, she's most likely given me information about how she perceives her body. Well, I was making mental notes all along and here is where that information also comes in handy during the culling process.

As I review the maybes, I find I might love an image, but if it draws attention to a feature I already know she's less than

thrilled about, I will *not* show her the image. Why? Because it's not about *me*. I refer back to her three words, searching for the images that are going to best illustrate those emotions or moods, and choose the ones that embody those things. I move them to the favorites pile, but only after I've compared them with like images and have determined which is the best one. It happens sometimes that a particular set or pose group is pure magic and they're all fabulous! These are harder to cull, but I scrutinize them to find the subtle nuances and select one or two that will be the most compelling.

Once I get through this second round of culling, I will click into the favorites pile to make sure I have a good representation of the various sets and poses we explored. Now, here again is where my approach differs from that of many other photographers. I'd like to preface what I'm going to say next by first telling you that I'm by no means implying that my approach is *the* right one—I believe that other successful photographers work in a way that suits their business models, visions, and goals. Each of us has to do exactly that—hence the self-assessment exercises in Part 1. But given my approach, my philosophy, and the experience I am dedicated to providing my clients, I am not inclined to cull the images to such a degree that they only see 30, for example, as some photographers will.

But let's pause for a second. While my preference is definitely to show more images, I'm cognizant of *not* working according to a standard rule that gets blindly applied to each and every client. Here again, I take my client's style and preferences into consideration. I ask my clients about their preference during the wrap-up part of the shoot. *Is your preference to see more or fewer images?* I will ask. Some clients want to see as many as I will show them and then it's up to me to narrow down to a selection I feel is representative, but manageable. Others will

be forthright in admitting if they see too many, they may want too many, and therefore feel disappointed because they know they won't be able to afford to have them all. Still others will simply admit they have difficulty making decisions and express concern that they may get paralyzed. For these last two situations, I'll offer to show fewer, but I know that my clients often change their minds. So, I'll let them know that even though I will narrow down to a smaller number, I will create a second tier of images; should they choose to view the second tier at the review meeting, I will happily show them.

Here's why my preference is to show more images: kind of like reviewing the many highlights from a once-in-a-lifetime safari trip, the image review session is an emotional journey through a one-of-a-kind experience she may believe, at this moment in time, she will never repeat again. By showing her more images, there are several valuable outcomes:

- Her strength, tenacity, and ability to stick it out, despite what she perceives as a challenge, are validated when she gets to see how, despite her jittery nerves at the beginning of the shoot, she nonetheless pulled it together and got the job done; one or two images don't constitute evidence, but seeing several images certainly drives the point home in a stronger way.
- She will feel empowered: the psychologist I interviewed for this book talked about the importance of making your client feel empowered; what better way to empower her than by allowing her to choose the images she will ultimately own (granted, she's doing so from a set that's already been culled for technical, compositional, and other professional criteria).
- You're holding true to your invitation to be her partner throughout the process; you'd be in violation of that

somewhat if you assumed responsibility for choosing the few images she could see from the shoot.

- Seeing a representative sample of all the images shot over the course of your shoot will help her to identify the common threads—she'll start to see that all your guidance throughout the shoot on positioning, posing, and movement made sense; it's common for clients to say things like, "Oh, now I see why you kept telling me to have delicate ballet hands! It really does make a difference!" This awareness will only further solidify her confidence in your talent and vision . . . and you may find you'll earn her repeat business sooner than you think! And next time she'll perform better because she's learned something!

- She gets to relive the experience, start to finish, but this time from a place of pride—all the negative or challenging thoughts and emotions she experienced during the shoot begin to fade away, and herein lies the key gift you can give! Clients have said to me, "I don't even need the images, the experience was the greatest gift of all." Of course they're

kidding about not wanting the images—they certainly do because it's a reminder that they triumphed over their fears and insecurities. This time, when the client cries in your presence, it's because she's so proud of herself and happy to have had this experience.

- She appreciates it! I've asked clients many times how they'd feel if I only showed them a small number of images—the response is never, "That would be great!" Most women would feel they were missing out on something and would resent not having had the opportunity to choose for themselves.

- Over the years shooting boudoir, I've had clients: return for a second collection of images and purchase a second album; request his and her albums with altogether different images; order additional items such as proof boxes because they loved many or all of the preview images; and come back for prints and wall art from images not initially chosen for their album. These add-on sales play a big role in increasing my per client sales averages. And none would be possible if I chose to show a mere handful of images.

A Note on Retouching Prior to the Review Session

Another popular strategy among photographers is to edit and retouch images prior to showing clients their images. While that's certainly one approach, it's not mine. And there are several reasons for this as well:

- For one, if I'm showing 75 images or more, I cannot afford to spend time retouching them first.

- More importantly, women with disorders such as body dysmorphia need to see themselves as they are, straight out

of camera, unretouched. If they know their images have been edited prior to the review, the internal dialogue might go something like this, "Yeah, I know these images only look good because she fixed them already." This way of thinking doesn't do much for her self-esteem at all. When I have clients who share they have disorders such as body dysmorphia, I let them know early in the process that I will not be reshaping them in any way. Their healing process requires acceptance of their bodies. They will never achieve

that if what's provided for them is an already idealized version of themselves right off the bat.

- Even women who don't have diagnosed disorders, but struggle with body image issues (and I assure you that's most women), can benefit from seeing images that are well shot, well composed, shot from flattering angles, and, yes, straight out of camera. It's like this: our worst insecurities—*everyone's going to notice the mountain that's erupted on the side of my nose*—somehow have a way of taking on larger than life proportions. Helping your client shrink those insecurities back down to size by showing her images

straight out of camera can be a life-altering experience for her! She may have held onto skewed beliefs about her body for years or even decades. One client cried after seeing her images during the review and said, "I guess I'd better stop telling myself I have no business being on the beach alongside all these pretty young girls . . . it's just not true!" If we retouch first, we potentially steal this possibility for healing from our clients.

- Some women don't want to be retouched. Period. So, in my studio, retouching—when and how it's done—is, like everything else, performed on a client-by-client basis.

Touch Base and Get Her Excited the Day before the Review

A day before the review, check in with her to see how she's feeling and rev her up one more time for the review; allay her anxiety about the images by letting her know you have plenty of good ones for her to choose from; then confirm the date, time, and location for the review.

Be sure to clarify your guidelines. Sometimes a client will be so excited to review the images, she'll think it's a great idea to invite hubby along, or her friends, or her sister, or she'll decide she doesn't need a babysitter and come with her four year old in tow.

Again, while I handle this all on a case-by-case basis, my general preference is that clients come by themselves so that they can *decide for themselves*. I've seen women give in to hubby's control of the situation when he had absolutely no part in anything up to this moment, and lord have mercy, since he

isn't emotionally invested in the images as she is, he's probably only motivated by one thing: keeping the cost down!

I've seen siblings totally ruin the mood; downplay her achievement; beat down her ego; and challenge her choices. I've seen the conservative friend shut down the more daring choices I know took guts for my client to even attempt—and sometimes she'll accomplish it all in a wave of a passive-aggressive nonverbal.

These scenarios are like throwing water on a fire . . . and lucky you—you just might get to watch your sales go up in a cloud of smoke! So be clear about how the review session works and why.

A final point, and I certainly hope you realize this by now, is that this meeting is ideally, whenever possible, a move-mountains-to-make-it-happen, face-to-face meeting. That rapport you've established; your interactions thus far; the

relationship you've been building; your ability to read her body language and reactions are all so valuable during the review session and in moving forward.

This is the culmination of all your work up to this point! As such a key moment, how could you possibly relegate it to an online ordering page and expect her to: a) be moved; and b) make a big purchase?

Now, prepare yourself to knock her socks off!

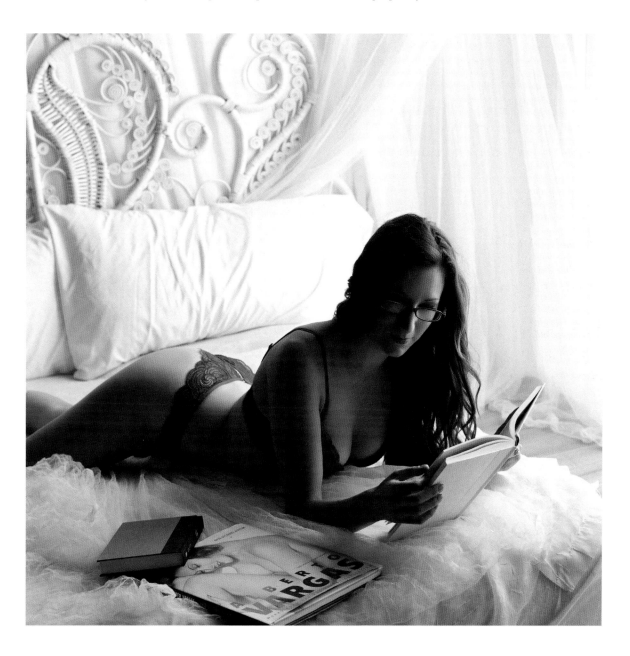

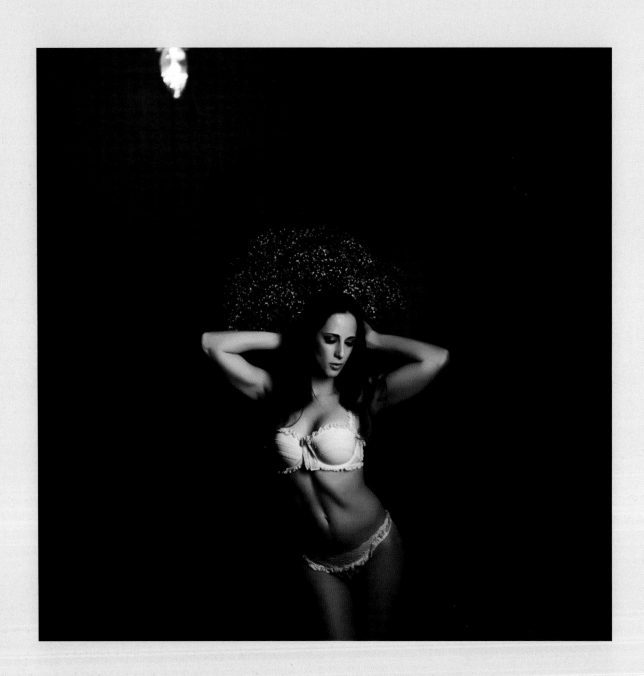

An Interview with Tiffany

Tiffany is a client who was experiencing turmoil in her marriage at the time of our shoot.

What motivates you to pursue a boudoir shoot right now?

I'm at a very strange time in my life right now. Doing my first shoot with you was very liberating for me. I have never felt so beautiful before in my whole life. There are so many emotions that I am going through right now that I feel doing another shoot will enable me to explore them.

Heading into your shoot, how would you describe how you feel?

When I was on my way to the first shoot with you, I was nervous, not knowing what to expect but also extremely excited . . . This time around, I'm more excited than nervous as I kind of know what to expect . . . I've been getting more comfortable in my sexuality and am very interested in new ideas; things that I've never done before and what better way to get a feel for it than to be in a private room with someone you trust and possibly be able to create a scene where I can get a feel for something new? I want to explore my vulnerabilities, my wild side that's been hidden forever, and my fear about the changes that I am making in my life.

What concerns you most?

. . . part of me is a little embarrassed about the feelings I have.

On a scale of 1–10 (10 being most confident) how would you rate how you feel about your body?

Probably about a 7. *(Post-shoot she indicated an 8 saying, "I work out four days a week and eat pretty healthy. I had a baby two years ago and just can't get rid of some of the stretched skin around my belly. But I'm learning to accept that this is the way I'm supposed to look and I'm learning to love my body.")*

Some clients describe the boudoir experience as a roller coaster of emotions. Was it so for you?

By the end of this shoot I felt really great. I felt sexy, calm, empowered. It's an amazing feeling to be practically naked and be able to act out your feelings; something that we don't do on a daily basis. Every woman wants to feel sexy. Every woman wants to love their bodies. That's hard to do in the society we live in. A boudoir shoot is an amazing way to feel amazing and learn to love our bodies.

What was most challenging for you during the shoot?

At one point, I realized, I'm too in my head. I just need to stop thinking and just be.

Anything else you wish to share . . .

This experience just made me feel more empowered. Like I can do anything. Be anything. I'm in the process of going through a nasty separation from my husband right now and this experience gave me just a little more reassurance that I am pretty and worth something. Maybe it sounds stupid, but small things make me happy. Even just a photograph.

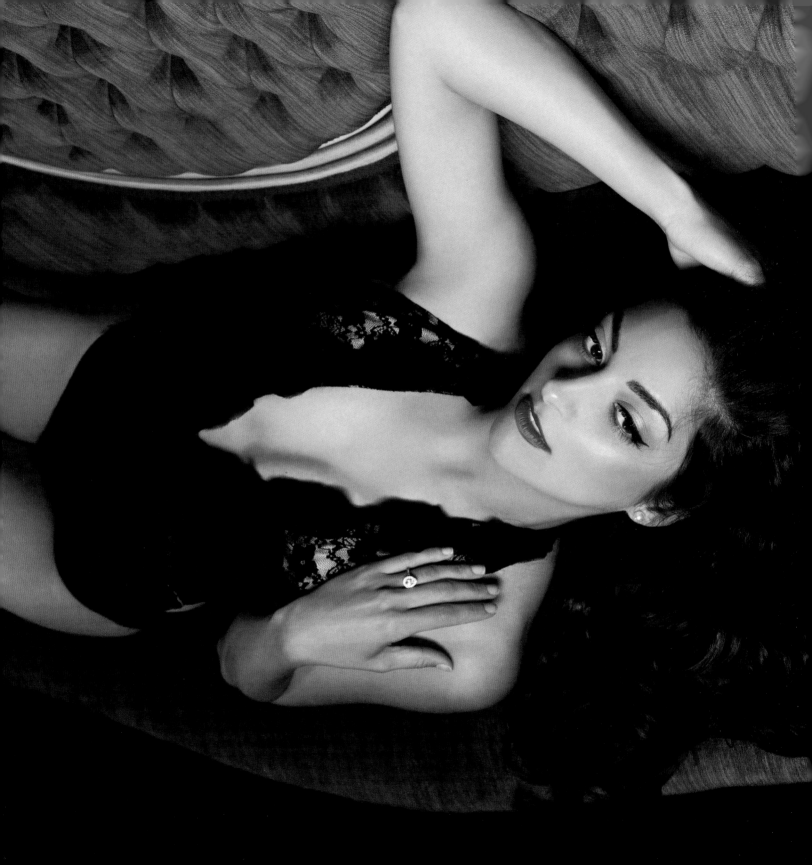

16

Showtime!

I don't win sales on price. I win sales on friendship. I give the "price sales" to someone else. They're the biggest pain in the ass on the planet, and so are the people associated with them.

Jeffrey Gitomer, *Jeffrey Gitomer's Little Red Book of Selling*

Three Ways to Ensure This Meeting Is a Success

1. Get Yourself Mentally Prepared for the Sale

Some people are naturals at selling, while others, such as myself, are not. I believe I'm in good company in the portrait photography industry, based on the many articles and websites dedicated to pumping photographers up to sell. The problem is we love what we do, and so we feel awkward charging for it. But if you want your business to survive, you have to get comfortable with getting compensated for the value you provide to others. Jeffrey Gitomer, in his book *Jeffrey Gitomer's Little Red Book of Selling*, which I picked up on a whim but now carry with me everywhere, says the key to effective selling through relationship building is to: " . . . 'sell to help the other person,' and let your sincerity of purpose shine through." This idea makes "selling" feel much more natural and in line with my mission, and transforms sales from this scary monster of a thing to a natural part of what I already do.

Perhaps, though, the single most important thing I've learned about the sales process—and this was emphasized in a pricing workshop I was fortunate enough to take with photographer and business woman extraordinaire Megan

Dipiero—is to *stay out of the way*. Present the culmination of your work together; blow her mind; present your pricing; and then sit back and shhhhh . . . let her soak it in. Awkward as the silence may be, she may just need to mull things over and play out the internal struggle between heart (*I love these images!*) and mind (*You're going to pay* what *for pictures?*).

2. Have Your Sales Tools and Samples on Hand

If you've read it once, you've read it a million times—you can't sell what you don't show. A few years back I showed lower end photobooks almost exclusively. I had one, perhaps two, higher end small albums that maybe I showed . . . and maybe I didn't if by my own estimate the client probably wouldn't be able to afford it.

Honest to goodness, I want to travel back in a time machine, find that me, and smack her in the head! What was I thinking?! Flash forward, and what was my high end album back then has been replaced by an even higher end album and guess what? That's *the* album I sell 95 percent of the time to clients from all walks of life.

I've learned a valuable lesson about judging my clients—trying to guess who will buy what is wasted time and could be damaging to your sales efforts. I've had young twenty-somethings scrape together funds for my best album, while wealthy soccer moms, with $15,000 worth of shoes in tow, went cheap and bought the least expensive album. You never know!

In any case, that my best album is selling almost all of the time means one thing: it's time to upgrade again, because if you're selling your top products consistently, that means there's certainly room for growth!

3. Revisit Her Goals

What were her three words? What insights into her hopes and dreams did she share throughout your interactions? What might she have expressed as her desired outcome during the shoot at the height of her excitement?

Consider the images you are about to present to her—and determine how you can connect the outcomes directly to her vision. She'll feel ownership in having created the beautiful images and be proud to see herself reflected in the art you've created.

Presenting the Results of Your Work

On review day, I'm generally just as excited to show her the images as she is to see them! The review takes place in my cozy lounge space (where she was first introduced to my studio and had her look transformed). Nine times out of ten I'm greeted with a huge hug, which is fabulous! The feeling is like old friends reuniting. When you build a relationship with your client, you come to like one another, trust one another, and that trust and like leads to them wanting to invest in your services. Jeffrey Gitomer, in his awesome book *Jeffrey Gitomer's Little Red Book of Selling*, sums it all up when he says, "Make friends before you start, or don't start."

When you don't build trust, and like for one another, or even friendship, you minimize the value of the experience. And when you minimize value, you leave the client no choice but to focus on price. That, my friend, is always a losing scenario.

Upon her arrival, I'll offer her a beverage or snack, but she's so excited to see her images that's usually the only thing she wants to know about. So we'll chitchat for a minute before we get down to business. I'll give her a few points of information regarding what we'll be looking at (e.g. straight out of camera, no retouching, some have been cropped, some are shown in BW but we can change that, etc.). And then the show begins.

I'll remember what music she requested during her shoot, and set that up so it softly plays as a backdrop to our review. While the music brings her back—emotionally—to the shoot day, she is now getting to see the shoot from my perspective. I begin the slideshow and quietly observe, making mental notes about which images elicit the strongest reactions from her. Usually, the reaction is immediate and strong.

If she's not jumping around with wide-eyed disbelief, it's probably because she's the quiet type—but since I've come to know her, I will have already anticipated this. I will prompt the quiet client for her thoughts here and there, careful not to disrupt her enjoyment of the presentation. It's easy to assume

just because she's not expressing herself outwardly that something may be wrong. But some people—usually the introverts—are just so used to living in their internal worlds that they forget to verbalize or outwardly express what's going on inside. Prompting her gives me valuable information I need to move forward.

Make It Emotional: Why Not? The Process Has Been All Along

At first, clients will often say, "It's so weird to see myself like this." Or, "I don't really see myself this way . . . " Their eyes never move from the screen as they stare in disbelief. *Is that really me?* Some women will tear up, others will simply be overjoyed, while others will sit almost mesmerized the entire time as they review their images.

"How do you feel?" I will ask once the slideshow is over, because I really want to know. You see, it's not about the images. *Are they pretty?* and *Do you like them?* are not the questions I want to be asking. And that's the whole point of this book: it's about tapping into the emotional journey involved in a woman taking up the challenge and celebrating her body when she may have spent most of her life hating her body or wishing it was different. *How do the images make her feel? That* is what I want to know.

It's helpful to her to hear her own voice, speaking out loud, saying: "I feel amazing!"

In that one sentence, there it is:

- value;
- your mission fulfilled;
- the reason she will go and tell everyone about you;
- her incentive for coming back over and over again.

Some of my repeat clients will jokingly accuse me of being addictive. Of course, it's not *me* they're addicted to; it's the experience—the way it makes them feel in the end. They realize that when they stared down the barrel of your lens, they came face to face with all their fears, all their insecurities, their struggles, but also their deepest wishes. And they emerged triumphant. *That* is the gift you give them. *That* is why your value can never be whittled down to a simple price on paper. *That* is why you can never simply hand over all your hard work on a disc at bargain basement prices.

Let Her Tell You Which Images Have Accomplished Her Goal

By the end of the slideshow, she's excited about grabbing the reins and playing her part in the selection process—remember you're partners! If we're eliminating the second tier altogether, I'll dump those images and move my favorites, which she's just seen, into the neutral tab. This way we start with an empty favorites grouping.

I show her how to move her favorite images out of the neutral and into the smiley pile, and I provide support as she mulls over which images she likes best. The whole time I encourage her to ask questions and we discuss the merits of one image over another.

I will explain how I see the images from a photographer's perspective, using terms like composition, lines, and lighting. She's always grateful that I'm treating her as an equal, and she both appreciates and values my perspective. Again, engaging her in your thought process further solidifies your expertise in her mind. "That's why you're the expert!" she'll say, still happy to have a part in the final culling.

But, just as important, I want to hear her thoughts as she's going through the images. I want to hear why she likes one image over another. This information is important because we've established a relationship. Should she choose to come back again in the future, this information will only add to the reservoir of information I already have about who she is—her likes and dislikes—and it will enhance our experience during our next shoot. Also, hearing herself speak out loud about how the images fulfill her vision and what they mean to her solidifies their value for her.

As we work together to narrow down to the images she feels she must own, I remain very attuned to her emotions. Sometimes, and this usually happens at the very beginning of the culling process, she will not want to delete anything. The idea of losing precious images that represent her emotional journey might create anxiety for her. When I observe this anxiety, I quickly provide a solution: I mention she can have all the images I've presented in a beautiful proof box, and I show her a sample. Problem solved = sold!

With that peace of mind established, she can now focus on narrowing down to the images that will make up her album or image portfolio, and our conversation shifts a bit; now that we've established that the images are all beautiful, we discuss which ones will work best as a collection.

Speak, but Then Be Sure to Listen

In our society, being an extrovert (a term which describes the outgoing people in our society, those who are energized by social settings) is valued higher than being an introvert (a reference to those we observe as the shy and more reserved individuals in social settings). But being self-aware and introspective—strengths more aligned with the introvert—is extremely beneficial in the context of boudoir photography.

As an introverted boudoir photographer, I provide my clients with the information and support they need, but then I give them the space to work through their thoughts. I am able to do this because I am well aware of what my internal models are. What drives the manner in which I work with my clients is not the idea that I'm the expert and I know best. Instead, it's the understanding that she will naturally be most drawn to the images that say something important about her and who she is right now. Because I've already eliminated the images I felt did not work technically or within the vision she set forth, there's no risk in allowing her the freedom to engage in this exercise. The entire time I engage with my client I am observing not only how she is feeling and reacting to the images before her; I am also observing the role I'm playing and how I might be either supporting or hindering the process. This is an ongoing assessment throughout our time together.

Creating a quiet space in which she can work through her thoughts also has the benefit of leaving room for her questions. If you're speaking incessantly, she may not be attuned to the questions she might want to ask, or be able to get a word in edgewise so that she can ask them. Be sure you're comfortable with silence. In the sales process, it's a helpful tool.

Speak . . . then listen.

Most people think "selling" is the same as "talking." But the most effective salespeople know that listening is the most important part of their job.

Roy Bartell

Show . . . Then Ask for Her Thoughts

Asking open-ended questions (questions that cannot simply result in a yes or no answer) during the review session can be a tremendous aid to her in thinking through what she'd like to do with the images. It also gives you the opportunity to address anything that might be on her mind.

Questions like "What are your thoughts about this particular series?" or "When you envisioned images that depicted strength (one of your three words), which images do you feel speak most strongly to that?" Keep her focused on her goals; show her that everything up to this point has been in direct response to her vision; and support her throughout the culling process.

Manage Her Expectations Regarding Retouching

Since my preference is to show a representative sample of the entire shoot, I do not retouch images before the review. Instead, I:

- guide my client in choosing flattering outfits in the first place;
- take my time when shooting so I avoid truly unflattering angles, lighting, etc.—if it doesn't look good as I peer through

the lens, I do not take the shot; instead I shift my angle until I find something I do feel is worth capturing;

- cull to eliminate any images that, in retrospect, I worry she may feel are unflattering.

By taking these steps, the argument about how cruel it is to show a woman unretouched images has been made irrelevant. My goal is to shoot beautifully in camera so that she'll be struck by how great she looks in camera, rather than distracted by her perceived flaws.

Isn't that more empowering?

Granted, women being women, some of us would prefer to know that common "problem" areas (like cellulite, stretch marks, spider veins, puffy tummies, and such), should they show up even remotely in any of the images, can be eliminated.

If I perceive she is hesitating over images she clearly likes but for some reason isn't pulling the trigger on, I will say, "It seems you keep coming back to this image; can I ask, what is stopping you?" If she hasn't been courageous enough up to this point to directly ask, "Can you get rid of that?" now is her opportunity to say, "Well, I love this image, I just don't know if I like the way my thigh looks here." At that time, we can discuss the role of retouching and the level to which we agree retouching will be done on her images.

Requests regarding retouching run the gamut, and are a completely personal choice. A woman should never feel you are judging her for her perspective on it! These diverse perspectives are *the* reason I will not do retouching prior to showing clients their images. Some women want absolutely no retouching done to their skin and body whatsoever. None! Others would have excessive requests if you allow them, but I gently let my clients

know (early in the process) I will not do excessive edits . . . and then I inspire them with the reasons why. The majority of women, though, fall somewhere in the middle—owning their shapes and sizes, but requesting that the common problem areas I mentioned above be softened. Fair enough! That's a total "can do" in my book.

I feel it is harsh to tell a woman that she should *not* want to have any retouching at all. Just as the psychologist I interviewed talked about fat shaming, I see this as a different kind of shaming.

Telling a woman she should not want to look a little like the women in the magazines—so long as magazines continue their ridiculous insistence on the façade of perfection—only makes women feel more guilty about asking for retouching.

Now, do I agree magazines take it to a ridiculous level? Yes! We *should* be actively protesting what they do—particularly when the proportions they sell us on as "ideal" don't even align with anything that's remotely human, and particularly when the "face of beauty" they present doesn't even represent a growing majority of Earth's population!

So, in the meantime, eliminating cellulite, removing veins and stretch marks, and minimizing a puffy tummy shouldn't be illegal—it's not going to fundamentally change who a person is, or make them unrecognizable. Truth be told, a loving significant other probably doesn't even see her flaws anyway; I know this because I'm always surprised when I compare before and after images of a client I may have gently retouched: the after image is always how I saw her all along!

A Word about Outsourcing Retouching

I had a nightmare one night. In it, I outsourced retouching of a client's images to a foreign group. Not respecting my copyright—how could it be enforced in a foreign country?—they plastered their city's billboards and businesses with her images. And in a stroke of bad luck (remember this is a nightmare), my client visited the country and was appalled to find her naked body everywhere. The residents of the city all pointed and stared at her as she walked by.

I woke up sweating. Now while you might think this story is far-fetched, and while I admit I have never heard of this happening to a boudoir photographer (yet), I have heard of boudoir images being stolen and used to market products online, and I do know a wedding and family photographer whose client did travel to a foreign country to find an image of their family up on a billboard selling some product they'd never heard of before. This story was probably the source of my nightmare.

Bottom line: here's my advice—you've worked hard to build trust with your client. Be sure you keep it. If you outsource retouching, let her know. Some women are not so keen on the idea of having their images handled by anyone other than the photographer they hire to do the job. Be up front about your process, and give her the option to decide it's okay, or that it's not. After all, it's her body.

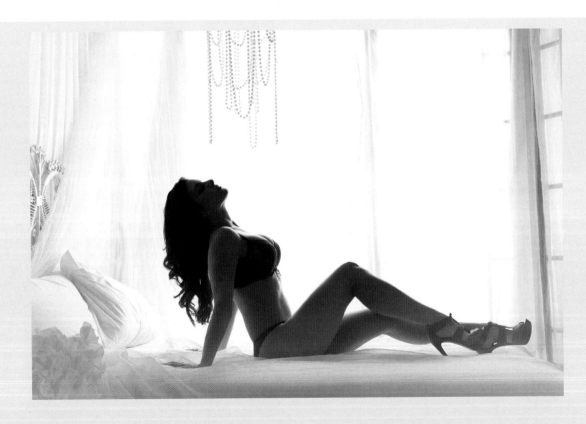

An Interview with Jamilyn

I had the pleasure of shooting Jamilyn in early 2015 and hope to work with her again in the future.

What motivates you to pursue a boudoir shoot right now?

I have noticed age creeping up on me in the mirror. I wanted to preserve and grab a hold of my youth in beautiful photographs.

Heading into your shoot, how would you describe how you feel?

Definitely excited with nerves.

What concerns you most?

Posing and not looking awkward. I am not a professional.

What are you most excited about?

That I know Susan will help me look my best! She is so comfortable to work with!

On a scale of 1–10 (10 being most confident) how would you rate how you feel about your body?

I would say 8.

Some clients describe the boudoir experience as a roller coaster of emotions. Was it so for you?

I was nervous that I wouldn't like my hair and makeup—but I loved it. It was very exciting and fun during the shoot and by the end I felt like a pro!

What did the photographer do specifically that helped ease any anxiety or fears?

Showed me poses!

Once you saw the images from your shoot, what was your reaction?

So happy! Even unretouched they looked great.

Aside from beautiful images are there any other positive outcomes from your boudoir experience?

Well yes—I believe I became pregnant the night I presented them to my husband!

Acknowledge Her Contribution to the Process

Once you've whittled the good ones down to the absolutely must-have group of images she will proudly call her Collection, be sure to acknowledge her role up to this point in serving as your partner. She should be entitled to feel proud of your collaborative success. She helped identify a vision; worked with you to design a shoot around it; and has now culled through to arrive at images that mean everything in the world to her and will soon as well to her significant other (assuming there is one).

It should feel like a huge achievement to her, because it most probably is one. And now, riding on this cloud, she can head into the ordering process, determining which album is going to be suitable for housing these beautiful images she's so carefully chosen.

Seal the Deal

I begin the product review by showing her the top fine art album and then the second and third tier albums. These three different albums are from three different companies and accommodate different personalities and aesthetics. I stack the size differences so she can see what a 6×6 versus 8×8 versus 12×12 looks like.

Oftentimes, she'll ask, "What does everyone else do?"

Here's my chance, yet again, to point out that everyone is different, that it's really about what she herself wants to have, how she wants to display her images, what meaning these images represent in her life . . . and so on. More often than not, she will go with the best album—because her experience has delivered clear value; because she considers this an experience of a lifetime; because she trusts that when I tell her this is the best album, it is; and because she is proud of the images she's played a significant role in creating.

My website offers price ranges, but nothing more specific. During the review session, I will show them the pricing menu if they ask for it. But interestingly, most do not. They simply choose the album they want and then confirm its value.

Now that my client is sold on the value of my service, has seen the results of our collaboration, has narrowed down to the images she absolutely must have, and has a better sense for how labor-intensive boudoir photography is, suddenly the prices don't seem so ridiculously high. Even if she hadn't anticipated spending more than a certain amount, it's easier for her to justify the cost now because the product is paired with an experience unlike any other she's ever had. And while payment is generally due in full at the time the order is made, I must be consistent in my promise to be flexible in accommodating each individual. For those who extend a bit further than they initially thought they would, I will create a payment plan, and this plan is customized to her specific situation. In no instances, however, does a client walk away with a product that isn't fully paid for.

On rare occasions, I will have a client who wants more than she can afford. I handle these situations delicately because I never want her to walk away feeling disappointed. If we need to whittle

the number of images down a bit further, I help her do so in a way that feels painless. If she needs to aim lower on the level of album, I assure her that each of the albums I offer is a winner. In the digital culture of today, I must fight against the feeling people have that they need to have 600 images. From the beginning, I tell my clients the goal is to have the best of the best; each image should stand on its own as a powerful symbol of their experience and collectively tell their story. Reminding them of this during the review shifts their focus in a positive direction and helps them accomplish the task of letting go whatever they need to in order to walk away 100 percent happy with their purchase.

Things to Watch For

Confidence in your service, and in the experience you've provided your client, will carry you through the review and selection session. Just be sure to:

- acknowledge and integrate the emotional nature of her journey in the review and selection session—her buying power is fueled by her emotions;
- cull the images based on *her* decision-making process— she may not be as emotionally attached to the images you prefer for technical or other reasons (again, see the first bullet);
- identify cues that your help is needed—ask open-ended questions and help her clarify her thoughts; provide your perspective on the merits of a particular image and help her break whatever block she might be experiencing;
- allow her thinking space without too much of your sales talk;
- acknowledge her role in your collaboration;
- ensure your approach to retouching her images will result in the best outcome;
- discuss her expectations regarding retouching;
- be up front about your outsourced retouching practices;
- take her order while her enthusiasm is at its highest;
- stick with a policy (such as payment is required in full at the time of the order) that ensures your profitability;
- be clear about client-specific payment plans: provide details about when and how many installments will be made;
- ensure your client walks away feeling completely happy, comfortable, and satisfied with the review session.

Partnering and assuming a problem-solving approach can get you past any hurdle or challenge that might present itself during the review session.

Once you've successfully gotten through this session, she will be eagerly and enthusiastically awaiting the final results of your work. This is also a great time to provide her with any referral incentives you may have in place, or extra business cards at the very least, so she can put all her bubbly energy to good use! I often pair cards and incentives with a sneak peek of an image she will undoubtedly share with all her friends and family. The peek keeps her enthusiasm high and will buy you time to edit and order her art products.

Note: Pictures have a way of moving people to action more successfully than words and a business card alone could ever do. It's better to get the referral engine churning sooner rather than later.

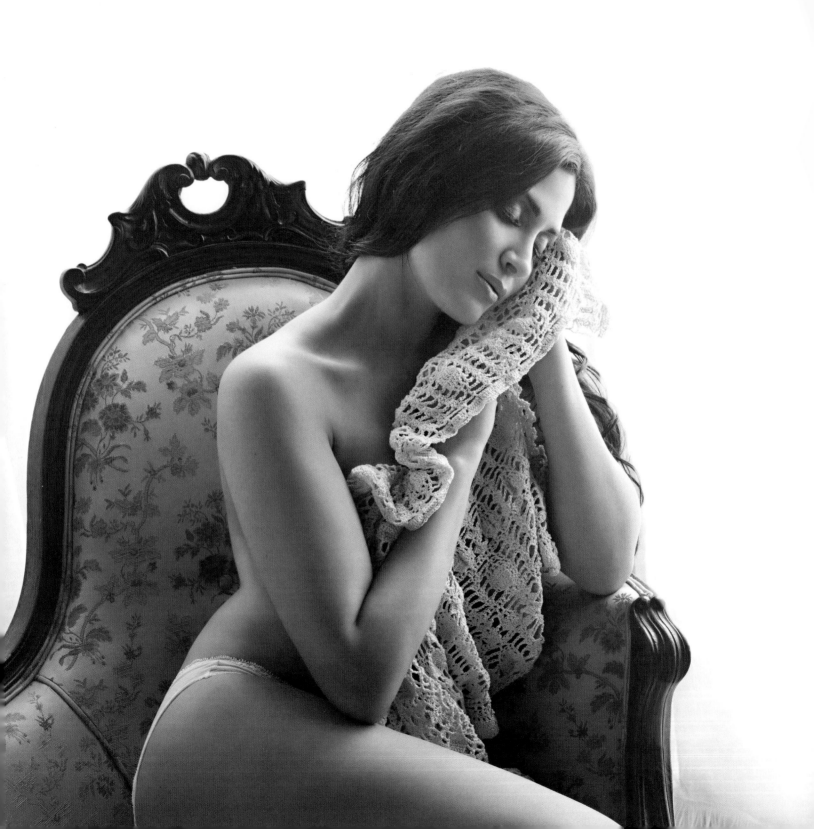

17

Keeping Her in the Loop

There are no traffic jams along the extra mile.

Roger Staubach

As you can imagine, she is feeling head over heels in love with her images and is overflowing with excitement; she can't wait to share her heart and soul with the one she loves. If she did this as a gift for herself, then that someone she's undoubtedly renewed her love for . . . is herself—the most important person of all! Above all, through this experience she's proven to herself that she is without a doubt beautiful, sensual, and well worth a little bit of pampering.

You, on the other hand, are feeling happy the meeting went well, and overjoyed with your sale, but you also know you have some work ahead of you. You must polish your images to perfection, order her products, and ensure everything arrives in perfect condition—just as you'd envisioned, and in time for her wedding, anniversary, birthday, or even if there's no specific event, in a timeframe that meets her expectations.

And here's where things get tricky. Up to this point, she has been your sidekick, your partner in the process. But now, it's all up to you. If you go all radio silent on her, she'll feel like you've abandoned her. As the days and weeks go by she will wonder what you're doing and how her images are coming along. A day will feel like a week, a week like a month. Her eagerness to have everything yesterday might cause her to start leaving messages on your phone, on top of emails in your inbox, in addition to posts on your FB page expressing her anticipation for the final product, and inquiring about when she should be expecting to have her materials. This, of course, will happen while you're: attempting to manage numerous clients at various stages of the engagement process; juggling shoot days with editing days; and managing the gazillion other responsibilities involved in running a boutique business. Forget about your personal life. Needless to say, it can get overwhelming.

Setting Expectations and Establishing Timeframes

Setting expectations is the most important thing you can do with your clients. Not once, not twice, not even three times, but over and over again throughout your process.

I repeat key information about the post-shoot process and timeframes to my clients at numerous points throughout the engagement. I hadn't even realized how many times I do until I created this list!

- When they first visit my website, my info page clearly outlines post-shoot working timeframes . . .

- . . . but since I never assume visitors to my site actually

read anything, during our initial exploratory phone call I mention it . . .

- . . . and because I don't expect them to remember half of the firehosing I give them during that first nervous phone call, it's on my contract . . .

- . . . but because everyone knows no one ever reads a contract from start to finish . . .

- . . . I casually mention it at the shoot . . .

- . . . but because their nerves are shot to hell and they're so preoccupied with the slew of emotions flooding them during the shoot, I mention it again at the wrap part of the shoot . . .

- . . . and since I'm well aware the endorphins swimming in their bodies are clouding their headspace, including eardrums, I provide a double signed copy of the contract and let them know that info can be found on there, on my website, and of course by reaching out to me . . .

- . . . and I know well they won't read the contract or my website, so I send a follow-up email after the shoot thanking them for a great shoot, confirming their review session date, and reminding them that they should try their best to keep their review date because the post-shoot X-week working timeframe only begins once we've had our review session . . .

- . . . but of course they either won't remember or won't read that part of the email, so they'll show up to the review session and the first question they'll ask once they have chosen their images is "How long will it take for me to get the finished images?" so I'll answer the question . . .

- . . . and the next day I'll send another thank you email and remind them that I'll be in touch in X weeks' time with their finished product . . .

- . . . but it won't matter because they're just too darned excited! And that's a good thing!

What's bad is if they or you, or heaven forbid both of you, end up frustrated and ruin all that beautiful juju you've established up to this point.

When things get a bit nutty, breathe, and keep in mind her excitement is merely getting the better of her. Take it as a compliment. Keep reminding her of all you have to do in order to get her a quality end product, and if it helps, offer a rush option—just be sure to attach whatever incremental fee is going to make it worth your while; you know you like to be up at 3 a.m. editing anyway, right? Well, hopefully not, but you get my drift. Besides, a rush fee will provide extra income . . . but if she opts out on rushing her book, well then she has no business pestering you, does she? Pure psychology! (See mom? I *am* using my master's degree!)

Maintain the Excitement and Deliver on Your Promise Until the End

So, how do you keep the client excited when your turnaround time might be six weeks or more (assuming you're working predominantly with albums, as I do)? Following are some helpful strategies:

- Encourage her to follow you on Twitter, Facebook, Instagram, Pinterest, and any other social media platforms you use regularly—by following you, she'll see your activity and know you're busy; it won't feel as if you've disappeared off the face of the Earth as much.

- Somewhere along the way, in between review session and arrival of her purchase, send her a fully edited sneak peek in the form of a web sized file she can keep on her iphone or ipad—read portable; it will feel like having you in her back pocket . . . or at least her purse; but it will buy you

time and it will serve as evidence that you're making progress;

- Give her updates during important milestones: "Hi! I just ordered your album today!," or "Great news! Your album just shipped from the printer and is on its way—would you like me to ship it to you or would you like to set up an in-person meeting once I have it in my hands?"

By keeping her updated, she'll get that old partner feeling again and be so happy to be back in the loop!

Deliver Her Treasure

Once I've received and quality-checked her photography products, I will call her to personally deliver the good news. Here, again, rather than have a standard protocol that requires a client come to me to pick up her album and other goodies, I give her the option of meeting in the studio, meeting over coffee, or shipping it directly.

Perhaps it's a location thing. I'm located on Long Island, which is outside of NY City by about an hour or more. I draw not only local Long Islanders, but also folks from Manhattan, Queens, Brooklyn, Staten Island, Bronx, Westchester, Connecticut, and upstate New York. But I have also had clients travel from other states such as North Carolina, Maine, and California. Giving her the option of how she'd like to obtain her beautiful albums is good customer service as I see it, and she appreciates having a choice.

Shipping it doesn't mean your final art product will make any less of an impact, and her request for shipping doesn't mean that she's any less excited. Sometimes it's merely a matter of getting it into her hands as quickly as possible when work, childcare, and shoot schedules don't always accommodate an ASAP meeting. Whether I ship or prepare for pick up, everything is always beautifully wrapped, tied up with a ribbon, and topped with a handwritten note.

Add a Personal Touch: the Gift of Surprise

In addition to the time I take to wrap and present each client's albums and products beautifully, I also like to add a personal touch of some kind—a special surprise that lets her know I was paying attention.

It could be a Wonder Woman mug, a calendar with inspiring quotes for each month, or something relatively low cost they might have expressed interest in ordering down the line (like a print, or an accordion book). In any case, it's always something I know she will appreciate because it's unique to her and directly links back to a conversation we shared.

I never give her the heads up that it's coming. I let it be a sweet surprise. Making this gesture lets her know she's valued; it also makes you memorable. Few business owners make an effort to stand out. And just as the opening quote to this chapter reads . . .

There are no traffic jams along the extra mile.
Roger Staubach

Measure the Impact

Feedback is any business owner's ongoing barometer for how they're doing, as well as an opportunity to identify areas for growth and improvement; asking for feedback also demonstrates to the client that you care about her experience. Once I know the client has shown the album to her significant other or, if it's for herself, has taken time to review it, I will reach out and get her feedback . . . that's of course if she hasn't already texted, emailed, or posted rave reviews followed by a minimum of four exclamation marks!

See, at this point there should be no surprises. I don't understand how some people say, "Well I went to another photographer but when I finally got the book, I wasn't happy."

My question is always: "How the heck did *that* happen?" Wasn't the client part of the process? Didn't she have a say? But then I learn, nope. She did not. What a sad, missed opportunity.

Gathering her feedback closes the loop . . . for now. Thomas J. Watson Jr. said, "Whenever an individual or a business decides that success has been attained, progress stops."

Remember, the relationship isn't over—you've made a friend! And by treating her as such, she can't forget you, and you can't pretend she never came into your life.

So what should you do? Read on and find out . . .

An Interview with Adrianna

I had the pleasure of shooting my client Adrianna several times.

What motivates you to pursue a boudoir shoot right now?

Expanding my modeling portfolio was the first reasoning. Secondly, I want pictures for myself so that when I get older I will be able to appreciate my days of youth. Thirdly, the experience.

Heading into your shoot, how would you describe how you feel?

Nervous was definitely a first emotion. Doubting myself caused me to feel this way. Thoughts of "did I lose enough weight for this shoot?" crossed my mind a lot.

What concerns you most?

Honestly? Not looking fat . . . being exposed and vulnerable; laying it all out on the table. It's a very scary thing. You can always hide under a bulky sweater or jacket, but there's NO hiding in a boudoir session. It's challenging to let go and be free; to trust your photographer and put all of your insecurities into their hands.

What are you most excited about?

Feeling like a supermodel.

On a scale of 1–10 (10 being most confident) how would you rate how you feel about your body?

7. (Post-shoot she indicated an 8.)

What three words would you select to describe the look/feel of the images you hope to create?

Sexy, classic, and classy.

Some clients describe the boudoir experience as a roller coaster of emotions. Was it so for you?

Boudoir was something new that I tried and the experience was exhilarating. As in the beginning of any shoot, I was nervous but warmed up after the first set. Susan has the excellent ability of making me feel comfortable and she energizes me. During the boudoir shoots I felt sexy and alive. It made me feel like a million bucks and like a superstar. The experience of it is worth it and every woman should experience this. It is empowering.

What did the photographer do specifically that helped ease any anxiety or fears?

Susan cheered me the whole time, telling me how great everything looked. Whenever I felt like maybe it doesn't look right, I would immediately change my mind when I heard her squeals of excitement!

What was most challenging for you during the shoot?
Feeling comfortable in my own skin. Overcoming my insecurities and imperfections. Learning to embrace myself for who I am.

Are there any specific or recurring thoughts you remember running through your head during the shoot? How did these make you feel?
"Does this position make my butt look too big?"; "Is my waist thin enough?"; "Omg, I hope my arm fat doesn't show in this shot!" These thoughts initially inhibited me but after I saw the pictures and finished product I realized how silly I was being.

Once you saw the images from your shoot, what was your reaction?
I was stunned. I felt empowered. I felt beautiful and content. I realized how hard I am on myself and learned to embrace myself just a little more. And yes the images were sexy, classic, and classy, just as I wished.

Aside from beautiful images are there any other positive outcomes from your boudoir experience?
Liking myself a little more.

Anything else you wish to share . . .
Women are gorgeous in whatever shape or size they come in. Every woman should do this because it brings out their femininity and power as a female.

18

The Importance of Maintaining the Connection Even After All Is Said and Done

You don't close a sale, you open a relationship if you want to build a long-term, successful enterprise.

Patricia Fripp

The Nature of Intimate Relationships

While you may not realize it, you engage in intimate relationships with your boudoir clients.

Did you squirm? Are you disagreeing with me?

Although we tend to think of intimate relationships primarily in the context of amorous relationships, there are three other kinds of intimate relationships:

- *I heart your brain:* Ever have a friend with whom you debate constantly? Maybe you "argue" about everything—politics, social policy, which group was the best band of all time, what neighborhood restaurant is the bomb. Guess what, yep—these shared intellectual and brain-sharing exercises constitute one type of intimate relationship.

- *BFFs sharing the silence:* That friend you invite over to read alongside, even though you may not swap a word for an hour, or that buddy you invite to share in a creative space, even though you both do your own thing quietly—each of you in your own world . . . Yep! That's another kind of intimate relationship.

- *I feel your pain:* The empathy you feel when someone else suffers; listening to her express her anxiety and fear; lending an ear when she shares her deepest secrets, hopes, and dreams; worrying whether something you do or say is going to be uplifting or upsetting to the other person . . . is this starting to sound familiar? It should because it's what we

boudoir photographers do all the time, isn't it? And you guessed it again—it's another form of intimate relationship.

When we realize that, yes, we do engage in intimate relationships with our clients, we can start to think a little bit differently about what happens once our engagement is technically "over."

Over the years, I've experienced the following over and over:

- Clients will express sadness that our work is done.

- She will express anxiety over not having our meetings to look forward to, not having me to talk to anymore.

- A client will hug me and tell me she'll miss me.

- She'll send me a personal friend request on Facebook and actively participate in commenting on my postings.

- I'll get emails and texts from her, sharing beautiful images or relevant articles she found online and thought I'd love.

- She'll share my FB business page posts with her friends.

- I'll be aware she's there, always quietly watching, always keeping up to date with my business, what I'm doing, what I'm posting.

In fact, as I was writing this (I kid you not!) a former client texted me this message:

I was just thinking how I would love to do another photo shoot. Then I thought that sounded narcissistic. It's just that the last shoot did something for me emotionally that I couldn't explain and I was thinking I could use that inspiration again. I suppose I could dig down deep for inspiration. I'm turning 62 in one month. Hard to believe since you did my "turning 60 milestone shoot." Still have a youthful spirit. The body continues to age. I want to appreciate it. That part is a challenge.

Her message illustrates exactly what I've been saying.

The transformative boudoir photo shoot is so much more than an image-making session; it can be a life-changing milestone for women, and an unforgettable emotional journey.

Getting messages like the one above is quite normal when your aim is to enable her to experience a transformation in her mind–body relationship. When two people share an emotional experience together, there's a bonding that takes place. And if you've established a strong one, then it's hard to let go of the other person. Besides, why would you want to if it's been a rewarding experience for you both?

Intimate relationships mean you've established an emotional connection, and you've invested a lot of time and attention in one another, but to maintain them requires continuous investment.

Nurture the Intimate Boudoir Photographer–Client Relationship

In Part 1, you took inventory of everything you bring to the table—your strengths, skillsets, talents, and personal qualities that will serve you as a boudoir photographer. Here is an opportunity to reflect on those once more. Developing and nurturing intimate relationships with your clients will require that you:

- are an effective communicator—a great listener; skilled at using questioning as a tool for guiding your client through her own thought process; and able to provide direction and feedback in a gentle and inspiring way;
- aren't shy about hearing about your client's inner world, and perhaps even sharing your own emotional journeys;

- are able to connect with others—some people, whether because of cultural upbringing or personality tendencies, have difficulty connecting with others; needless to say this trait can seriously impede your ability to establish an intimate relationship with your client;
- can, and are willing to, step outside your role of "photographer" and be friend, confidante, and be all the other things I've mentioned a boudoir photographer must be at various stages of the client engagement;
- have a heightened self-awareness—be in touch with how your client's emotional journey makes you feel; how your own reactions might be triggered by her feelings, thoughts, and stories; where your judgments and biases might come

into play; and how you're coming across to her (whether supportive or unsupportive) at all times.

People who are not aware of themselves frequently are not able to be aware of other people, at least not in terms of the potentially intimate aspects of the other person.

University of Florida Counseling and Wellness Center website

You must be all of these things from your very first interaction with your prospective client, all the way through the planning and shoot experience, and beyond, if you hope to maintain the relationship with her.

Come up with Creative Ways to Maintain the Bond

After I moved into my current space, which is around 2,000 square feet (a significant expansion from my prior 600 square foot space), I was so excited. Now that I had more room, I could finally start doing things I'd been wanting to do for some time. The first year was a settling-in period, a time spent shooting, and when I wasn't shooting I was busy transforming this big, cold space—which lacked any kind of warmth or personality initially—into a cozy boudoir den.

In the second year, I launched Women's Night Out. I started hosting evenings at the studio for ex-clients. I also invited women I knew had been following me for some time on Facebook because they'd pop up with comments and likes year after year, and yet I'd never met them. The women were encouraged to come with a friend if they chose.

Overall, the goal was simple:

- have fun;
- reconnect;
- have an excuse to get together again and share some laughs;

- introduce them to likeminded women who'd also worked with me;
- connect one another where I knew there were synergies; and
- make it worth everyone's while by all sharing in learning something new.

I had makeup artists and stylists entertain us by demonstrating their skills and teaching us something in the process. And I shot new snazzy FB profile pics for everyone.

Our first WNO was so interesting. I thought it would be awkward for the ex-client walking into my studio, knowing me but no one else (particularly if she hadn't brought a friend). Well, boy was I wrong! I barely had time to introduce the women to one another! They immediately began introducing themselves and sharing stories about their boudoir experience. Before I knew it, they were whipping out their cell phones and showing one another their boudoir images! I was in awe! It was inspiring!

As I stood back and watched them interact for a bit, I realized . . . my space was a safe place, a place they felt good about. And that awkwardness that comes from not knowing another person

and not knowing if you have anything in common . . . well, they didn't have that. They already knew they had something in common and it was a really fabulous thing—their boudoir experience!

Although I stopped the WNO for a bit because I got overwhelmed with my shoot schedule and life as a mother of three, I will have relaunched by the time this book is in your hands. It was enjoyable, it was a great way to stay connected with the many women I've shot over the years, and, for goodness' sake, they're also demanding it!

You may come up with other creative ideas for how you might continue to engage your client. Birthday cards, anniversary cards for the brides, newsletters, or year-in-review mailings—all of these things provide great opportunities to touch base with her here and there, and maintain the bond you worked so hard to build in the first place.

Quotes from clients: you can earn their repeat business . . .

- **I plan on doing one annually as I age to capture and embrace the body that I work so hard to take care of.** As I grow older, I (and my husband as well) can look back at the beautiful iconic images you, Susan, have taken, with fondness and marvel.

- Doing this boudoir shoot and seeing the results made me feel more sexy than I had before. While struggling with [cancer] for the past two years, I've lost more than just my hair . . . **These photos were a reminder of how I can truly look and made me realize that I'm just as sexy if not more sexy than I was before because of my confidence and strength** . . . I would love to continue working together to create a positive and creative image for people to be inspired by.

- I think the photos that Susan shoots make every woman look absolutely beautiful no matter what body shape they have. This experience has also given me confidence and a new awareness that **I really do look good at my age.** I would love to do another shoot because the results were fantastic!

- **Both shoots for me were full of positive energy and results. I believe that is so because Susan did not approach this session with her vision in mind, but mine.** She guided me when I asked, gave me suggestions and encouragement when she saw I was losing my focus . . . I can't wait to do it all again!

- **I am most excited to do it again. To take pictures feeling as good as I looked in my first shoot with Susan.** To try and let go of my inhibitions and relax into the scenes I am trying to portray.

Oil the Referral Engine

I've come to understand that success and satisfaction are all about authentic personal connection and that there's a direct correlation between personal relationships and professional success.

Paul N. Weinberg, coauthor of *The I Factor*

Once your client has her album or other art photography products, invite her to stay in touch with you. And in the spirit of *you get what you ask for*, don't forget to specifically ask her to mention you to friends and family. If I know she's got eager siblings, relatives, or friends waiting in the wings, I may even give her a card I've had printed specifically for this purpose: much like a gift card, it provides an incentive to the would-be client to turn her thoughts of "maybe" into phone calls and new bookings.

Also keep the dialogue going with your client by asking her to let you know how others respond to the images you've created together. This will, first and foremost, ensure you receive glowing testimonials. But, continuing your role as confidante and friend, it will also provide an opportunity to address any issue that might come up for her later.

You never know what motivates some people to do and say the things they will. I've heard reports of "friends" who are judgmental and say, "I can't believe you did something like that; it's pornography!" Whether out of jealousy or some other negative emotion, others may decide to rain on her parade. If this happens, she'll of course be hurt. But if she knows she can come to you (because you've invited her to do so), and she trusts you'll be able to provide another perspective, then you'll have the opportunity to intervene in a helpful way.

When this kind of thing happens, I will usually ask questions that will guide the client in thinking through her decision to share the images with this particular unsupportive "friend." Many times, the client will admit there's always been a rivalry or degree of competition between the two. We women can be so mean to one another sometimes! But hearing herself acknowledge this out loud can take away the sting, and minimize the damaging impact of the rival's words.

Keeping the lines of communication open can also alert you to when she's enthusiastically referred a friend; she'll be more likely to give you a heads up. The great thing about this is that the heads up usually comes with valuable information about the person she's referred. Things like "She's really, really shy, but once she comes out of her shell, she's a real vixen" can give you a sense of who you'll be talking to before she even reaches out. It's immensely valuable! Plus, it gives you and your now ex-client a reason to chat once more and add another milestone in your relationship.

Don't spend money on marketing. Let your clientele do that work for you and thank them for it.

Erin Zahradka, Creator of the Association of International Boudoir Photographers

Whenever a client refers someone, I always take the time to personally express appreciation. And while there are numerous ways to do that, how I go about it with her is based on who she is, and the nature of our relationship. After several years shooting boudoir, establishing these meaningful relationships, and seeing the results, my referral engine churns rather nicely.

Still, I implemented a referral program—not necessarily because I felt the need to further boost referrals, but because I wanted to formally recognize those who for years continue to send others my way.

I have clients who, since 2009/10 have consistently been in touch, mentioning me to others, and sending friends my way. I feel so honored every single time! And since I know that returning for another shoot may be cost-prohibitive for some of these women, I decided to reward them for paying me this honor. After a certain number of referrals, my ex-clients can earn a complementary session complete with album. It's my way of saying thank you: thank you for not forgetting me; thank you for sharing kind words about me and my work; and thank you for trusting me enough to send others my way!

In sales, a referral is the key to the door of resistance.

Bo Bennett

It's common knowledge that a referral is like gold to a small business owner. Unlike someone who finds you on Google and needs to be convinced you're the right person for her, a referral has usually already been sold on you and your work. The energy they bring to the first call is different—they usually feel, and therefore interact with you, as if they already know you, and the questions they ask pertain more to how the experience might be customized for them rather than basic information that may or may not already be clearly outlined on your website. Often these women call ready to book! And while you must still do the work of establishing a bond with this woman, having that personal referral makes it a much easier task.

An Interview with Christine

I had the pleasure of shooting my client Christine several times as she progressed in her weight loss journey and as I progressed in growing my business. Our first shoot took place in my living room and the most recent one was in my current 2,000 sq ft studio. Her interview highlights many of the main points I raise in Body and Soul—*may her story inspire you as she's inspired me over the years.*

What motivates you to pursue a boudoir shoot right now?

I have been fat my whole life. People react differently to overweight people. I was on a plane once to Bermuda and the woman next to me insulted me the entire flight. She kept asking the flight attendant why she had to sit next to me and why I wasn't required to buy two seats. I cried the entire flight. At that point I was 330 lbs. I finally decided after years of yoyo dieting it was time to just have band surgery. I lost 165 lbs. It took several years for the weight to finally come off. I never liked having my picture taken when I was fat, there are very few pictures of me through the years. I look at my wedding pictures and I hate them . . . I never felt like a beautiful bride or a princess like they say you're supposed to feel on your wedding day. I saw some boudoir pictures online and I wanted to see what it would be like to try that. So I searched the Internet and I found Susan.

Heading into your shoot, how would you describe how you feel?

OMG, I was so freaked out . . . I brought such frumpy outfits with me and a dress I had bought six months before. And when I put it on, it fell down too funny. It was too big. But Susan made it work and that is now my Facebook photo. Susan was amazing, we did the shoot in her home. She made me feel so good. She made me feel relaxed. We eventually redid the shoot to sex it up a little and we laughed the entire time the second time.

What concerns you most?

My body. I hated my body all those years I wasted being fat and now I'm older and my body is not what it once was. Would people look at these photos and say what was she thinking?

On a scale of 1–10 (10 being most confident) how would you rate how you feel about your body?

I give it a 5. *(Post-shoot she indicated a 7, saying: To put things into perspective, I had always thought myself as a zero, because I was seeing myself through glasses that where filtered by the negative energy I had surrounded myself with. I saw myself as I was told I looked like. Then, through Susan's positive reinforcement, for the first time in my life I looked at myself through unfiltered glasses and I was amazed because I didn't think I looked like that.)*

What three words would you select to describe the look/feel of the images you hope to create?

Beautiful, sexy, confident.

What specifically might the photographer do to help you feel more comfortable and confident heading into your shoot?

Susan welcomed me that day like I was an old friend. We talked a bit before we started, to ease the tension. She made me laugh throughout the shoot. She asked me what kind of music I liked and put it on. I would say alcohol but our shoot was early in the morning . . . lol.

Please share any other insights or information about your thought process, fears, hopes, etc.

Susan has since photographed me four times. She has shown me I'm just as beautiful on the outside as I am on the inside. I look at my pictures now and can't believe that's me. I would recommend any woman to do a boudoir shoot. Find that inner beauty that you long for. PS Thank you, Susan, my world is a different place since I first met you and those pictures have a lot to do with it.

Some clients describe the boudoir experience as a roller coaster of emotions. Was it so for you?

OMG. Heart pounding. So nervous. Questioning myself, am I doing the right thing? . . . She had a girl there to do my makeup. We sat down and talked while she did my makeup. I have to say I couldn't believe how I looked when she was done. I never in my wildest dreams thought I could ever look so pretty. Then I had to go change. I came out and Susan had set up this huge antique mirror.

She said sit down in front of the mirror. I have to say for years I would never look at myself in the mirror. But that day I faced one of my biggest fears looking at myself in the mirror and I was wearing lingerie. She shot a few pictures, then turned the camera around and said look how beautiful. I think at that moment the nervousness started to slowly disappear. We shot four different scenes that day and as time went on we laughed and joked. We talked about our kids, what was going on in our lives, and before you know it I was smiling and giggling. I was relaxed and enjoying myself.

What did the photographer do specifically that helped ease any anxiety or fears?

She made the experience feel like two girlfriends getting together and just having fun. Forget what you think you look like and relax. Your beauty will shine through. Then Susan, with such a soft and positive tone, made me see who I really was. Slowly she took pictures of me, and showed me that I was a beautiful woman. Her positive words and inspiring tone, for the first time in my life, made me feel like a woman, a woman to be desired and a woman to be proud of.

What was most challenging for you during the shoot?

Letting someone take my picture. Since I had not let anyone take my picture for years.

Are there any specific or recurring thoughts you remember running through your head during the shoot? How did these make you feel?

"OMG. What the hell did I get myself into?"

Aside from beautiful images are there any other positive outcomes from your boudoir experience?

Because of the photo shoot, I started to dress differently, showing off my body more in a positive light. I walked with more self-awareness that I never had before. I even noticed men flirting with me more; this was something I saw happen to my friends, but never to me. I felt alive for the first time.

Anything else you wish to share . . .

I have had different comments from women as to why would I do such a thing, but I tell them don't judge till you try it. It's not just about sex or doing something to try to turn a man on. It's about confidence and beauty. It's about showing there's more to me than the eye can see. To Susan, Thank you soooooooo much, you have brought out someone in me that I never knew was there . You have made me look at my life in a different way. I feel meeting you I have made a friend for life.

19

Concluding Thoughts

If you work just for money, you'll never make it, but if you love what you're doing and you always put the customer first, success will be yours.

Ray Kroc

Capture the Beauty by Seeing the Beauty

I used to be shy about saying this, but I think it's critical that boudoir photographers own this: I have a gift, and that gift is the ability to see a woman's beauty, no matter who she is, and no matter her shape, size, color, or age.

The ability to *see*, truly see, a person is not something everyone has. But it's a necessary skill if you're going to reflect back to a woman the beauty she possesses. If she doesn't happen to embody today's beauty ideal, or she doesn't embody *your* personal definition of beautiful, then how else can you expect to capture images in which she looks beautiful?

Your ability to see her beauty, though, is only half the equation. You must also see her beauty as *she* sees it. Don't miss the important step of finding out what she finds beautiful about her body. Some women will tell you they don't especially love anything about their bodies. Don't accept this: help her find something . . . it will enable her to begin to see herself from a different perspective. Maybe she has an elegant neckline, or graceful hands, or expressive eyes.

No matter how small or detailed, if she can begin to see and acknowledge her beauty, then you will have a great starting point for your work.

Model the Behavior You Wish to See

Whether you realize it or not, she will be looking to you constantly for direction. And she will follow your lead:

- Address emotions involved in the journey, and you will give her the language to provide you with valuable information about what's going on in her inner world.

- Focus on the positives about her, and she will begin to forget the things she finds bothersome about her figure.
- Praise her for her accomplishments, her courage, and her tenacity, and she will begin to build confidence during those times when she might otherwise feel vulnerable.

Energy is an interesting thing: if you buy into the idea that you will attract to you those who share the ride along your particular

wavelength, then it's helpful to regularly assess what you're putting out there into the universe. Is it positive, healing, uplifting energy, or is it something else less useful to the women with whom you wish to work?

Do Right by Your Clients and They Will Do Right by You

If you go out of your way to create an amazing and unforgettable experience for your client, don't be surprised when she goes out of her way to support you on social media and direct others to you via ongoing word of mouth. Show her flexibility, empathy, and understanding, and should you need it in return, she will be more likely to show it to you.

In my years of shooting boudoir photography, I've only had to reschedule a shoot due to my own complications two times (both times it was because I came down with the flu). I felt horrible about it, knowing she had done so much to prepare. But by acknowledging her situation and empathizing with the huge inconvenience I knew my untimely illness had caused, I removed any ill feelings she might have had and received her empathy in return.

From Day One, Remember to Be the Stabilizing Center Throughout Her Seesaw of Emotions

If I've said it once, I've said it 100 times: emotions are the key throughout this journey for your client! If you're not an emotional person or aren't comfortable identifying and addressing emotions, let me be honest: this may simply not be the field for you.

Without a doubt, it will be an emotional ride for her, and your success as a photographer hinges on your ability to serve as the stabilizing force throughout her many ups and downs over the course of your work together.

Above All, Don't Be Afraid to Look into Someone's Soul: How Else Will You Recognize It When You See It?

Human beings are social creatures. We thrive on meaningful connections with others. Certain cultural tendencies, however, sometimes make it difficult to do so. As a Latina, my cultural upbringing resulted in one of the top reasons why I never quite felt I fitted in with Corporate America. Latin people, particularly where I come from, tend to be warm, friendly, and personal. This tendency to be overly personal and overly friendly didn't fly so well in Corporate America, which I experienced as cold and impersonal. This clash meant I had to don a mask and essentially become someone I was not in order to fit in and accomplish my work in a way others deemed appropriate.

Needless to say, after many years of doing exactly this, I burned out. I quit working as an organizational psychologist and did what any creative, personal, friendly woman would do . . . I became a boudoir photographer!

I'm joking about that last part, kind of, but my point is essentially this: what you do in your work should align with who you are, not work against it. If you have the ability and inclination to establish meaningful relationships with others, if this kind of thing feels natural for you, then boudoir photography just might be a niche in which you find great success. And that's exactly what I wish for you: may you find great success in whatever you do!

An Interview with Jessica B.

I first shot Jessica when I was still operating out of my living room; we have since become friends, we've collaborated on fashion designs, and she is one of my muses. I asked her to reflect on the very first time I ever shot her.

What motivates you to pursue a boudoir shoot right now?
Self-acceptance.

Heading into your shoot, how would you describe how you feel?
I was very anxious, scared, excited . . . to be honest I didn't know what to expect. This was my first time trying to show this side of me in front of a camera.

What three words would you select to describe the look/feel of the images you hope to create?
Sexy, daring, feminine.

Some clients describe the boudoir experience as a roller coaster of emotions. Was it so for you?
For me it was like discovering a whole new world I didn't know lived in me. I grew up as so many of us with so many complexes and low self-esteem. The first time Susan shot me was an unforgettable experience. That day I realized there was a sexy me wanting to come out, and for the first time in my life I was able to see beauty in me.

What did the photographer do specifically that helped ease any anxiety or fears?
She started playing some soft and beautiful Julieta Venegas music—that was a great starting point since she knew my first language is Spanish. She made me feel at home and welcome. She made me feel like we knew each other forever.

What was most challenging for you during the shoot?
At first I thought I was going to have a hard time feeling comfortable showing this side of me, but Susan just made it so easy. She did really make me feel like a beautiful woman.

Aside from beautiful images are there any other positive outcomes from your boudoir experience?
I remember her looking at the images in her camera and saying OMG how does it feel to walk around being so beautiful? Lol I was never ever told anything like that, that day I believed it and I saw it in those images. Well after our first shoot we pretty much became inseparable . . . and because of it I learned little by little to accept myself and to see the beauty in me as something unique.

Once you saw the images from your shoot, what was your reaction?
I was AMAZED beyond words! I couldn't believe what my eyes were seeing. Beautiful work.

Anything else you wish to share . . .
God has given Susan the talent to be able to touch hearts and change lives in a way she can't even imagine.

PART 4

RESOURCES FOR THE
BOUDOIR PHOTOGRAPHER

Authentic unretouched beauty #1

20

Interview with a Clinical Psychologist and Specialist on Body Image

Trust is a boudoir photographer's main currency.

Dr. Laura Ellick, psychologist and specialist on body image

I must admit, I was a little nervous about sitting down with a clinical psychologist to discuss boudoir photography. For starters, I was fully aware that, for lots of people, boudoir is still this mysterious, unfamiliar, and, let's be honest, potentially offensive thing. She validated this by letting me know that when she mentioned to others she would be sitting with me to discuss this book, some expressed confusion or outright disgust, equating boudoir photography with porn! While she stated outright that she disagreed, she did admit she did not know a lot about it. So, whether or not she would see the value of the boudoir experience as I saw it was TBD.

I approached our interview with an overview of my business and then presented her with the client experience (much as I have in the previous chapters) stage by stage, walking her through each step of the boudoir photography engagement so that she might speak to the challenges, value, and pitfalls associated with each. She listened intently to everything I said, reacting at times with surprise and delight. She also enthusiastically shared helpful information that I pass along to you here.

In Part 1 of my book, I discuss the importance of self-assessment and introspection prior to engaging in boudoir photography work. Given your experience working with women and seeing firsthand just how challenging the issues of body image can be, what are your thoughts about that?

If you're doing boudoir photography, you should be very clear about your own views on aging, as well as your views on overweight society, or even those who just don't fit into the standard size 6 model. There's a huge judgment in our particular country about overweight being associated with lack of willpower. That comes across as fat shaming. Self-awareness never hurts.

For a woman struggling with body image issues, how might a boudoir photographer respond?

Most photographers are, if I have this right, focused on things like lighting and setting and I think there's less of a feeling of how do I really connect with this person or make them feel safe. It's the connection with people that's going to make everything work well.

Prior to the shoot how might a woman be feeling, particularly if she has body image issues (and don't most of us have those)?

There's certainly a tremendous amount of anxiety! Anxiety about how it's going to go, how she'll be dressed in front of another person. There are lots of questions she may not have the courage to ask such as: is the photographer going to be respectful of her boundaries? What are the rules regarding touching? Will she be touched? What's normal and what's not normal in this type of experience? Overall, there's a huge degree of uncertainty and anxiety.

So how might a boudoir photographer address those, particularly if they're unspoken?

The photographer should clearly discuss expectations and the process—how it all works—prior to the shoot. They should also be aware that the client is, whether she shows it or not, experiencing a great degree of anxiety about the shoot. If photographers can "normalize" the experience (let the client know that what she's thinking and feeling is normal), it will help to ease her anxiety, and take away the feeling that something's wrong with her. Let her know beforehand, "You may have powerful emotions come up before or during the shoot. Some women may feel a roller coaster of emotions." By normalizing the experience you give control back to the client.

Some photographers shoot primarily for themselves—to reflect their style, their brand, their lighting and posing style preferences. And this carries all the way through to the post-production process, which we'll discuss later. In my book, I talk about the importance of designing the entire process from start to finish so that you integrate who your client is into the shoot. What are your thoughts on that?

You want the essence of the person, the best version of them to come out. A client should be invited to explore what aspect(s) of her personality she wants to come out.

So, you've prepared the client and supported her in planning a great shoot, and shoot day arrives. What's going on with our client?

How a boudoir photographer interacts with the client from the moment she arrives is so important. She is at her most vulnerable, but knowing there's a partner with her every step of the way will help her feel more comfortable. This will also set the stage for how the rest of the shoot is going to go. Photographers should also be aware of the power differential inherent in the photographer–client relationship. You have the power to make her look beautiful . . . or knock her down. This alone can cause anxiety, so reassure her you are her partner through this process.

During the shoot clients will usually be nervous, especially once we get started. Other times, they'll appear distracted—like they've gone somewhere else in their heads. What's going on for her once shooting begins?

I once had headshots done. Headshots! Fully clothed. And still I was so anxious. I knew the photographer had shot beautiful, famous people. I sat there thinking, "I'm sure the photographer is wondering how on earth she got stuck with this person." Imagine how a woman standing before you in her underwear might feel. Respect and address the vulnerability they might be feeling and that alone can relax her. Let her know that she might be feeling a little anxious, and that's okay. Try to work slowly at first to warm her up, then take timeouts if she needs them; allow her to put on a robe and take a break if she is feeling anxious. During a shoot she can start crying if it gets too overwhelming for her.

So, I'm really interested in your perspective on this. As part of my efforts in bringing the client out of her shell and revealing who she really is I push her to pour her heart and soul into her self-expression. To me, there's a huge difference between a pretty picture, where a client's expression doesn't always sync up with the

Authentic unretouched beauty #2

Wow. That's mind-blowing. It makes total sense. It's like the structure of the therapy session: you make her comfortable in the beginning; go up the hill to where they might feel more vulnerable but you know that's where growth happens; but then you come back down and get her ready to go back into the world. It's important, though, that the photographer check in regularly: ask how are you feeling? Are you feeling empowered? The client should also be reassured: "Just know that we can stop if you need to feel safe."

One of my concerns in presenting this approach to shooting boudoir is that others may read it as encouragement to attempt to play therapist to the client, which is not at all what I do or am asking boudoir photographers to do. How do you see the difference here?

What you're doing is not therapy . . . but there's no doubt it's *therapeutic* for the client who faces challenges with her body image, and that's a great thing! A client who has lived with self-hatred or self-consciousness about her body is going to be primed to pick out the most negative aspects in most photos. I've asked clients to show me selfies or photos from recent events, and they ALL point out what's wrong: a big nose, "fat" arms, etc. It's crazy and disheartening. What's special about this experience is that it gives the client an opportunity to see her body not as an object to be reviled, but as the beautiful essence of her.

Done right, I think boudoir photography has the potential to help a client see not just her outer shell but her entire personality shine through the photos. She will then have a different frame of reference and

pose or energy of the image, and one that brings her to happy tears because it's so authentically *her*. I talk about how the role of a photographer must evolve over the course of a shoot: from teacher, to cheerleader, and then to mentor and confidante. As trust builds, so should what she's willing to put forth in terms of energy and revelation. What's your reaction to this?

photos to "prove" that her big nose and "fat" arms may just be products of her body image distortions. That's probably worth about ten therapy sessions right there!

Some clients are very outspoken about their body image struggles, while others may be more reluctant to talk directly about them. What are some potential flags and/or pitfalls here?

Some signs that a woman might struggle with her body image are comments that hint at self-hatred, a very real disconnect between what the brain sees and her reality, or their perception is skewed. You may also be able to tell that a client struggles with body image issues by how she interacts with you or the comments she makes about her body. A client who makes sure certain body parts are covered up or is reluctant to have you shoot from certain "sides" may be struggling with body image issues. A more telling sign would be a client who expresses outright disdain for a certain body part, or her entire body, or who tries to make a joke: "all the women in my family have these thunder thighs."

If a photographer suspects the client might be struggling with body image issues, she must be very careful with her words. A simple offhanded comment such as "Let me modify the light so that it falls on your legs better" might be interpreted in her head as *I'm fat so she needs to modify what she's doing to hide it.* She may not say anything, but she'll tense up and her body language may show her discomfort. The photographer may not even realize it's something she said, not intending to upset the client.

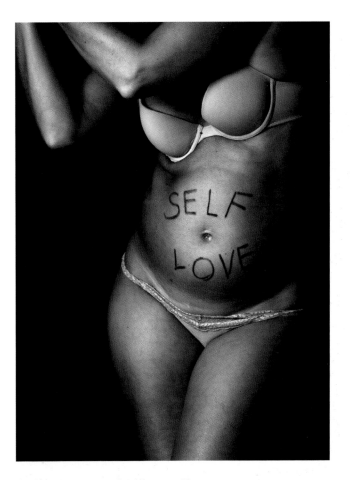

Authentic unretouched beauty #3

So what should a photographer do to manage her client and keep the shoot moving forward?

Focus on the positives: e.g. your hair is so shiny; your cheeks are glowing, etc. Providing encouragement will help keep her from focusing on the negatives and to instead focus on her positive features. Also, photographers should be constantly aware of body language—the client is probably going to freeze up as soon as a comment is made, no matter how innocent, about how something needs to be changed or different.

Speaking about modifications, let's tackle the contro-versial subject of retouching. What are your thoughts about it? When is it helpful? When is it harmful?

Ooh, I have a love/hate relationship with retouching. I'm appalled by magazines—how they whittle women to impossible proportions and size 0 waists. I do believe in highlighting a woman's best features though. Getting rid of cellulite, brightening complexions, eliminating stretch marks—that's all fine. But when it comes to changing features—noses, size of hands—that's just not *her* any more. Each woman should see herself the best she can look at her shape. I get that retouching is important—it's your business; you want to give people a great product. But a photographer should never lose sight of their main currency: the personal connection and trust they work so hard to establish with their clients throughout the process.

I've experienced a great degree of longevity with my clients—what I mean by that is that clients will stay in touch, come back for multiple sessions, and refer others to me many years after they've had their own shoots—which means the experience was memorable for them. How might boudoir photographers ensure they generate referrals and repeat business from their clients?

Referrals are going to happen if trust has been developed and maintained throughout the process. As I mentioned before, I think trust is a boudoir photographer's main currency—word of mouth is certainly based on that. And of course, maintaining connections with your clients even after the session is important. If you want a referral from someone, you'd better connect with your client during your time with her.

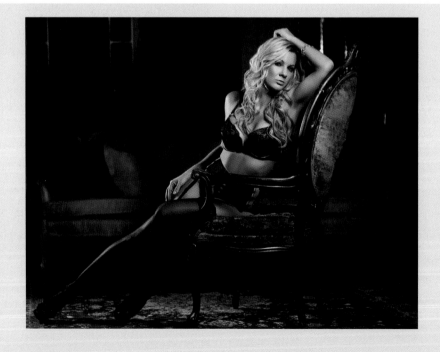

An Interview with Kelly

I first shot Kelly for her husband's 40th birthday. But after the shoot, she revealed a deeper secret and a second meaningful reason for the shoot.

What motivates you to pursue a boudoir shoot right now?

I'd love to boost my self-confidence and step out of my comfort zone. Since my teenage years (over 20 years ago) I have suffered from Body Dysmorphic Disorder. So when my friends and family tell me I look beautiful, I don't believe them. At 5'4" and average weight of 116 lbs at 39 years old I only see all the flaws and imperfections, as well as appearing to look and feel so much bigger and flawed than I really am. BDD affects your everyday thought process. So I think about improving this self-esteem and self-criticism and hope a photo shoot will help! I want to feel beautiful and confident on the inside as well as the outside.

Heading into your shoot, how would you describe how you feel?

I feel very nervous yet so excited for this adventure!

On a scale of 1–10 (10 being most confident) how would you rate how you feel about your body?

A 6 at most. *(Post-shoot she said, "Totally a 10!!")*

What three words would you select to describe the look/feel of the images you hope to create?

Sexy, confident, beautiful.

What specifically might the photographer do to help you feel more comfortable and confident heading into your shoot?

Meeting with me and understanding why the shoot is important to me. The photographer's confidence, professionalism, and being fun to work with. It would also be a huge help if photographer shows some posing techniques along with tips.

Some clients describe the boudoir experience as a roller coaster of emotions. Was it so for you?

The beginning with getting ready for the shoot was nerve-racking and my thoughts were all over!! During the shoot, as I learned poses and got more comfortable in front of the camera, it became so fun. I truly felt like a model! By the end of the shoot I was so excited to see some teaser pix! I had a blast and can't wait for the next shoot!

What did the photographer do specifically that helped ease any anxiety or fears?

I loved that the photographer showed me her camera shots of me throughout the shoot. I was like "Wow—is that really me?!" I could not believe how the set designs, lighting, and me could make such an amazing image!

What was most challenging for you during the shoot?

The posing in certain positions was challenging. Most of us are not real models—so we are not used to "popping"

out our hips at all, no less for hours that day! It was a great workout though!

Once you saw the images from your shoot, what was your reaction?
I was beyond excited and overjoyed when I saw the images! They totally captured me looking and feeling sexy, confident, and beautiful! I couldn't have been happier.

Aside from beautiful images, are there any other positive outcomes from your boudoir experience?
Yes, I definitely had a boost of self-confidence and self-love. For someone who does not feel this often, it involves a lot of beautiful emotions.

Anything else you wish to share . . .
At first this was a gift to my husband, but then I realized that to me—the shoot was so much more than sexy images! It truly was part of a life-altering experience.

Given everything we've discussed, what would you say are the top characteristics that would make a boudoir photographer successful in working with women who have body image issues?

- Trustworthy
- Sensitive
- Sense of humor
- Empathy
- Effective communication skills
- Ability to take another person's perspective
- Ability to walk into every shoot with the same level of enthusiasm as if it was your first shoot ever
- Therapeutically minded, meaning open to the psychology of the experience; interested in dealing with people; understanding that connection determines the power of a relationship—if you can't connect with people, it's just not going to happen.

After our discussion, I mentioned to Dr. Ellick my concern that photographers, who tend to focus almost exclusively on the technical aspects of photography, might be inclined to skim through or altogether skip the first part of this book, which focuses on self-assessment and introspection.

This was her response: "It would be a real shame if photographers missed doing the introspective part of this work. The same way a therapist is trained in grad school to assess her own triggers and what populations she should or should not work with, so should photographers really be aware of their own perspectives, values, judgments, capabilities, and attitudes."

If you are one of those photographers who did skim through or skip the first part of this book, I hope you now understand the importance of self-awareness in creating meaningful work through boudoir photography. I encourage you now—having gone through the remaining parts of this book, having read the stories of real clients who benefited tremendously from boudoir

photography, and having read the psychologist's perspective—to go back and revisit the introspective exercises in Part 1. It can only enhance your vision for your business, strengthen your drive and purpose for your work, and further solidify your relationships with your clients.

As you go about building your boudoir photography business, keep this book handy and refer to it often as each interaction with a new client might bring forth new challenges or new questions. May you build a thriving boudoir business and transform the lives of women from every walk of life, one woman at a time.

Dr. Laura Ellick received her Ph.D. in Clinical Psychology from St. John's University in 2000. She is currently a speaker and therapist, and author of the book *Total Wellness for Mommies* (available at amazon.com). Her private practice focuses on work with clients who have eating disorders, body image issues, and medical illnesses. For information on her practice or to book her for a speaking engagement, you can call her directly at 516-635-6186.

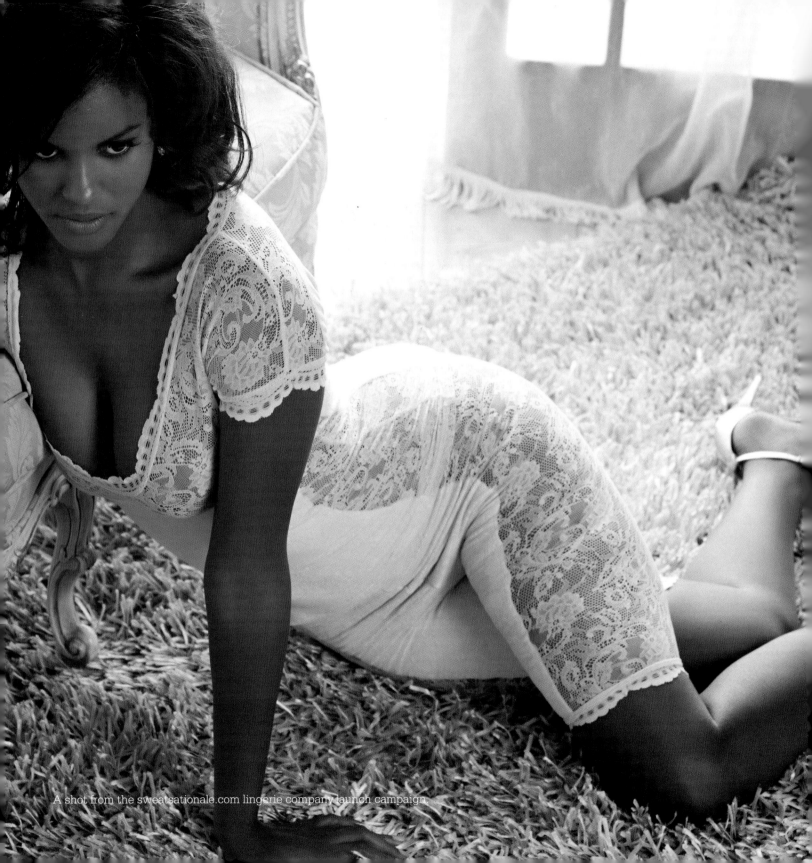

A shot from the sweatsationale.com lingerie company launch campaign.

21

Additional Client Interviews

Help others achieve their dreams and you will achieve yours.

Les Brown

When I reached out to a select group of repeat clients, new clients whose stories I felt were compelling, and old clients I'd established friendships with over the years, I never imagined I'd get each and every one of them to provide responses to my interview questions. I also never imagined their responses would be as soul-baring as many of them are.

While I've introduced some of their stories throughout this book, there were others I felt compelled to share. If you've been moved and inspired by their stories, and have found the information they've shared helpful to you in conceptualizing your own boudoir business, then you'll enjoy the additional interviews I've included here.

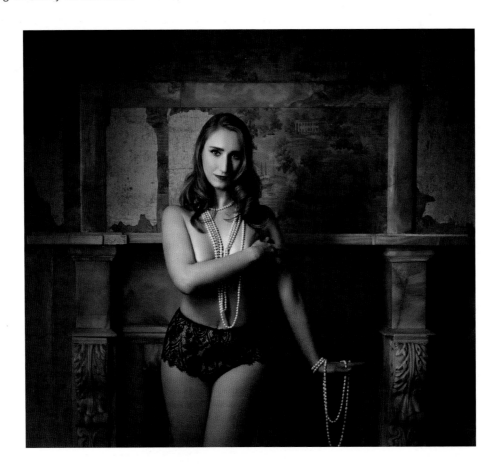

An Interview with Rhonda

Rhonda is a beautiful woman in her fifties who I had the pleasure to shoot in late 2014 and again in 2015 during a mini day session. The content below was provided after her first shoot. She clearly articulates many of the sensitive issues faced by women in her age group.

What motivates you to pursue a boudoir shoot right now?

Sometimes people may think that I am a girl who has been pretty most of her life, so why the "insecurity act?" Well . . . this girl went from a kid to a mom and a wife very early on and missed out on any glamorous moments one may encounter in their twenties and thirties and even early forties. Having a big family takes the focus away from you. The shoot means I can be who I am . . . or who I hope to become through photos. Upon seeing Susan's photos on Pinterest I was immediately drawn to her! I think it's totally a personal and intimate relationship between photographer and model. Even after . . . feeling beyond crazy for thinking I could do this . . . I went for it. The real motivation came from a friend saying to me . . . "You're not getting any younger . . . you might want to take some pictures while you still look half way decent!" That comment really got to me, I thought now is the right time for me to shine.

Heading into your boudoir shoot, how would you describe how you feel?

I showed up to the studio with a bag of stuff and a bigger bag of worries . . . it was more about me feeling unworthy of a real photographer fussing over me all day. You know,

I thought "Wow!! Rhonda, you must be crazy to think you deserve this day." I was so apprehensive about not looking as good as Susan's other ladies . . . Immediately I felt a connection with Kelly the makeup artist. And then . . . enter Susan! It was all good after our first hello.

What concerns you most?

People can be insensitive and ask why I thought I was worth spending money on . . . well, they don't understand the way it makes you feel to have somebody tell you how pretty you look all day!!! I realized that I was scared to have photos of my face taken. This surprised me. I stayed away from direct eye contact . . . I would love to be able to stare into the camera and feel good and embrace my looks, my imperfections, and my age.

What are you most excited about?

The thought of being able to do another shoot with Susan is making me feel happy. Sounds trite, but it's the truth! . . . The idea of a woman telling her story through photos is such a breakthrough idea. We all have our own tale to tell!

On a scale of 1–10 (10 being the most confident) how would you rate how you feel about your body?

The body thing has never been a real issue for me. I would give my confidence level at about an 8. The exercise girl has always been front and center, and I do believe I inherited some good genes from my granny!

Aside from beautiful photographs, what else do you hope to get out of the experience?

. . . the idea of being able to leave behind the essence of myself is quite thrilling. I envision being able to show the real me with emotion, and raw feelings through my eyes. They are truly what I use to show my emotions.

What three words would you select to describe the look/feel of the images you hope to create?

Feminine. Natural earthiness. Raw sexiness.

Some clients describe the boudoir experience as a roller coaster of emotions. Was it so for you?

The beginning was a bit nerve-racking. When I first walked out in my undies I felt so exposed physically and mentally. By evidence of my photos you can tell I relaxed very quickly. Susan laughing with me giving me direction on poses and, most importantly, saying how good shots looked made me feel so at ease!

What did the photographer do specifically that helped ease any anxiety or fears?

Susan more than just being a super talented and creative photographer has a great love of women . . . she is a warm energy that truly brings out your inner beauty no matter how far it has been hiding!

What was most challenging for you during the shoot?

I would have to say hands down staring into the camera. I have always been insecure about my looks so when you are asked to act confident and pose and smile . . . I felt like the pictures wouldn't look right . . . I was wrong!

Aside from beautiful images, are there any other positive outcomes from your boudoir experience?

ABSOLUTELY!! Ever since seeing my photos, I draw upon that good feeling of "HEY YOU DON'T LOOK SO BAD" when I am feeling less than perfect. Sometimes my insecurities get the best of me and thinking about the fact that I pulled off an amazing shoot brings me way up!!!

Even if you started this journey as a gift to someone else, do you feel this experience was a gift to yourself in some way?

This started as an idea for my husband . . . but quickly turned into a gift and a blessing for me and only me! Yes . . . my husband loves my album but not as much as I adore sitting in bed looking through them when nobody is watching!!

Did you get what you hoped out of this experience?

Yes, and then some . . . hence, can't wait to participate in the [next] mini-shoot day!

Anything else you wish to share . . .

. . . doing a boudoir photo shoot is like being queen for a day. When does one get to show up someplace, be warmly embraced, told how pretty you are, and get doted on all day??? Well for me . . . never!

An Interview with Jessica H.

Jessica is a colleague, a talented art photographer who I invited to participate in this project for two reasons: 1) she's beautiful and pregnant, and 2) she is very quiet and introspective and I just knew there was a deep and rich world within and I wanted to get a glimpse. I am grateful to her for overcoming her fears and anxieties and accepting the challenge!

What motivates you to pursue a boudoir shoot right now?

When you originally spoke to me about . . . this amazing opportunity I wanted to run away, which is exactly why I agreed to it. I see this shoot as the next level for me to become more self-empowered. I am most likely the same as most women. Here I am, in my thirties and have never felt comfortable in my own skin. I had an Ah-Ha moment on my 30th birthday. I hit my darkest moment and I decided to start fresh and to change the way I see and react to the world and the people in my life. I had to start detaching from my fears of the past and move forward. After opening up to several people, I had realized I experienced a rough childhood. Growing up, I was always surrounded by fear and just simply felt powerless. It's been a few years of shaking off the past and redeveloping ME. I know that our history is what molds us and helps us to be the person we are today. However, now is my time to flourish and to figure out what will help me feel love and to become more self-empowered . . . I am now roughly six months pregnant. Which means this will be a maternity boudoir shoot! I am thrilled to be captured in this moment. I actually have no images of myself from my first pregnancy. Which is a shame because I think the curves of a pregnant woman are beautiful.

Heading into your boudoir shoot, how would you describe how you feel?

I am extremely excited to go into this maternity boudoir shoot. I think this will be a liberating opportunity for me to experience and to grow from. On the other hand, it frankly scares the hell out of me. I know this is under a controlled/safe environment, but I keep on thinking I am going to feel extremely uncomfortable being close to or fully nude. I have fears of not being a good model, fears of being judged with my body being exposed, just simply fears. Which is why I know this is something I must do for me.

What concerns you most?

What concerns me the most is that I am not a size 2 model. I will be somewhat naked and photographed. I have fat on my body. My body now jiggles a bit more and is a bit lumpy. Plus I have a scar, stretch marks, and skin issues. Need I say more? However, the scar and stretch marks are there to remind me how powerful I am. My body helped to support and nurtured another life. The skin issues are due to my heritage, having a bit of Irish in me and also being pregnant.

What are you most excited about?

I am thrilled to be professionally photographed. I am always behind a camera, so it is nice to step out front this time. But I am extremely excited to see the magic that you

create during this session. I view your work as fine art, so to be captured in something so amazing will be very exciting for me.

On a scale of 1–10 (10 being most confident) how would you rate how you feel about your body?
Currently, I think I am around a 6. Being pregnant is helping me feel better about my body. Otherwise, I tend to be around a 4 or 5.

Aside from beautiful photographs, what else do you hope to get out of the experience?
I am hoping to build self-confidence, and to feel empowered. Oh, and to feel better about my body just the way it is.

What three words would you select to describe the look/feel of the images you hope to create?
Soft. Powerful. Pure.

What specifically might the photographer do to help you feel more comfortable and confident heading into your shoot?
To be kind, and to understand that not everyone feels comfortable in their own skin. No matter how the outside package looks to them.

Post-shoot: Some clients describe the boudoir experience as a roller coaster of emotions. Was it so for you?
Honestly, the shoot was hard for me. I could not stop obsessing about how my body looks. Once the initial shock wore off, I did feel a bit better about myself during the shoot. However, I still could not turn off my self-judging thoughts. All I could think about were the negative things I normally see in myself on a daily basis. There was one pose I did want to capture that was even further out of my comfort zone and I went for it! I felt extremely vulnerable, but I did it. I left the shoot feeling amazing and liberated even though I felt out of sorts.

Overall I am thrilled I did the shoot. I plan on doing another one post pregnancy. I feel that I am the type of person that would do great once I have an alcoholic beverage to help loosen me up. I just need to turn my inner thoughts off or way down to fully feel comfortable in my own skin.

What did the photographer do specifically that helped ease any anxiety or fears?
Susan was fantastic. We had lots of laughs and an overall great time. Susan would stop and show me how to move and pose. It was great to see her be so animated in each scenario. Susan would also call me out when she saw me getting too serious or getting lost, overthinking the posing. It really makes a difference when you pose for a photographer that takes the time to work with you and to help you come out of your own shell. What really made me trust Susan as my photographer is that she is fun, down to earth, realistic, and loves what she does. It's great to work with someone who has such a love and passion to help women of any background to feel sexy, and beautiful. I have and will keep on referring Susan to any and all women out there that would like to have a boudoir shoot.

What was most challenging for you during the shoot?
At first I thought the initial strip down was the hardest roadblock I would face. However, getting out of my own

head during the shoot was the hardest by far for me. I, on any given day, will overthink and overanalyze anything and everything. This is my biggest weakness in general.

Are there any specific or recurring thoughts you remember running through your head during the shoot? How did these make you feel?

Negative self-thoughts would constantly come into my mind during the shoot. Which is sad. I looked forward to this shoot for a long time. These negative internal thoughts threatened to take away from this amazing experience.

Aside from beautiful images, are there any other positive outcomes from your boudoir experience?

Yes, there are several positive outcomes. I am extremely proud of myself to step outside my comfort zone and to pose for a boudoir shoot. It really was such a liberating experience and I am thrilled I did it. I am also hoping that after seeing these images I will learn to appreciate and love my body in a different way. I really do look forward to having another shoot done.

Even if you started this journey as a gift to someone else, do you feel this experience was a gift to yourself in some way?

I do think that every woman should pose for a boudoir shoot. However, this has to be a gift for herself before giving it to anyone else. It's a way for any woman to love herself in a different way. The "gift" would be to share the images with the significant partner.

Did you get what you hoped out of this experience?

Yes, I think so! I went in not expecting much, just really excited and nervous. I love the creative energy Susan had during the shoot and how much fun it really was. I must say I was more comfortable during the shoot than I had originally anticipated.

Anything else you wish to share . . .

I think Susan is an amazing creative soul and I am honored to pose for her. I also would like to state that my emotional shortcomings should not reflect on the artist. I have always been taught not to love myself and/or my body, to always see the negative before any positives. Loving myself is a huge lesson I am still trying to learn in my mid-thirties.

An Interview with Michelle L.

Michelle is an old friend, a successful business woman, and a tough cookie. I invited her to participate in this project because I figured it might push her to do something she might not otherwise ever pursue. I knew that I always found her beautiful, but how she felt and what she would gain from the experience I wasn't sure.

Heading into your boudoir shoot, how would you describe how you feel?

I'm feeling nervous . . . and excited. I'm nervous because I've always felt self-conscious in photos and I've never taken boudoir photos. My mind keeps wondering what it's really going to be like. How do you pose? How do you not laugh? How do you relax? I honestly just don't know what to expect.

What concerns you most?

Like most women, I'm concerned about my flaws really showing through. I've gained about 15 pounds over the past few months and I don't feel very sexy.

What are you most excited about?

The end result. I'm excited for my husband to see the photos. We've been together for nearly 20 years. I think these photos will spark memories of first meeting and I hope they will set the stage for the next 20 years.

Aside from beautiful photographs, what else do you hope to get out of the experience?

I'm hoping for a little extra swagger in my step! You know that feeling you get from feeling a little more confident? Or, that feeling when you have a fun little secret that's bursting to get out?

What three words would you select to describe the look/feel of the images you hope to create?

Sensual. Seductive. Sensitive.

Some clients describe the boudoir experience as a roller coaster of emotions. Was it so for you?

The shoot was relaxed, but I was a bundle of nerves. We eased into it by talking through the outfits and the settings. The nerves subsided and the excitement and high energy came through. By the end I was feeling calm . . . and exhausted.

What did the photographer do specifically that helped ease any anxiety or fears?

We talked through what to expect during the session and, as hoped, we laughed a lot.

What was most challenging for you during the shoot?

Letting go and relaxing into posing. It's hard to do—much harder than anyone would think. Real models deserve a lot more credit than I've ever given them. Sorry girls (and guys)!

Are there any specific or recurring thoughts you remember running through your head during the shoot? How did these make you feel?

"Man, I hope I don't look as nervous as I feel" "Wait, my left or her left?" In the end, both thoughts made me feel relaxed and happy!

Aside from beautiful images, are there any other positive outcomes from your boudoir experience?

I do feel more confident.

On a scale of 1–10 (10 being most confident) how would you rate how you feel about your body pre and post-shoot?

Going in to this, I'd say I'm a 3. Less than a year ago, I would have said 7. I pulled a hamstring pretty seriously and haven't been able to work out as usual. Add another year to my age and you've got the 3 I'm feeling today.

Post-shoot: I'd say I'm up to a 5 now . . . but I'm also back to trying to work out (hurt hamstring and all). Let's do it again next year and see if we can get back to the 7.

An Interview with Andrea

Andrea is a lovely client whose equally lovely friend purchased the session as a surprise gift. She is a breath of fresh air in that, unlike many curvy girls, she is very comfortable in her own skin. As a result we were able to laugh and enjoy the session to the fullest degree. I am grateful our paths crossed and even more grateful that she agreed to be part of this book.

What motivates you to pursue a boudoir shoot right now?

This is an unexpected and intriguing gift, given to me for my bridal shower by a platonic dear girlfriend who is like family. It has been a doorway to expressing so many things about our relationship as we talk in preparation for this shoot. There is something she sees in me that caused her to believe this would be a wonderful self-expressive experience for me. I am surprised and delighted by the whole thing.

If you've had a boudoir shoot in the past (whether with me or with someone else) what motivated you to pursue it then?

I've never considered such a thing, although those that know me ask "why not?" I'm discovering that those closest to me see me as someone who would be happy and comfortable pursuing this type of an experience.

Heading into your boudoir shoot, how would you describe how you feel? What are the predominant emotions you're experiencing prior to your shoot? Sometimes contradictory feelings emerge (e.g. scared but excited)—if you are experiencing this, please elaborate below.

I am definitely excited. Since this was not my idea, and the shoot is a gift, it is taking me a little while to process the whole idea. I believe I will be up for anything, with very little self-consciousness. Ah, but I realize that when it comes right down to the moment, I may experience unique emotions, such as shyness or anxiety, or . . . some I haven't thought of. I think it will be quite an emotional adventure.

What concerns you most?

I feel I will be comfortable if we sincerely like one another. If you are put off by my loud laughter, or there is any tension between our personalities, I feel it will be a less than wonderful experience and I might become self-conscious. I just want to have fun and feel beautiful, and leave the world behind for a few hours. Then, have the photographs to immortalize that time, and that the photos are wonderful. So, I guess I would be concerned that the experience and/or the photographs won't measure up to those expectations.

What are you most excited about?

I am most excited about being able to focus totally on my thoughts, feelings, and appearance for many hours.

I look forward to the experience of professional hair and makeup, and the pampering that entails. Then after all of that, I will have this amazing product that will always remind me of the experience.

On a scale of 1–10 (10 being most confident) how would you rate how you feel about your body?
I would say an 8. I am much happier and more confident with my body than when I was a young woman. I am a good size 18, and have all the bumps and perceived flaws that go with that. When I was young, and a perfect size 7, I never felt as good as I do now. I always say "The bigger I am, the sexier I feel."

Aside from beautiful photographs, what else do you hope to get out of the experience?
I hope to have a wonderful day, enjoying the company of another artistic person (you, the photographer). I can't wait to be made up, and spend the day enjoying my sensuality.

What three words would you select to describe the look/feel of the images you hope to create?
Artsy. Edgy. Lovely.

What, if anything, would make you feel more comfortable and confident heading into your shoot?
A really nice relationship with you, the photographer, that has built through pre-shoot communications where we feel as if we are beginning a friendship. If you are enjoying shooting me as much as I enjoy being photographed, I will be so relaxed and confident.

What specifically might the photographer do to help you feel more comfortable and confident heading into your shoot?
For me it will all be about feeling good about you, so that I don't feel self-conscious about being a little risqué in the moment. So smiling and laughter is a wonderful thing!

Considering and preparing for my privacy, knowing some person or situation I'm not comfortable with will present itself, will go a long way to ensuring I am confident, relaxed, and somewhat uninhibited.

Please share any other insights or information about your thought process, fears, hopes, etc.
I wonder if I will appear in the photographs the way I feel. I sometimes joke that I have a kind of "reverse anorexia." I look in a mirror and feel very good about what I see. Then . . . somebody takes a picture! Oops, the camera never lies. I'm surprised that I don't look the way I thought I might. I do straddle the line between voluptuous and overweight, but I always feel voluptuous. I hope the photographs capture the confidence that I've developed over the years. This is something that was severely lacking when I had a "perfect" young body.

Post-shoot: Some clients describe the boudoir experience as a roller coaster of emotions. Was it so for you?
I found I felt pretty good throughout the entire experience. Of course, that has everything to do with feeling comfortable with you, the photographer, before and during the entire shoot. By the end, I was just feeling fabulous, like I had just experienced something really special.

What did the photographer do specifically that helped ease any anxiety or fears?

Susan, you were friendly and open. There was no hint of inhibition, which lessened any I might have. You seemed knowledgeable and professional, and were able to answer any questions I had with answers that put me at ease. There was a feeling that I would be safe and comfortable, and free to be as uninhibited as I chose.

Are there any specific or recurring thoughts you remember running through your head during the shoot? How did these make you feel?

I remember being pleased that I felt the way I'd hoped I'd feel. Relaxed with the process, and fairly uninhibited. I was fascinated that I was actually doing this, as it was a gift, and not something I had ever considered. Yet, there I was, being photographed in lingerie and less, and truly loving it.

Aside from beautiful images, are there any other positive outcomes from your boudoir experience?

Oh yes! I discovered how I truly feel about myself, as for me this experience required quite a lot of introspection.

It's a wonderful thing when you look within, and like what you see. Additionally, I discovered, through talking about this experience, how people close to me perceive me, and it was most enlightening and wonderful. This especially applies to the friend who was inspired by something about my personality and life experiences to give me this gift of a boudoir shoot.

On a scale of 1–10 (10 being most confident) how would you rate how you feel about your body post-shoot?

Probably the same as before, around an 8. I am, to be clear, quite thrilled to feel about an 8 in confidence at 50 years old, and being a bigger girl. I really loved the images, and that was before post-production touch ups.

Did you get what you hoped out of this experience?

Yes! I will always remember so much about the day, and the fact that my friend gave me this incredible gift. I've always been someone who enjoys photographs to remember the moments of my life, and this is no exception. I'll always be grateful to have met, and spent such unique and intimate time with, such a talented artist as yourself, Susan. The photographs will be something I will treasure.

An Interview with Jessica A.

Jessica A. is a client I'd shot as a gift to her husband. Having a second opportunity to shoot her was equally wonderful. She is vivacious, beautiful, and comfortable in her curvy body. As such she is an inspiration!

What motivates you to pursue a boudoir shoot right now?

Having shot with Susan before, I was eager to repeat an amazing experience.

Heading into your boudoir shoot, how would you describe how you feel?

I think there are a lot of conflicting emotions that arise whenever you do something out of your comfort zone. I would say that while I am scared I am also excited. Shooting makes me feel vulnerable as well as empowered. But I think for me part of the thrill is facing all of these emotions head on.

What three words would you select to describe the look/feel of the images you hope to create?

I actually couldn't narrow it down to three, but I would like my images to reflect a woman that is both soft and pretty as well as strong and sexy.

What, if anything, would make you feel more comfortable and confident heading into your shoot?

Knowing that I'm in the right hands puts me completely at ease.

Some clients describe the boudoir experience as a roller coaster of emotions. Was it so for you?

In the beginning I was nervous, excited, self-aware. During I felt at ease. By the end I felt liberated and confident!

What did the photographer do specifically that helped ease any anxiety or fears?

Susan just has a way of making you feel comfortable. She also makes sure to tell you how beautiful the images are while taking the pictures so it helps increase your level of confidence.

Are there any specific recurring thoughts you remember running through your head during the shoot? How did these make you feel?

I hope I don't look fat! It made me feel a little insecure.

Once you saw the images from your shoot, what was your reaction?

Just made me feel confident and sexy. Liberated!

On a scale of 1–10 (10 being most confident) how would you rate how you feel about your body post-shoot?

8. *(Pre-shoot she indicated a 7.)* I feel like my curves are the curves of a real, natural woman. These shoots have made me look at my body in a whole new way!

An Interview with Victoria

Victoria is the other half of the Jean and BFF shoot I referenced in Chapter 12. Both of these women are inspirations. Both are beautiful. And both agreed to have their stories told in Body and Soul.

Heading into your boudoir shoot, how would you describe how you feel?

I was diagnosed with breast cancer and having a bilateral mastectomy, and I always wanted pictures of myself and thanks to some great friends they made it possible. I'm excited!!!

What three words would you select to describe the look/feel of the images you hope to create?

Memorable, beautiful, happy.

Some clients describe the boudoir experience as a roller coaster of emotions. Was it so for you?

This photo shoot was an amazing experience for me. Especially since I was about to embark on a major life-changing surgery. Susan made me feel so beautiful and comfortable in front of the camera and once I got a glimpse of the pictures I felt even more comfortable, which allowed me to let all guards down and just go for it. The entire experience was Hollywood-like and I can't wait for my next experience with Susan for the after pictures.

What did the photographer do specifically that helped ease any anxiety or fears?

Susan was very relaxed and sweet and complimentary. Her professionalism yet down to earth sweetness made you feel so comfortable she was a pleasure to work with.

Are there any specific recurring thoughts you remember running through your head during the shoot? How did these make you feel?

Yes! I can't wait to see the pictures! I was having so much fun I didn't want the shoot to end. And all I could think was my body will never look like this again but what an experience and what a great way to remember it!

Once you saw the images from your shoot, what was your reaction?

My images were gorgeous, I couldn't believe it was me, amazing!

Aside from beautiful images, are there any other positive outcomes from your boudoir experience?

It allowed me to feel even more comfortable in my own skin. That I am beautiful and you don't have to be a perfect size 0 with large breasts and a big butt to be beautiful!

Anything else you wish to share . . .

To have these pictures now since I have had my surgery to look back at them means the world to me. I am so happy I had this experience. I absolutely love being in front of the camera and working with Susan. If I could do this more often, I absolutely would!

An Interview with Cheme

Cheme is an amazing woman who transformed her body through a fierce dedication to changing her lifestyle. She ran her first marathon in 2014 and although I was not able to attend her pre-marathon celebration because I was working (big surprise there), I cheered her from afar. Still, it wasn't until she sent me her responses that I realized the extent to which she still battles the internal demons. I hope that the images I provide her will help her to eventually conquer and silence them.

What motivated you to pursue a boudoir shoot right now?

The fact that it is something out of my character. Something new and exciting to do. To show off my body that I have worked and continue to work on. To be able to look back at myself and know that I am beautiful!

Heading into your boudoir shoot, how would you describe how you feel?

I feel nervous! Nervous that the pictures will not look good or, more so, my body will not look good. Especially that my expressions will not come across how they should.

What concerns you most?

The way I look concerns me most. Even though I work out, run, etc., there is still that doubt that I have. I think even more so that the pics will not come out as good as they did the first time. The last shoot gave me a self-confidence that I never imagined I had.

On a scale of 1–10 (10 being the most confident) how would you rate how you feel about your body?

There is always that little voice that creeps in and tells me that I should be working harder or eating better. I try to just keep it in the middle so I continue to push to where I want to be. I would say a 5.

What three words would you select to describe the look/feel of the images you hope to create?

Sensual. Confident. Sexy.

Post-shoot: Some clients describe the boudoir experience as a roller coaster of emotions. Was it so for you?

At the beginning of my shoot I was a bundle of nerves. I hoped I would look fine and the pictures would be good enough. By the end of my shoot I felt more confident and relaxed.

What did the photographer do specifically that helped ease any anxiety or fears?

She spoke to me every step of the way, making sure to explain the positions as well as asking me if I was okay through it all.

What was most challenging for you during the shoot?

The most challenging for me is the whole shoot experience. I am still very shy about my body and the way that it looks. What others see . . . I still feel like I am

overweight . . . shows just how crazy the mind can be. So to me the shoot is more than just pictures. It's about perseverance.

Once you saw the images from your shoot, what was your reaction?
I could not believe that it was me. The three words were definitely captured in my shoot.

Aside from beautiful images, are there any other positive outcomes from your boudoir experience?
Knowing that I came out of my comfort zone and was able to do something that I thought I would never do is a huge outcome. I will forever be thankful for now seeing myself as truly beautiful!

On a scale of 1–10 (10 being the most confident) how would you rate how you feel about your body?
9—always room for improvement! Haha! *(Pre-shoot she'd indicated 5.)*

Anything else you wish to share . . .
Thank you, thank you, thank you, Susan! You are a rare gem and I can only hope you continue to show people that they are truly beautiful. Thank you for helping me find my inner and outer beauty!

An Interview with Cherie

Cherie is a mover and a shaker and an art gallery owner. Having worked with all kinds of artists, I invited her to participate in this project and she obliged me. While her experience was a bit different in that she was observing me and my process as I shot her, I felt including her perspective was also useful.

What did the photographer do specifically that helped ease any anxiety or fears?
You are great! I really enjoyed talking with you, and your attitude in general. And your constant encouragement during the shoot was enthusiastic, and genuine

What was most challenging for you during the shoot?
I think it took me a little while to relax . . . And then holding a pose was a real work out!

Once you saw the images from your shoot, what was your reaction?
YES. Wow. You nailed it . . .

Aside from beautiful images, are there any other positive outcomes from your boudoir experience?
It was really fun! I really enjoyed hanging out with you . . . You are sweet and kind. Thank you!

On a scale of 1–10 (10 being the most confident) how would you rate how you feel about your body?
8–9.

Even if you started this journey as a gift to someone else, do you feel this experience was a gift to yourself in some way? If so, how?
Yes . . . getting an image like that is thrilling! It is a gift to myself.

Did you get what you hoped out of this experience?
Yes. I really loved seeing your studio . . . and to work with you is a pleasure.

Appendix

Is Boudoir Photography Right for Me? (Self-Assessment Questionnaire)

Rate yourself on a scale of 1–10 for each descriptor below:

1. I am clear about my motivations for pursuing boudoir photography.
2. I am able to handle the emotional needs of the boudoir client.
3. I am able to handle differences without judgment.
4. I have a high level of self-awareness.
5. My people skills are excellent.
6. I am easily able to defuse the situation when others are upset.
7. I have a great sense of humor.
8. I am compassionate and empathetic.
9. I am creative yet flexible when working with others.
10. I am unbiased—I see beauty in everyone.
11. I am good at directing people.
12. I am well versed in flattering poses for a wide range of body types.
13. I appreciate the role of women in our society.
14. My technical skills are at a level where I can easily make the right decisions that will flatter every body type.
15. I am able to draw people out of their shells.
16. Aside from creativity, I have strong business skills.
17. I am willing to be a respectful member of the boudoir photography community.

Sample Client Follow-Up Questionnaire

What words would you use to describe your overall boudoir experience?

What were the highlights of your experience? What did you find most helpful?

What if anything, surprised you most about your boudoir experience?

How did you feel going into the session?

How did you feel after your session?

If there's anything you would suggest we change or improve to create a better experience, what would it be?

Would you refer us to your friends, family?

Are you glad you hired us for your boudoir photography session?

Is it okay if we share your feedback anonymously with prospective clients?

Is there anything else you wish to share?

Sample Client Intake Questionnaire

What is motivating you to pursue a boudoir shoot at this time?

What three words would you use to summarize the feel of the images you wish to create?

What would you most like to get out of your boudoir shoot?

What are you most excited about?

What, if anything, would you anticipate might be your biggest challenges?

Is there anything you'd like to share that might help the photographer create images you'll love? (e.g. tattoos you don't want emphasized)

What do you love most about your body?

What do you prefer to de-emphasize about your body?

Is there anything else you wish to share?

Resource List for Boudoir Photographers

Following is a list of resources I have found helpful to me in my boudoir photography work:

- PPA
 www.PPA.com
- The Boudoir Album Company: Based in Canada, this album company offers high quality albums and a level of customer service that is unmatched in the industry.
 www.theboudoiralbum.com
- Metal prints/fine art prints
 www.Whitewall.com

- Prints on glass
 www.Fractureme.com
- The Association of International Boudoir Photographers
 www.aibphotog.com
- Packaging products
 www.Ricestudiosupply.com
 www.h-bpackaging.com
- Small customized gifts
 www.beau-coup.com
- Set design props
 www.save-on-crafts.com

Index